information
is beautiful

information is beautiful

David McCandless

Collins

Collins
An imprint of HarperCollins publishers
77–85 Fulham Palace Road
London
W6 8JB

www.collins.co.uk

First published in 2009 by Collins

10 9 8 7 6 5 4 3 2 1

www.davidmccandless.com

The author asserts his right to be identified as the author of this work

A catalogue record for this book is available from the British Library

ISBN: 9780007294664

Printed and bound in the UK by Butler Tanner and Dennis Ltd, Frome

Mixed Sources

Product group from well-managed
forests and other controlled sources
www.fsc.org Cert no. SW-COC-1806
© 1996 Forest Stewardship Council

FSC is a non-profit international organisation established to promote the
responsible management of the world's forests. Products carrying the FSC
label are independently certified to assure consumers that they come
from forests that are managed to meet the social, economic and
ecological needs of present and future generations.

Find out more about HarperCollins and the environment at
www.harpercollins.co.uk/green

to the beautiful internet

Introduction

This book started out as an exploration. Swamped by information, I was searching for a better way to see it all and understand it. Why not visually?

In a way, we're all visual now. Every day, every hour, maybe even every minute, we're looking and absorbing information via the web. We're steeped in it. Maybe even lost in it. So perhaps what we need are well-designed, colourful and – hopefully – useful charts to help us navigate. A map book.

But can a book with the minimum of text, rammed with diagrams, maps and charts, still be exciting and readable? Can it still be fun? Can you make jokes in graphs? Are you even allowed to?

So I started experimenting with visualizing information and ideas in both new and old ways. I went for subjects that sprang from my own curiosity and ignorance – the questions I wanted answering. I avoided straightforward facts and dry statistics. Instead, I focussed on the relationship between facts, the context, the connections that make information meaningful.

So, that's what this book is. Miscellaneous facts and ideas, interconnected visually. A visual miscellaneum. A series of experiments in making information approachable and beautiful. See what you think.

David McCandless

FOOD

POWER

LIFE

FILM

MEDIA

MUSIC

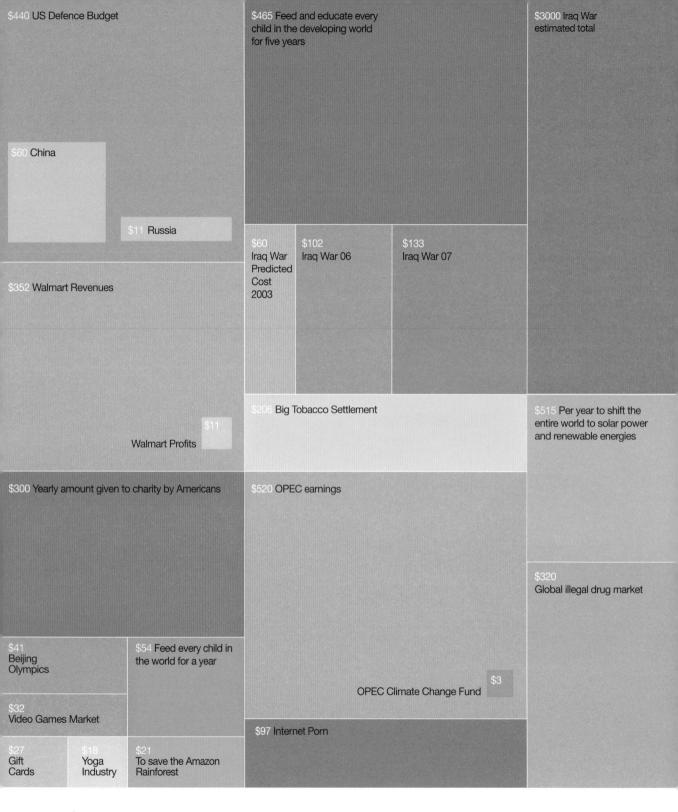

$440 US Defence Budget

$60 China

$11 Russia

$352 Walmart Revenues

$11 Walmart Profits

$300 Yearly amount given to charity by Americans

$41 Beijing Olympics

$32 Video Games Market

$27 Gift Cards

$18 Yoga Industry

$21 To save the Amazon Rainforest

$465 Feed and educate every child in the developing world for five years

$60 Iraq War Predicted Cost 2003

$102 Iraq War 06

$133 Iraq War 07

$206 Big Tobacco Settlement

$520 OPEC earnings

$54 Feed every child in the world for a year

OPEC Climate Change Fund $3

$97 Internet Porn

$3000 Iraq War estimated total

$515 Per year to shift the entire world to solar power and renewable energies

$320 Global illegal drug market

Billion-Dollar-O-Gram

Billions spent on this. Billions spent on that. It's all relative, right?

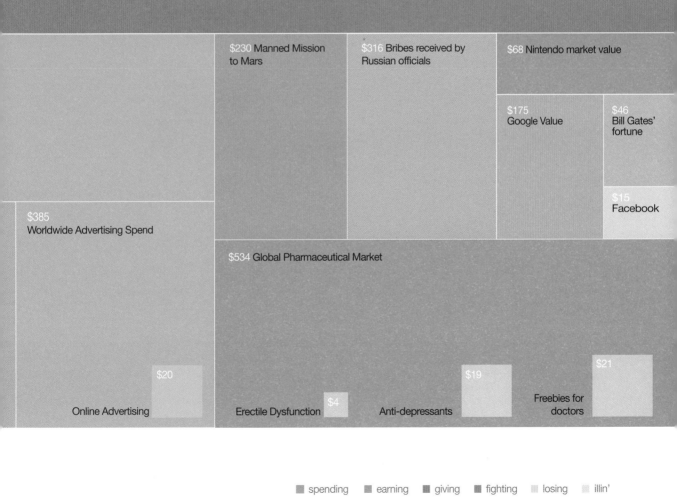

$230 Manned Mission to Mars

$316 Bribes received by Russian officials

$68 Nintendo market value

$175 Google Value

$46 Bill Gates' fortune

$15 Facebook

$385 Worldwide Advertising Spend

$534 Global Pharmaceutical Market

$20

Online Advertising

Erectile Dysfunction

$4

Anti-depressants

$19

Freebies for doctors

$21

▓ spending ▓ earning ▓ giving ▓ fighting ▓ losing ▓ illin'

source: MSNBC, Guardian, Washington Post, Forbes, UNODC, BBC News. All figures 2006-07 unless otherwise stated.

$7800 'Worst case' scenario cost of financial crisis to US Government

$2800 Total cost of financial crisis to US Government to date (Aug 09)

$500 The New Deal, the US recovery package after the Great Depression of 1933 (in today's dollars)

$823 NASA's total all time budget (1958-)

$115 The Marshall Plan to rebuild Europe after WWII (in today's dollars)

$238 UK government bailouts

$570 Chinese government stimulus package, Nov 08

$67 German gov bailout Jan 09

$35 French gov bailout Dec 08

$24 Wall St bonuses 2006

$36 Wall St bonuses 2007

$18 Wall St bonuses 2008

$200 Africa's entire debt to Western nations

■ Spending ■ Wincing ■ Giving ▢ Crying

source: Wikipedia, Guardian, Business Week, Ritzholtz.com

Left

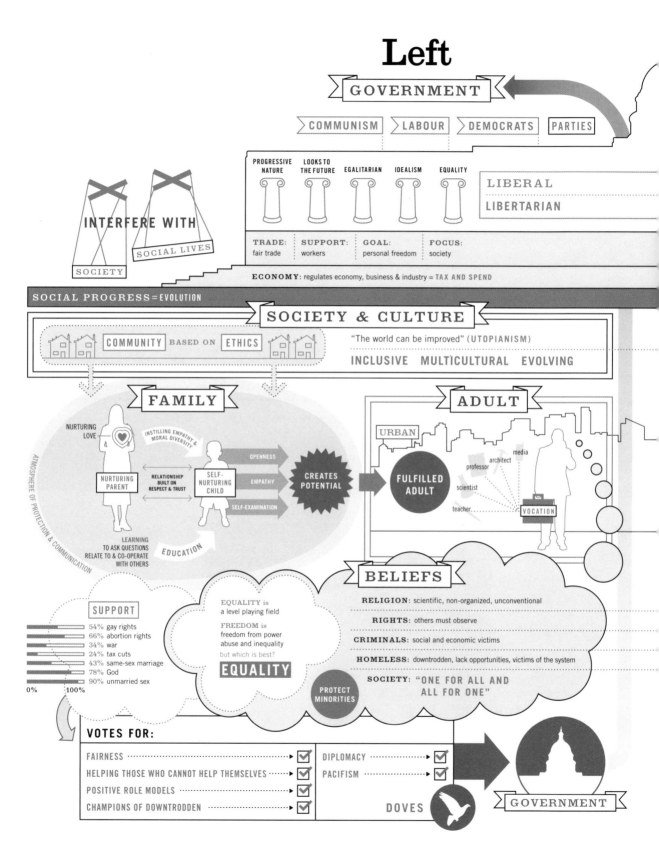

GOVERNMENT

COMMUNISM | LABOUR | DEMOCRATS | PARTIES

PROGRESSIVE NATURE | LOOKS TO THE FUTURE | EGALITARIAN | IDEALISM | EQUALITY

LIBERAL

LIBERTARIAN

TRADE:	SUPPORT:	GOAL:	FOCUS:
fair trade	workers	personal freedom	society

ECONOMY: regulates economy, business & industry = TAX AND SPEND

INTERFERE WITH SOCIAL LIVES

SOCIETY

SOCIAL PROGRESS = EVOLUTION

SOCIETY & CULTURE

COMMUNITY BASED ON ETHICS

"The world can be improved" (UTOPIANISM)

INCLUSIVE MULTICULTURAL EVOLVING

FAMILY

NURTURING LOVE

INSTILLING EMPATHY & MORAL DIVERSITY

NURTURING PARENT

RELATIONSHIP BUILT ON RESPECT & TRUST

SELF-NURTURING CHILD

OPENNESS
EMPATHY
SELF-EXAMINATION

CREATES POTENTIAL

LEARNING TO ASK QUESTIONS RELATE TO & CO-OPERATE WITH OTHERS

EDUCATION

ATMOSPHERE OF PROTECTION & COMMUNICATION

ADULT

URBAN

FULFILLED ADULT

media
architect
professor
scientist
teacher

VOCATION

BELIEFS

RELIGION: scientific, non-organized, unconventional

RIGHTS: others must observe

CRIMINALS: social and economic victims

HOMELESS: downtrodden, lack opportunities, victims of the system

SOCIETY: "ONE FOR ALL AND ALL FOR ONE"

EQUALITY is a level playing field

FREEDOM is freedom from power abuse and inequality but which is best?

EQUALITY

PROTECT MINORITIES

SUPPORT

54% gay rights
66% abortion rights
34% war
24% tax cuts
43% same-sex marriage
78% God
90% unmarried sex

0% 100%

VOTES FOR:

FAIRNESS ☑

HELPING THOSE WHO CANNOT HELP THEMSELVES ☑

POSITIVE ROLE MODELS ☑

CHAMPIONS OF DOWNTRODDEN ☑

DIPLOMACY ☑

PACIFISM ☑

DOVES

GOVERNMENT

Right

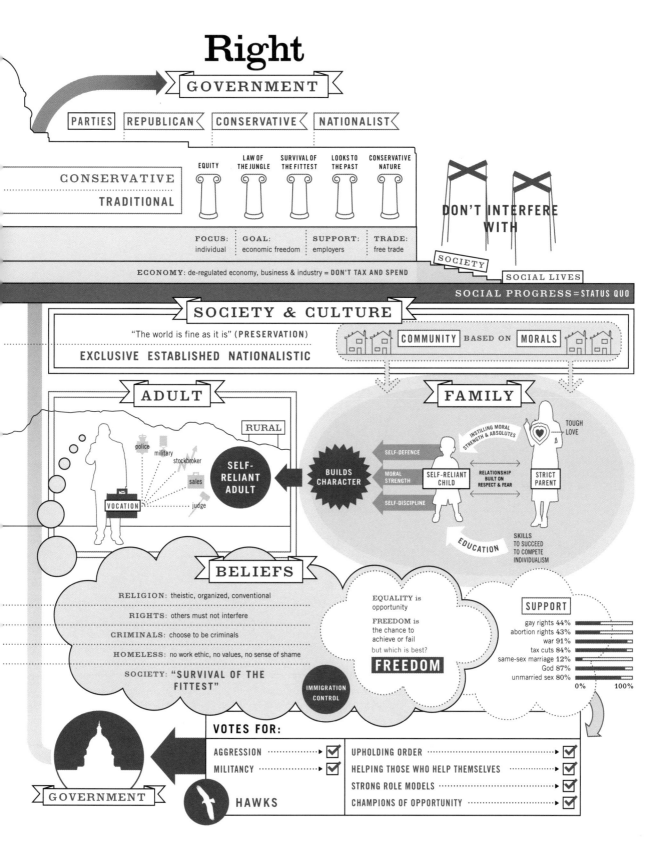

GOVERNMENT

PARTIES — REPUBLICAN — CONSERVATIVE — NATIONALIST

CONSERVATIVE
TRADITIONAL

EQUITY | LAW OF THE JUNGLE | SURVIVAL OF THE FITTEST | LOOKS TO THE PAST | CONSERVATIVE NATURE

FOCUS: individual | GOAL: economic freedom | SUPPORT: employers | TRADE: free trade

ECONOMY: de-regulated economy, business & industry = **DON'T TAX AND SPEND**

DON'T INTERFERE WITH
SOCIETY
SOCIAL LIVES
SOCIAL PROGRESS = STATUS QUO

SOCIETY & CULTURE

"The world is fine as it is" (PRESERVATION)

EXCLUSIVE ESTABLISHED NATIONALISTIC

COMMUNITY BASED ON MORALS

ADULT

RURAL

police
military
stockbroker
sales
judge

VOCATION

SELF-RELIANT ADULT

BUILDS CHARACTER

FAMILY

INSTILLING MORAL STRENGTH & ABSOLUTES

TOUGH LOVE

SELF-DEFENCE
MORAL STRENGTH
SELF-DISCIPLINE

SELF-RELIANT CHILD

RELATIONSHIP BUILT ON RESPECT & FEAR

STRICT PARENT

EDUCATION

SKILLS TO SUCCEED TO COMPETE INDIVIDUALISM

BELIEFS

RELIGION: theistic, organized, conventional

RIGHTS: others must not interfere

CRIMINALS: choose to be criminals

HOMELESS: no work ethic, no values, no sense of shame

SOCIETY: **"SURVIVAL OF THE FITTEST"**

EQUALITY is opportunity

FREEDOM is the chance to achieve or fail

but which is best?

FREEDOM

IMMIGRATION CONTROL

SUPPORT

gay rights 44%
abortion rights 43%
war 91%
tax cuts 84%
same-sex marriage 12%
God 87%
unmarried sex 80%

0% — 100%

VOTES FOR:

AGGRESSION ☑
MILITANCY ☑

UPHOLDING ORDER ☑
HELPING THOSE WHO HELP THEMSELVES ☑
STRONG ROLE MODELS ☑
CHAMPIONS OF OPPORTUNITY ☑

GOVERNMENT

HAWKS

note: colour with your country's colours for left and right // source: Wikipedia, Britannica.com, New Scientist, Conservative-resources.com,

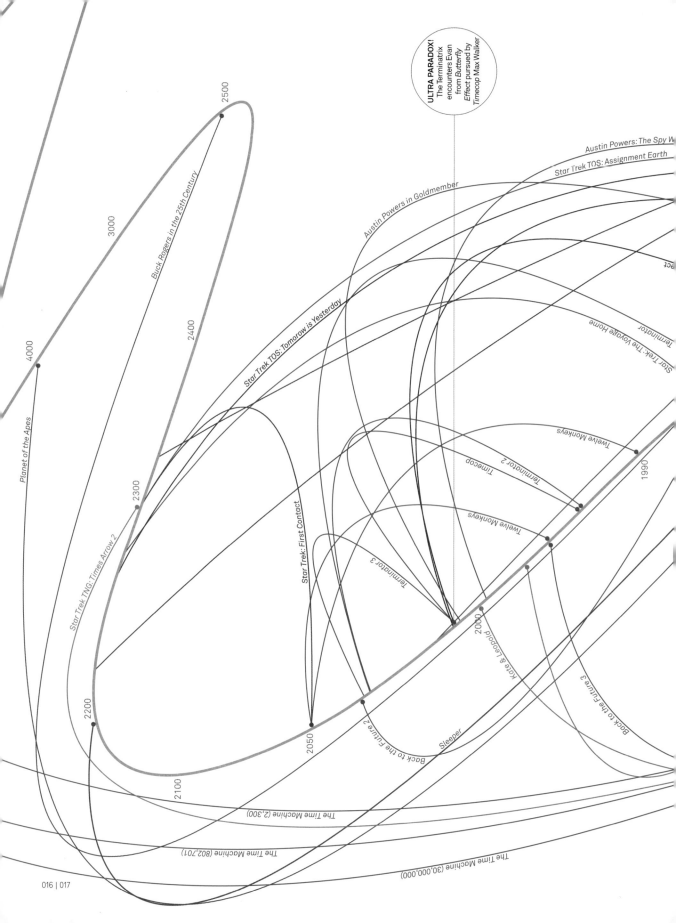

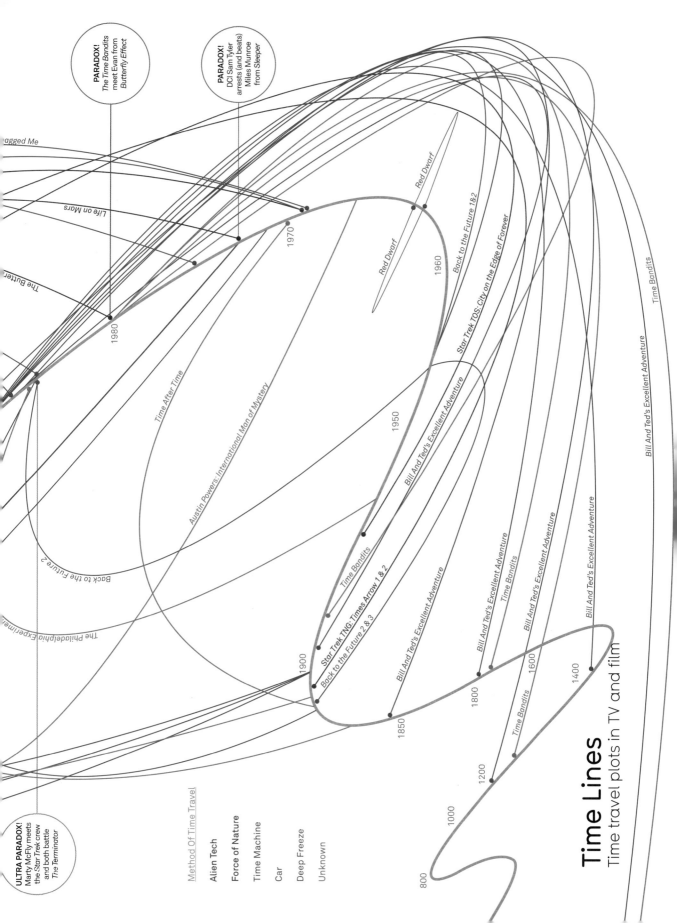

Time Lines

Time travel plots in TV and film

PARADOX!
The Time Bandits meet Evan from *Butterfly Effect*

PARADOX!
DCI Sam Tyler arrests (and beats) Miles Munroe from *Sleeper*

ULTRA PARADOX!
Marty McFly meets the *Star Trek* crew and both battle *The Terminator*

Method Of Time Travel

Alien Tech

Force of Nature

Time Machine

Car

Deep Freeze

Unknown

...agged Me

Life on Mars

The Butter...

Time After Time

Austin Powers: International Man of Mystery

Back the Future 2

The Philadelphia Experiment

Red Dwarf

Red Dwarf

Back to the Future 1 & 2

Star Trek TOS: City on the Edge of Forever

Bill And Ted's Excellent Adventure

Bill And Ted's Excellent Adventure

Time Bandits

Time Bandits

Bill And Ted's Excellent Adventure

Bill And Ted's Excellent Adventure

Time Bandits

Bill And Ted's Excellent Adventure

Time Bandits

Bill And Ted's Excellent Adventure

Time Bandits

Star Trek TNG: Times Arrow 1 & 2

Back to the Future 2 & 3

1970

1980

1960

1950

1900

1850

1800

1600

1400

1200

1000

800

Snake Oil?

Scientific evidence for popular dietary supplements showing tangible health benefits when taken orally by an adult with a healthy diet.

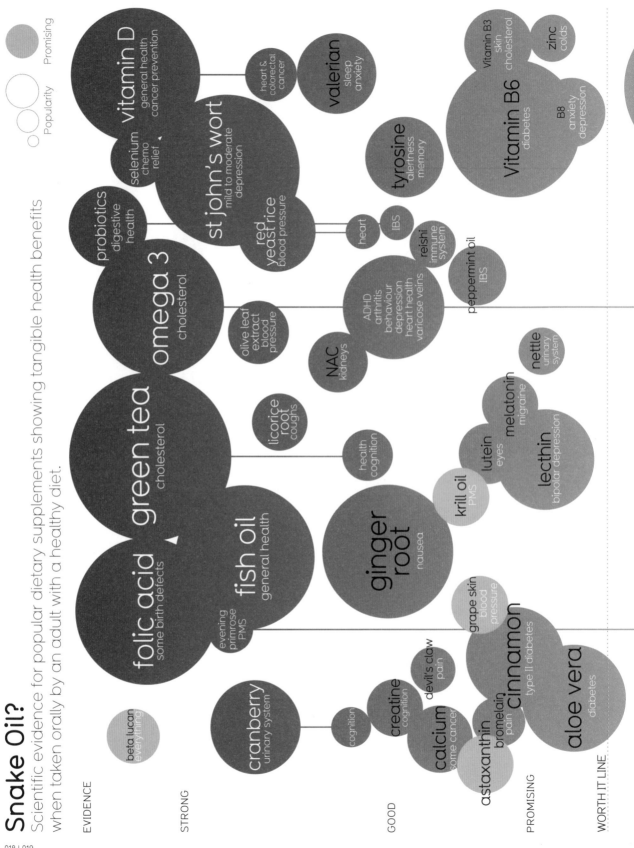

Popularity
Promising

EVIDENCE

STRONG

GOOD

PROMISING

WORTH IT LINE

vitamin D general health cancer prevention

selenium chemo relief

heart & colorectal cancer

valerian sleep anxiety

st john's wort mild to moderate depression

red yeast rice blood pressure

probiotics digestive health

omega 3 cholesterol

green tea cholesterol

folic acid some birth defects

fish oil general health

evening primrose PMS

olive leaf extract blood pressure

NAC kidneys

heart

IBS

reishi immune system

ADHD arthritis behaviour depression heart health varicose veins

peppermint oil IBS

tyrosine alertness memory

Vitamin B6 diabetes

Vitamin B3 skin cholesterol

zinc colds

B8 anxiety depression

licorice root coughs

health cognition

ginger root nausea

krill oil PMS

lutein eyes

melatonin migraine

nettle urinary system

lecthin bipolar depression

cognition

cranberry urinary system

creatine cognition

devil's claw pain

grape skin blood pressure

calcium some cancer

bromelain pain

cinnamon type II diabetes

astaxanthin

aloe vera diabetes

beta lucan everything

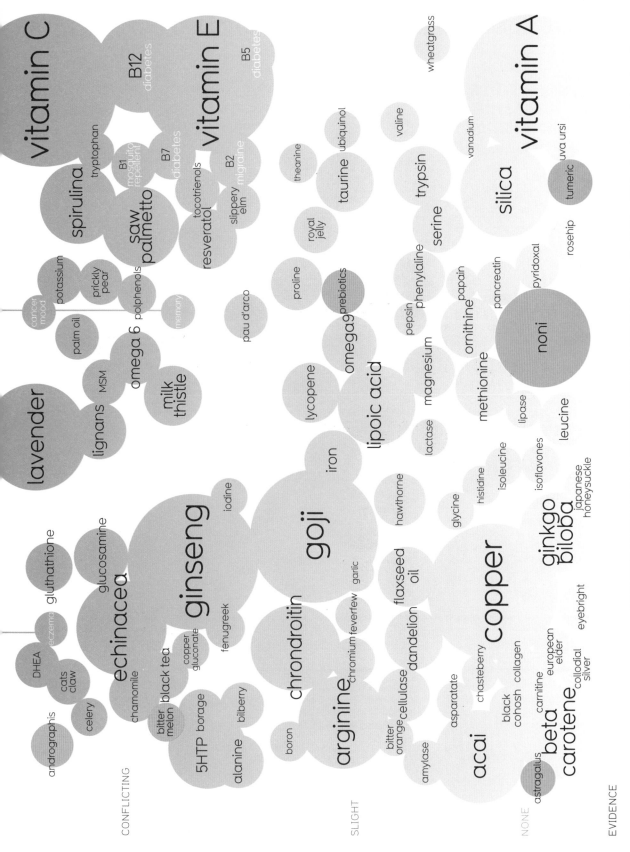

source: English language placebo-controlled double-blind human trials on PubMed.org, The US Office of Dietary Supplements, Herbmed.org, European Medicines Agency

CONFLICTING

SLIGHT

NONE

EVIDENCE

The Creationism-Evolutionism Spectrum
Where did everything come from?

Circle size = approximate number of believers (this side only)

FLAT EARTHERS
The Earth is flat because the Bible says it is. Flat like a coin. Or perhaps a plate.

GEOCENTRICISM
Earth is centre of the universe. All modern science is bunk.

PROGRESSIVE CREATIONISM
God created man and the animals. Everything else evolved.

YOUNG EARTH CREATIONISM
The Earth is 6000 years old. Humans are not related to animals. And you will burn in Hell if you don't believe this.

INTELLIGENT DESIGN
Because things are so well designed, they could not have evolved. Therefore God must've created them.

GAP CREATIONISM
The world and mankind created in 7 days, but then there was a gap of a billion years or so.

DEISM
God created Earth and man but has been silent since.

SCIENTOLOGY
Galactic ruler Xenu gathered the disembodied spirits of alien beings called Thetans into human form.

THEISTIC EVOLUTION
God creates through evolution

Evolution is fine. But God intervenes at critical moments in the history of life. The Hand of God is also necessary for the creation of the human soul.

HINDU EVOLUTION
God *is* evolution

Evolution is a spiritual process. Humanity is God incarnate, evolving towards a realization of this living truth.

BUDDHISM
The creation of humanity unknowable, therefore irrelevant. What is, is.

MOST MUSLIMS

POSITION OF THE CATHOLIC CHURCH

ONE EXTREME

UNIVERSAL DARWINISM
All universal processes, yep all, are governed by Darwinian evolution.

CO-EVOLUTION
Co-operation, not competition, between organisms accelerates evolution. "Survival of the nicest."

DARWINIAN EVOLUTION
Survival of the fittest
Random mutations give certain organisms a survival advantage in their environment. This adaptation is passed on to their offspring over hundreds of generations ("natural selection"). No God necessary.

GROUP SELECTIONISM
Entire species are actually higher-level organisms in their own right. Natural selection affects species differently.

CONVERGENT EVOLUTION
Complex elements like eyes have evolved more than twice. Huh? Exactly. Deeper structures are at play.

NEO LAMARCKISM
Not as random as we think. Genes show some capacity to "choose" mutations.

NEO DARWINISM
Selfish genes in DNA evolve slowly over time taking we, the host organisms, with them.

PUNCTUATED EQUILIBRIUM
Evolution is essentially static until sudden dramatic events shift it into a higher gear.

LAMARCKISM
Traits acquired by parents during lifetime can be passed on to their offspring. Proven incorrect.

THE OTHER

source: Wikipedia, BBC.com, Skeptic.com

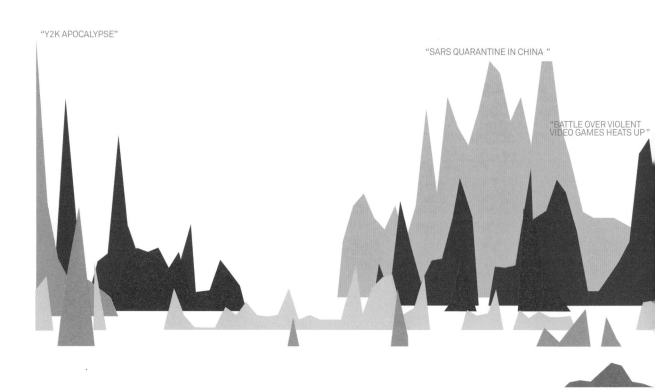

"Y2K APOCALYPSE"

"SARS QUARANTINE IN CHINA "

"BATTLE OVER VIOLENT
VIDEO GAMES HEATS UP "

2000 2001 2002 2003 2004

Story (approximate worldwide deaths)

▲ Killer Wasps (1000) ▲ Autism Vaccinations (0) ▲ Mad Cow Disease (204) ▲ Bird Flu (262)

▲ Killer Wifi (0) ▲ Asteroid Collision (0) ▲ Violent Video Games (Unknown) ▲ Swine Flu (702)

▲ Mobile Phones & Tumours (0) ▲ Millennium Bug (0) ▲ SARS (774)

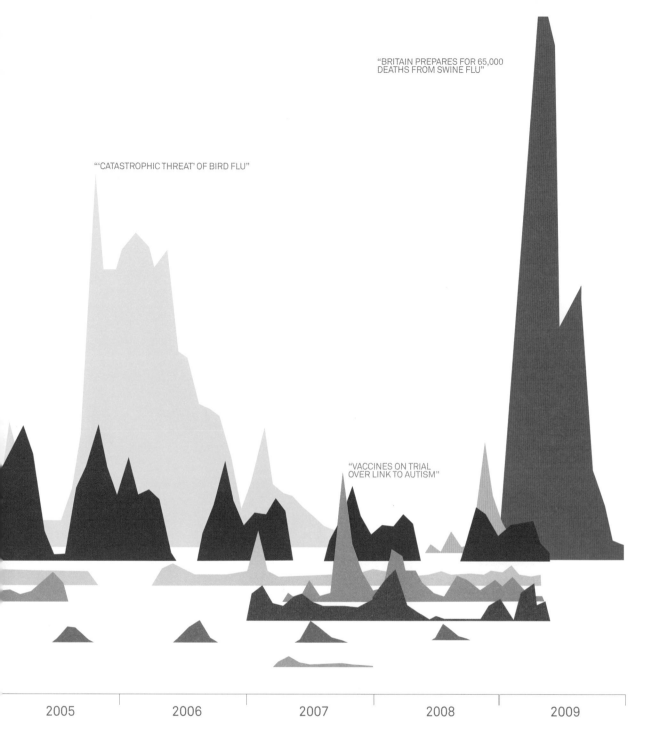

"BRITAIN PREPARES FOR 65,000
DEATHS FROM SWINE FLU"

"'CATASTROPHIC THREAT' OF BIRD FLU"

"VACCINES ON TRIAL
OVER LINK TO AUTISM"

2005 2006 2007 2008 2009

Mountains Out of Molehills
A timeline of global media scare stories

source: Google News (worldwide deaths at time of print)

slow moneyless DVDs by post Italian gin bald ugly cute Tom Cruise

fast fist bump CBT

indie contrived gym membership French vodka quiet beautiful pico high five Jesus

mainstream original real wood smoking halal nano Botox Bono

urban fake silver spray paint loud kosher turbo nobody Pope

thrift nuked the fridge messy local organic boreout

together taste real neat sushi Peter Ustinov

alone chic flavour jumped the shark Botox sandwich pizza burnout

happy bad blonde spanking new sitting climate change straight scar tissue

cool thin good blonde old miniskirt Atkins gay

nice awake ballroom dancing blood new skiing fat denim vegan

"not bad" sleep jazzercize pregnancy bitch

mental illness cricket anal bla

"great!" love sex porn

hate jail yoga

staying in unprotected sex ironing death DIY porn order random

going out thug shooting pain violence niche folk rock

contraception engagement ring love making pleasure profanity normal forgetting Adriatic Baltimore House

abortion boy friendly hotness autism nonsense obvious Balearic Dylan

hysteria stupid lesbianism pragmatism schizophrenia sense subliminal bowling children's music information

calm awesome loyalty treatment individuality propriety ukulele punk poetry everything

young ignorant competence prevention conformity scaremongering classical comedy

old educated contempt Easter October sleaze pedantry rock 'n' roll crafting

mongrel self-pity Christmas December Wednesday anonymity

pedigree Thursday Friday politeness chronic disease darts cooking

Tuesday Monday weather fishing

X is the New Black
A map of clichés

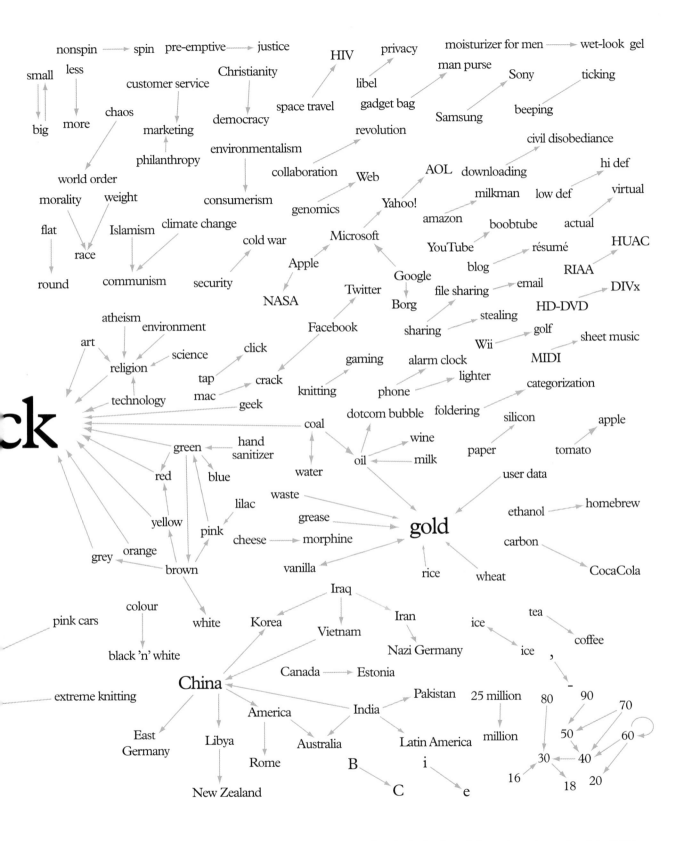

Searches for the phrase 'is the new' on various media outlet websites.

idea: Randall Szott // source: Google, Guardian.co.uk, NewScientist.com, Wired.com, Nytimes.com

Tons Of Carbon I

Per year unless otherwise stated

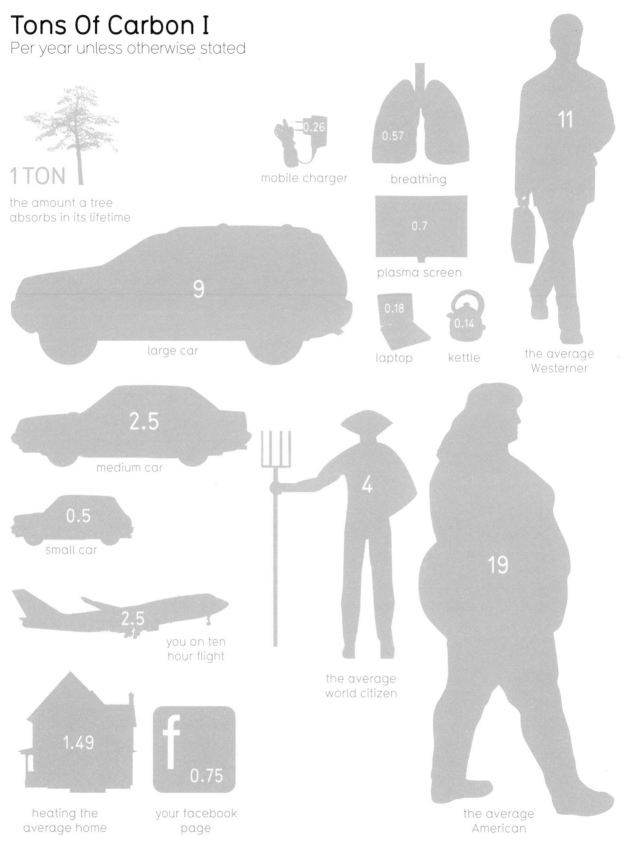

1 TON
the amount a tree absorbs in its lifetime

0.26
mobile charger

0.57
breathing

0.7
plasma screen

0.18
laptop

0.14
kettle

11
the average Westerner

9
large car

2.5
medium car

0.5
small car

2.5
you on ten hour flight

4
the average world citizen

19
the average American

1.49
heating the average home

f 0.75
your facebook page

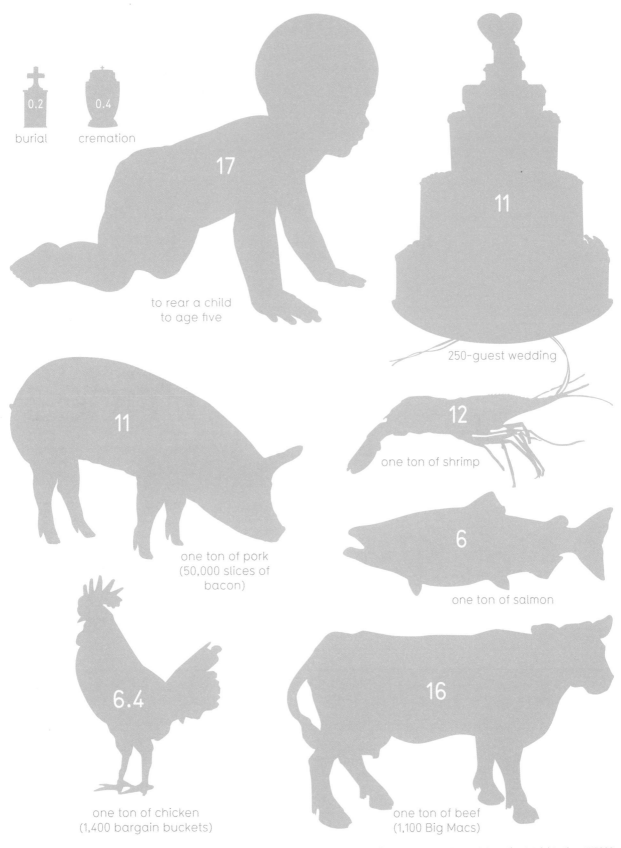

0.2
burial

0.4
cremation

17
to rear a child
to age five

11
250-guest wedding

11
one ton of pork
(50,000 slices of
bacon)

12
one ton of shrimp

6
one ton of salmon

6.4
one ton of chicken
(1,400 bargain buckets)

16
one ton of beef
(1,100 Big Macs)

source: New York Times, Environmental Protection Agency, IPCC, Energy Information Administration. UNESCO

Books Everyone Should Read

A consensus cloud

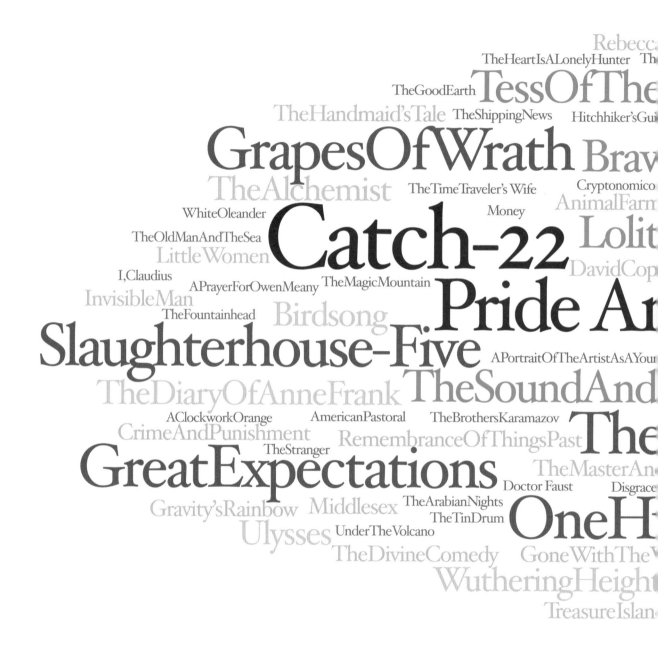

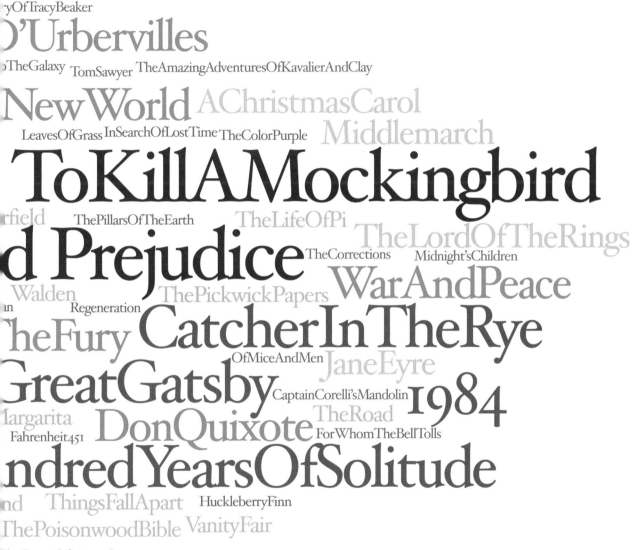

yOfTracyBeaker

D'Urbervilles

TheGalaxy TomSawyer TheAmazingAdventuresOfKavalierAndClay

New World AChristmasCarol

LeavesOfGrass InSearchOfLostTime TheColorPurple Middlemarch

ToKillAMockingbird

rfield ThePillarsOfTheEarth TheLifeOfPi TheLordOfTheRings

d Prejudice TheCorrections Midnight'sChildren

Walden Regeneration ThePickwickPapers WarAndPeace

heFury CatcherInTheRye

OfMiceAndMen JaneEyre

GreatGatsby CaptainCorelli'sMandolin 1984

Margarita DonQuixote TheRoad

Fahrenheit451 ForWhomTheBellTolls

ndredYearsOfSolitude

nd ThingsFallApart HuckleberryFinn

ThePoisonwoodBible VanityFair

TheCountOfMonteCristo

source: Desert Island Discs, Pulitzer Prize, AskMetafilter.com, World Day Book Poll, Booker Prize, BBC Big Reads, Oprah's Book Club List & the author's own top five

Which Fish are Okay to Eat?

Crashing fish stocks. Pollution. Over-exploitation. Near-extinction.

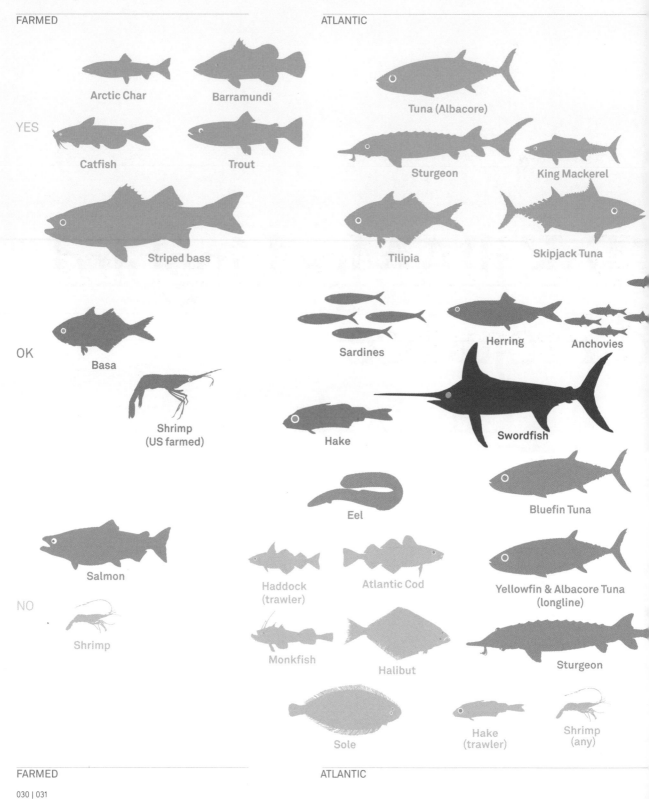

FARMED

ATLANTIC

YES

Arctic Char

Barramundi

Catfish

Trout

Striped bass

Tuna (Albacore)

Sturgeon

King Mackerel

Tilipia

Skipjack Tuna

OK

Basa

Shrimp
(US farmed)

Sardines

Herring

Anchovies

Hake

Swordfish

Eel

Bluefin Tuna

NO

Salmon

Shrimp

Haddock
(trawler)

Atlantic Cod

Yellowfin & Albacore Tuna
(longline)

Monkfish

Halibut

Sturgeon

Sole

Hake
(trawler)

Shrimp
(any)

FARMED

ATLANTIC

PACIFIC

Pollock

Salmon

Sardines

Mullet

Halibut

Spiny Lobster

Pacific Cod

Spot Prawns

Yellowfin & Albacore Tuna
(pole-caught)

Sole

Lingcod / Burbot

American
Lobster

Bluefish

Sea Bass Black

Snapper / Mutton Fish
Chilean & Yellowtail

Shark

Mahi Mahi /
Dolphinfish

Chilean Sea Bass / Toothfish

Cod
(Trawler)

Skate

Orange
Roughy

Marlin

Caribbean
Lobster

Snapper / Mutton Fish
Red, Silk, Vermillion

Eel European &
American

PACIFIC

source: Marine Stewardship Council

2005

2004

2003

2002

SUMMER | WINTER

2007

2008

2009

2010

The "In" Colours
Women's fashion colours

source: pantone.com

The "Interesting" Colours
Selected women's fashion colours

SUMMER

2002

pinkle lily green poppy red 03

tigerlily cadmium plaza taupe 04

coral reef kelp begonia pink 05

french vanilla melon clove 06

silver peony tarragon golden apricot 07

golden olive croissant snorkel blue 08

lucite green dark citron rose dust 09

roccoco red deep ultramarine cameo pink 10

2002

gypsy lavender turkish coffee peacock

03

hollyhock cognac dull gold

04

tango red norse blue elderberry

05

moroccan blue rattan moss

06

simple taupe apple cinnamon red mahagony

07

carafe chilli pepper lemon curry

08

royal lilac shiitake withered rose

09

split pea dark plum raspberry

10

WINTER

source: pantone.com

Three's a Magic Number

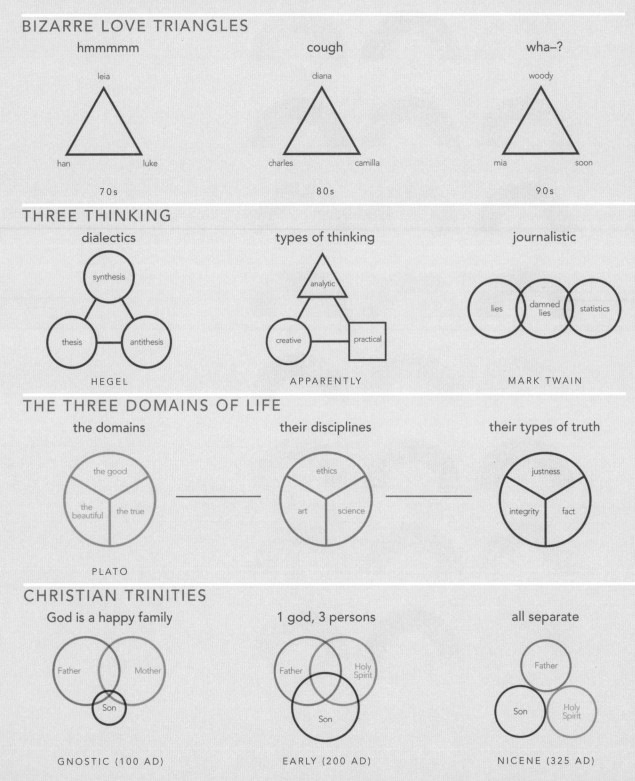

BIZARRE LOVE TRIANGLES

hmmmmm
leia

han luke

70s

cough
diana

charles camilla

80s

wha–?
woody

mia soon

90s

THREE THINKING

dialectics
synthesis

thesis antithesis

HEGEL

types of thinking
analytic

creative practical

APPARENTLY

journalistic
lies damned lies statistics

MARK TWAIN

THE THREE DOMAINS OF LIFE

the domains
the good

the beautiful the true

PLATO

their disciplines
ethics

art science

their types of truth
justness

integrity fact

CHRISTIAN TRINITIES

God is a happy family
Father Mother

Son

GNOSTIC (100 AD)

1 god, 3 persons
Father Holy Spirit

Son

EARLY (200 AD)

all separate
Father

Son Holy Spirit

NICENE (325 AD)

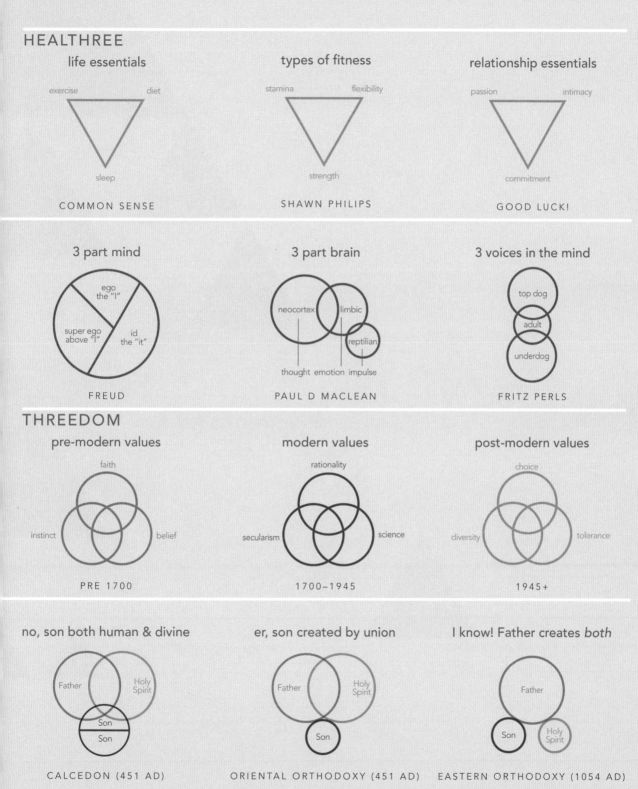

HEALTHREE

life essentials

exercise — diet

sleep

COMMON SENSE

types of fitness

stamina — flexibility

strength

SHAWN PHILIPS

relationship essentials

passion — intimacy

commitment

GOOD LUCK!

3 part mind

ego
the "I"

super ego
above "I" id
the "it"

FREUD

3 part brain

neocortex limbic

reptilian

thought emotion impulse

PAUL D MACLEAN

3 voices in the mind

top dog

adult

underdog

FRITZ PERLS

THREEDOM

pre-modern values

faith

instinct belief

PRE 1700

modern values

rationality

secularism science

1700–1945

post-modern values

choice

diversity tolerance

1945+

no, son both human & divine

Father Holy
Spirit

Son
Son

CALCEDON (451 AD)

er, son created by union

Father Holy
Spirit

Son

ORIENTAL ORTHODOXY (451 AD)

I know! Father creates *both*

Father

Son Holy
Spirit

EASTERN ORTHODOXY (1054 AD)

source: Wikipedia, The Gale Encyclopedia Of Religion

Who Runs the World?

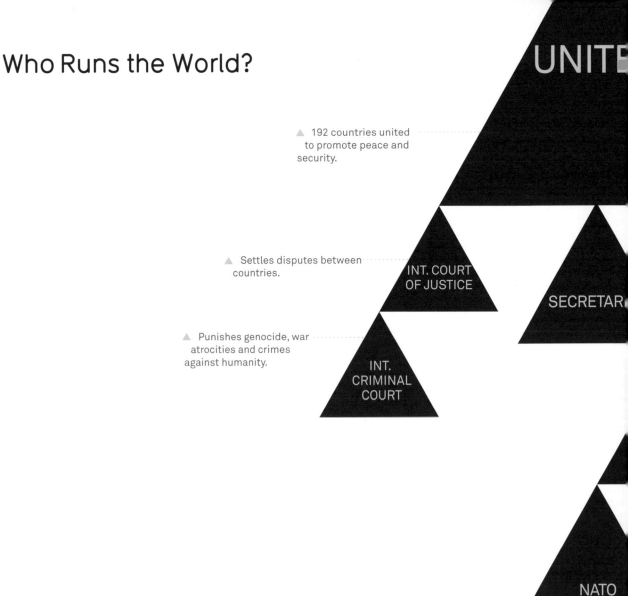

UNITE

▲ 192 countries united to promote peace and security.

▲ Settles disputes between countries.

INT. COURT OF JUSTICE

SECRETAR

▲ Punishes genocide, war atrocities and crimes against humanity.

INT. CRIMINAL COURT

NATO

▲ Worldwide intelligence agency. Anti-terrorism, trafficking, and organized crime. James Bond stuff basically.

INTERPOL

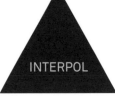
NATION STATES

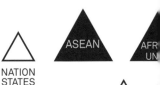
ASEAN

AFR UN

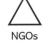
NGOs

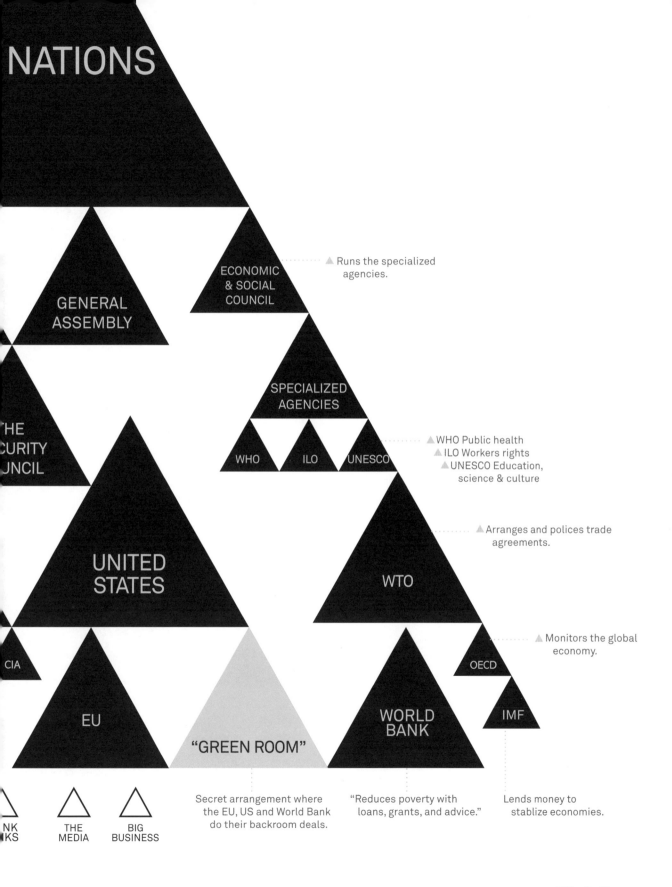

NATIONS

ECONOMIC & SOCIAL COUNCIL
▲ Runs the specialized agencies.

GENERAL ASSEMBLY

SPECIALIZED AGENCIES

WHO ILO UNESCO

▲ WHO Public health
▲ ILO Workers rights
▲ UNESCO Education, science & culture

THE SECURITY COUNCIL

UNITED STATES

WTO
▲ Arranges and polices trade agreements.

CIA

EU

OECD
▲ Monitors the global economy.

"GREEN ROOM"

WORLD BANK

IMF

NK KS

THE MEDIA

BIG BUSINESS

Secret arrangement where the EU, US and World Bank do their backroom deals.

"Reduces poverty with loans, grants, and advice."

Lends money to stablize economies.

source: Wikipedia, UN.org

Who *Really* Runs the World
Conspiracy theory

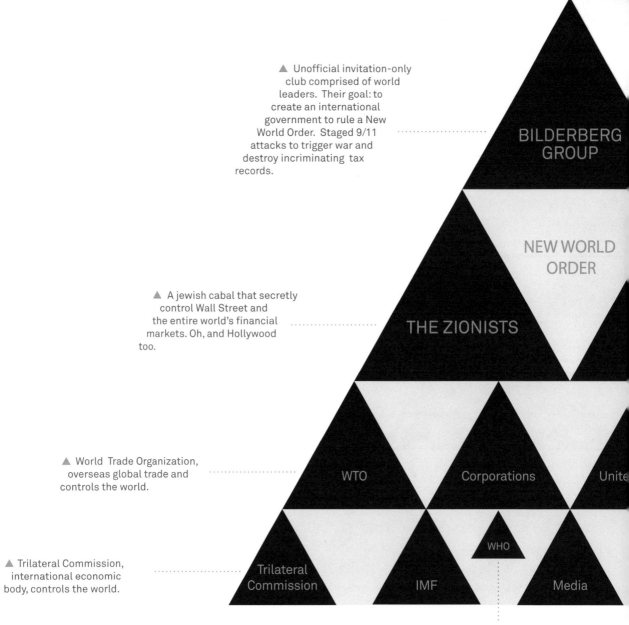

▲ Secret group, similar to Freemasons, who mastermind world events and control governments for their own purposes.

▲ Unofficial invitation-only club comprised of world leaders. Their goal: to create an international government to rule a New World Order. Staged 9/11 attacks to trigger war and destroy incriminating tax records.

▲ A jewish cabal that secretly control Wall Street and the entire world's financial markets. Oh, and Hollywood too.

▲ World Trade Organization, overseas global trade and controls the world.

▲ Trilateral Commission, international economic body, controls the world.

▲ Invents disorders like ADHD to market drugs.

BILDERBERG GROUP

NEW WORLD ORDER

THE ZIONISTS

WTO

Corporations

Unite

Trilateral Commission

IMF

WHO

Media

ILLUMINATI

SATAN

SHAPESHIFTING LIZARDS

▲ Reptilian humanoids. The Babylonian Brotherhood controls the world. Its ranks include George Bush, Queen Elizabeth and Kris Kristofferson.

The Anti-Christ

UNITED STATES

ALIENS

CIA

ons

UFOs

Black Ops

▲ Contrails are chemicals.
▲ Fluoride in water is mind-control juice.
▲ AIDS/HIV/Bird Flu/SARS – all man-made.
▲ Invented crack cocaine to shackle underclass.
▲ Global warming a fraud.
▲ Evidence of WMDs in Iraq faked to justify war.
Err...

▲ Aliens routinely abduct and experiment on humans. US government knows this but hides the truth.

source: Wikipedia, Skeptic.com

Stock Check
Estimated remaining world supplies of non-renewable resources

Metals

	Zinc	musical instruments	10 years
	Titanium	aircraft, armour	12 years
	Indium	solar panels, LCD screens	13 years
	Lead	bullets, car batteries	14 years
	Silver	bandages, medals, jewellery	14 years
	Gold	jewellery, bullion	14 years
	Hafnium	nuclear power, computer chips	17 years
	Chromium	plating, paint	20 years
	Tin	food cans, industry	23 years
	Uranium	nuclear weapons	23 years
	Copper	brass, wires, piping	26 years
	Tantalum	mobile phones	28 years
	Antimony	drugs, batteries	29 years
	Nickel	coins, plating	31 years
	Platinum	fuel cells, catalytic converters, more jewellery	39 years
	Cadmium	rechargeable batteries, TV screens	54 years

assuming a 1%–2.5% increase in demand every year depending on resource

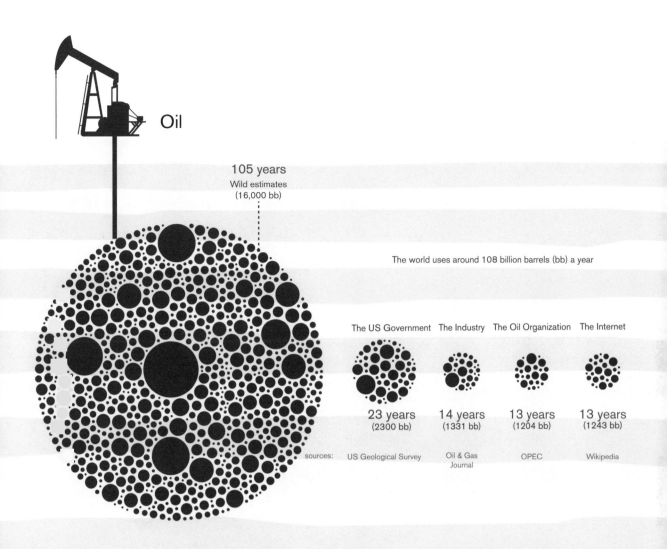

Oil

105 years
Wild estimates
(16,000 bb)

The world uses around 108 billion barrels (bb) a year

The US Government	The Industry	The Oil Organization	The Internet
23 years (2300 bb)	14 years (1331 bb)	13 years (1204 bb)	13 years (1243 bb)

sources: US Geological Survey / Oil & Gas Journal / OPEC / Wikipedia

Coal

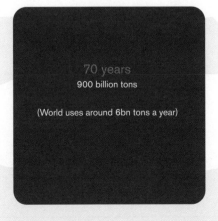

70 years
900 billion tons

(World uses around 6bn tons a year)

assuming a 1% increase in demand every year

Natural Gas

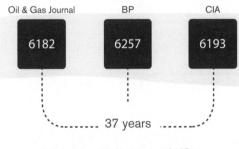

Oil & Gas Journal	BP	CIA
6182	6257	6193

37 years

Trillion cubic feet. World uses around 105 per year.

sources: US Dept of Energy

Proven reserves are, at best, minimum safe guesses of remaining
and easy-to-access resources. More reserves are likely to be found.

source: Wikipedia, OPEC, Environmental Investigation Agency, USGS, CIA Factbook, Oil & Gas Journal, World Energy Council, World Coal Institute, BP

30 Years Makes A Difference

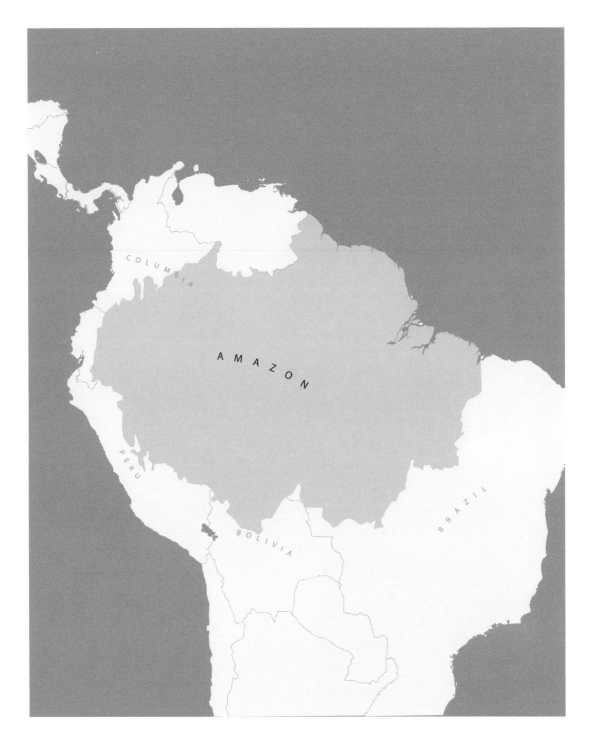

1978

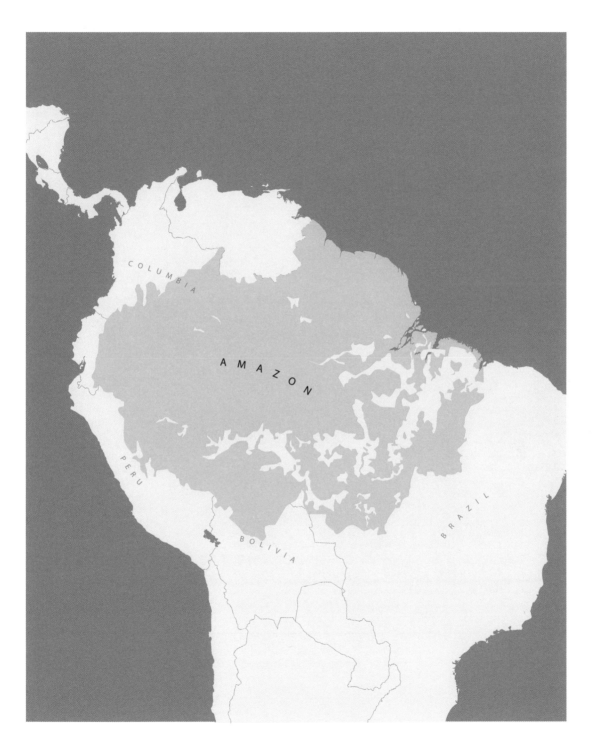

COLUMBIA

AMAZON

PERU

BOLIVIA

BRAZIL

2008

Creation Myths
How did it all start?

Ex Nilhilo (Out Of Nothing)

Abrahamic (Christianity / Judaism / Islam)
Day 1. God created light and darkness.
Day 2. He created water and sky.
Day 3. Separated dry ground from oceans, created all vegetation.
Day 4. Created sun, moon and stars.
Day 5. Created all water-dwelling creatures and birds.
Day 6. Created all creatures of the world.
Day 7. Have a nice rest.

The Big Bang
1. 15,000 million years ago all the matter in the Universe burst out from single point. **2.** Inflates from the size of an atom to the size of a grapefruit in a microsecond. **3.** Three minutes in, the universe is a superhot fog, too hot for even light to shine. **4.** 300,000 years later, everything is cool enough to form the first atoms. Light shines! **5.** After a billion years, clouds of gas collapse. Gravity pulls them in to form the first galaxies and stars.

Primordial "Soup"

Hinduism
In a dark vast ocean, Lord Vishnu sleeps. A humming noise trembles. With a vast "OM!" Vishnu awakes. From his stomach blossoms a lotus flower containing Brahma. Vishnu commands him to create the world, then vanishes. Brahma splits the lotus flower into heaven, earth & sky.

Chinese (Taoist)
There was a mist of chaos. The mist separated and the light rose to heaven and the heavy sank and formed the earth. From heaven and earth came yin and yang, masculine and feminine. Together they keep the world in harmony.

Infinite Universe / Continuous Creation

Steady state theory
Matter is generated constantly as the universe expands.
No beginning, no end.

Buddhism
The universe is not fixed in a state of 'being', but of 'becoming'.
At any moment some stars and galaxies are born while others die.

Infinite Universe / Cyclical

Big Bangs Big Crunches
Endless cycles of big bangs and big crunches, with each cycle lasting about a trillion years. All matter and radiation is reset, but the cosmological constant is not. It gradually diminishes over many cycles to the small value observed in today's universe.

Involution / Evolution (Hinduism, Theosophy)
Infinite number of universes in an infinite cycle of births, deaths and rebirths. Each cycle lasts 8.4 billion years. The universe involves (in breath) gathers all the material then 'evolves' (out breath) and expands. This cycle repeats infinitely.

Quasi Solid State (QSS)
The cosmos has always existed. Explosions, of all different sizes, occur continuously, giving the impression of a big bang in our locality.

Bubble Universe
Our universe is a bubble spawned off a larger "foam" of other universes. Each bubble is different. Ours is finely tuned to support life.

source: Wikipedia, NewScientist.com

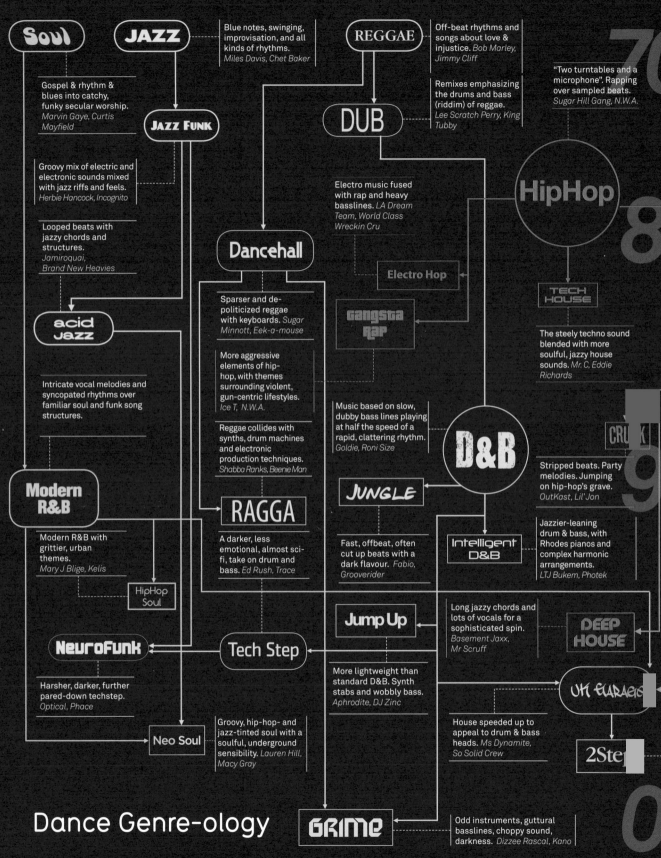

Dance Genre-ology

Soul

JAZZ — Blue notes, swinging, improvisation, and all kinds of rhythms. *Miles Davis, Chet Baker*

REGGAE — Off-beat rhythms and songs about love & injustice. *Bob Marley, Jimmy Cliff*

"Two turntables and a microphone". Rapping over sampled beats. *Sugar Hill Gang, N.W.A.*

Gospel & rhythm & blues into catchy, funky secular worship. *Marvin Gaye, Curtis Mayfield*

JAZZ FUNK

DUB — Remixes emphasizing the drums and bass (riddim) of reggae. *Lee Scratch Perry, King Tubby*

HipHop

Groovy mix of electric and electronic sounds mixed with jazz riffs and feels. *Herbie Hancock, Incognito*

Electro music fused with rap and heavy basslines. *LA Dream Team, World Class Wreckin Cru*

Looped beats with jazzy chords and structures. *Jamiroquai, Brand New Heavies*

Dancehall

acid jazz

Electro Hop

TECH HOUSE

Sparser and de-politicized reggae with keyboards. *Sugar Minnott, Eek-a-mouse*

Gangsta Rap

The steely techno sound blended with more soulful, jazzy house sounds. *Mr. C, Eddie Richards*

Intricate vocal melodies and syncopated rhythms over familiar soul and funk song structures.

More aggressive elements of hip-hop, with themes surrounding violent, gun-centric lifestyles. *Ice T, N.W.A.*

Music based on slow, dubby bass lines playing at half the speed of a rapid, clattering rhythm. *Goldie, Roni Size*

D&B

CRUNK

Reggae collides with synths, drum machines and electronic production techniques. *Shabba Ranks, Beenie Man*

Stripped beats. Party melodies. Jumping on hip-hop's grave. *OutKast, Lil' Jon*

Modern R&B

RAGGA

JUNGLE

Intelligent D&B

Jazzier-leaning drum & bass, with Rhodes pianos and complex harmonic arrangements. *LTJ Bukem, Photek*

Modern R&B with grittier, urban themes. *Mary J Blige, Kelis*

A darker, less emotional, almost sci-fi, take on drum and bass. *Ed Rush, Trace*

Fast, offbeat, often cut up beats with a dark flavour. *Fabio, Grooverider*

HipHop Soul

Jump Up

Long jazzy chords and lots of vocals for a sophisticated spin. *Basement Jaxx, Mr Scruff*

DEEP HOUSE

NeuroFunk

Tech Step

More lightweight than standard D&B. Synth stabs and wobbly bass. *Aphrodite, DJ Zinc*

UK GARAGE

Harsher, darker, further pared-down techstep. *Optical, Phace*

Neo Soul

Groovy, hip-hop- and jazz-tinted soul with a soulful, underground sensibility. *Lauren Hill, Macy Gray*

House speeded up to appeal to drum & bass heads. *Ms Dynamite, So Solid Crew*

2Step

GRIME — Odd instruments, guttural basslines, choppy sound, darkness. *Dizzee Rascal, Kano*

70 8 9 0

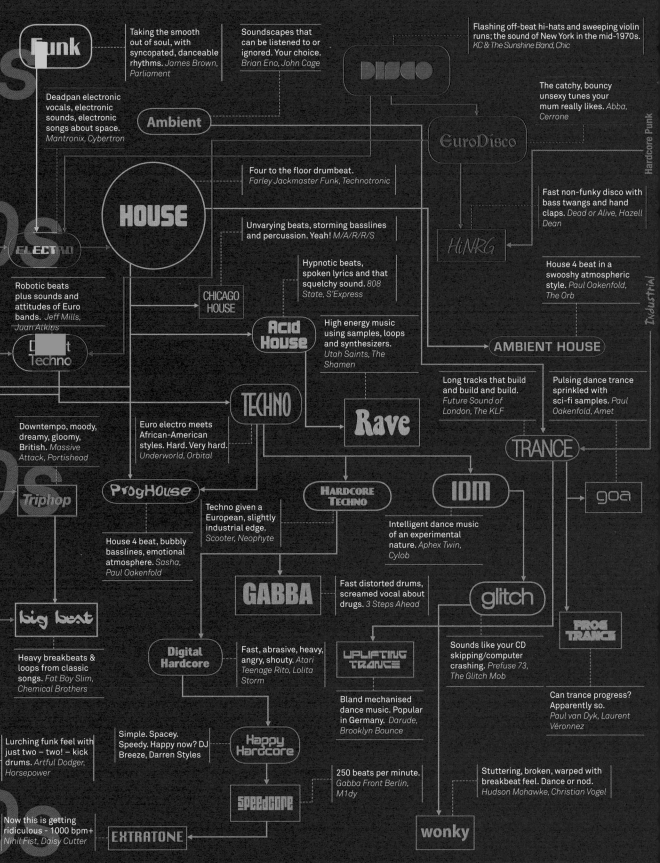

Funk

Taking the smooth out of soul, with syncopated, danceable rhythms. *James Brown, Parliament*

Soundscapes that can be listened to or ignored. Your choice. *Brian Eno, John Cage*

DISCO

Flashing off-beat hi-hats and sweeping violin runs; the sound of New York in the mid-1970s. *KC & The Sunshine Band, Chic*

Deadpan electronic vocals, electronic sounds, electronic songs about space. *Mantronix, Cybertron*

Ambient

EuroDisco

The catchy, bouncy unsexy tunes your mum really likes. *Abba, Cerrone*

Hardcore Punk

Four to the floor drumbeat. *Farley Jackmaster Funk, Technotronic*

HOUSE

Unvarying beats, storming basslines and percussion. Yeah! *M/A/R/R/S*

HiNRG

Fast non-funky disco with bass twangs and hand claps. *Dead or Alive, Hazell Dean*

ELECTRO

Robotic beats plus sounds and attitudes of Euro bands. *Jeff Mills, Juan Atkins*

Hypnotic beats, spoken lyrics and that squelchy sound. *808 State, S'Express*

CHICAGO HOUSE

House 4 beat in a swooshy atmospheric style. *Paul Oakenfold, The Orb*

Industrial

Detroit Techno

Acid House

High energy music using samples, loops and synthesizers. *Utah Saints, The Shamen*

AMBIENT HOUSE

Downtempo, moody, dreamy, gloomy, British. *Massive Attack, Portishead*

TECHNO

Euro electro meets African-American styles. Hard. Very hard. *Underworld, Orbital*

Rave

Long tracks that build and build and build. *Future Sound of London, The KLF*

Pulsing dance trance sprinkled with sci-fi samples. *Paul Oakenfold, Amet*

TRANCE

Triphop

ProgHouse

House 4 beat, bubbly basslines, emotional atmosphere. *Sasha, Paul Oakenfold*

HARDCORE TECHNO

IDM

goa

Techno given a European, slightly industrial edge. *Scooter, Neophyte*

Intelligent dance music of an experimental nature. *Aphex Twin, Cylob*

GABBA

Fast distorted drums, screamed vocal about drugs. *3 Steps Ahead*

glitch

PROG TRANCE

big beat

Heavy breakbeats & loops from classic songs. *Fat Boy Slim, Chemical Brothers*

Digital Hardcore

Fast, abrasive, heavy, angry, shouty. *Atari Teenage Rito, Lolita Storm*

UPLIFTING TRANCE

Sounds like your CD skipping/computer crashing. *Prefuse 73, The Glitch Mob*

Can trance progress? Apparently so. *Paul van Dyk, Laurent Véronnez*

Lurching funk feel with just two – two! – kick drums. *Artful Dodger, Horsepower*

Simple. Spacey. Speedy. Happy now? *DJ Breeze, Darren Styles*

Happy Hardcore

Bland mechanised dance music. Popular in Germany. *Darude, Brooklyn Bounce*

Now this is getting ridiculous - 1000 bpm+ *Nihil Fist, Daisy Cutter*

EXTRATONE

SPEEDCORE

250 beats per minute. *Gabba Front Berlin, M1dy*

Stuttering, broken, warped with breakbeat feel. Dance or nod. *Hudson Mohawke, Christian Vogel*

wonky

source: Wikipedia

The Book of You
A copy in every one of your 10,000,000,000 cells

The Book
Your complete DNA (or "genome") – 3 billion words

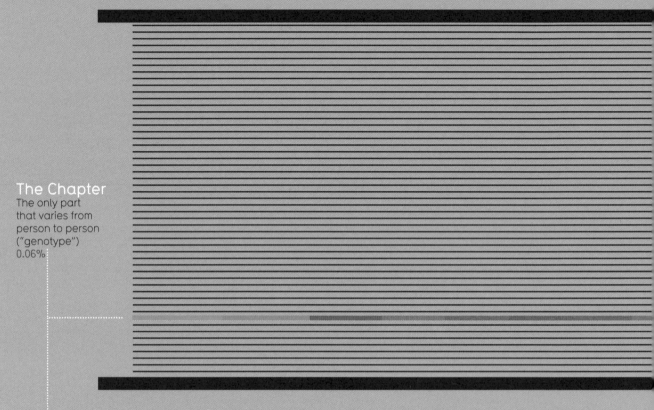

The Chapter
The only part
that varies from
person to person
("genotype")
0.06%

The Pages
Organized sections inside the chapter ("chromosomes"). Made of genes
23 pairs

The Paragraphs
Genes are clumps of DNA
made up of basepairs
20 – 25,000

The Words
Individual two letter
"words" of DNA
2 million

The Letters
Letters made of
individual molecules
4

A C
G T

Responsible for all your physical characteristics, susceptibility to certain diseases, and even earwax
We have identified the effects of around 5000 out of 2,000,000 (0.25%)

source: Decodeme.com, Wikipedia

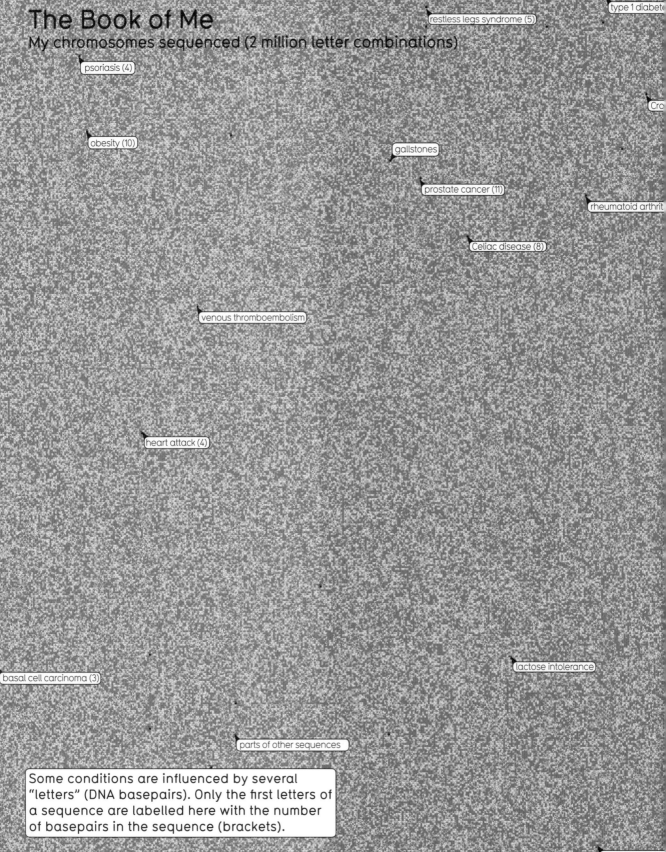

makes alcohol cravings stronger

bitter taste perception

haemochromatosis

intercranial aneurysm

sensitivity to pleasure

endurance athletics

warfarin metabolism (3)

bladder cancer

colorectal cancer (6)

nicotine dependence

determines earwo

alcoholic flush reaction

exfoliation glaucoma

green eye colour

blue eye colour

asthma

increased Alzheimer's risk (3)

baldness

source: Decodeme.com // programming : Mattias Gunneras

varied cognitive effects

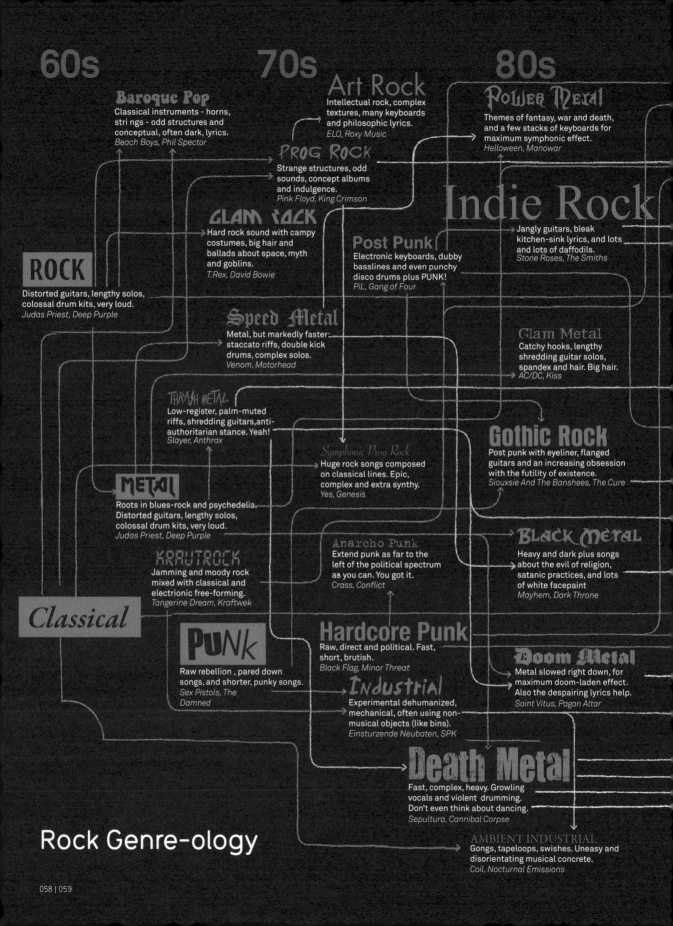

Rock Genre-ology

Baroque Pop
Classical instruments - horns, strings - odd structures and conceptual, often dark, lyrics.
Beach Boys, Phil Spector

Art Rock
Intellectual rock, complex textures, many keyboards and philosophic lyrics.
ELO, Roxy Music

PROG ROCK
Strange structures, odd sounds, concept albums and indulgence.
Pink Floyd, King Crimson

POWER METAL
Themes of fantasy, war and death, and a few stacks of keyboards for maximum symphonic effect.
Helloween, Manowar

GLAM ROCK
Hard rock sound with campy costumes, big hair and ballads about space, myth and goblins.
T.Rex, David Bowie

Post Punk
Electronic keyboards, dubby basslines and even punchy disco drums plus PUNK!
PiL, Gang of Four

Indie Rock
Jangly guitars, bleak kitchen-sink lyrics, and lots and lots of daffodils.
Stone Roses, The Smiths

ROCK
Distorted guitars, lengthy solos, colossal drum kits, very loud.
Judas Priest, Deep Purple

Speed Metal
Metal, but markedly faster: staccato riffs, double kick drums, complex solos.
Venom, Motorhead

Glam Metal
Catchy hooks, lengthy shredding guitar solos, spandex and hair. Big hair.
AC/DC, Kiss

THRASH METAL
Low-register, palm-muted riffs, shredding guitars, anti-authoritarian stance. Yeah!
Slayer, Anthrax

Symphonic Prog Rock
Huge rock songs composed on classical lines. Epic, complex and extra synthy.
Yes, Genesis

Gothic Rock
Post punk with eyeliner, flanged guitars and an increasing obsession with the futility of existence.
Siouxsie And The Banshees, The Cure

METAL
Roots in blues-rock and psychedelia. Distorted guitars, lengthy solos, colossal drum kits, very loud.
Judas Priest, Deep Purple

KRAUTROCK
Jamming and moody rock mixed with classical and electrionic free-forming.
Tangerine Dream, Kraftwek

Anarcho Punk
Extend punk as far to the left of the political spectrum as you can. You got it.
Crass, Conflict

BLACK METAL
Heavy and dark plus songs about the evil of religion, satanic practices, and lots of white facepaint
Mayhem, Dark Throne

Classical

Hardcore Punk
Raw, direct and political. Fast, short, brutish.
Black Flag, Minor Threat

PUNK
Raw rebellion , pared down songs, and shorter, punky songs.
Sex Pistols, The Damned

Industrial
Experimental dehumanized, mechanical, often using non-musical objects (like bins).
Einsturzende Neubaten, SPK

Doom Metal
Metal slowed right down, for maximum doom-laden effect. Also the despairing lyrics help.
Saint Vitus, Pagan Altar

Death Metal
Fast, complex, heavy. Growling vocals and violent drumming. Don't even think about dancing.
Sepultura, Cannibal Corpse

AMBIENT INDUSTRIAL
Gongs, tapeloops, swishes. Uneasy and disorientating musical concrete.
Coil, Nocturnal Emissions

80s
90s
00s

POST ROCK
Often purely instrumental. Uses rock instruments to create textures, tones and atmospheres.
Tortoise, Mogwai

Mathrock
Complex, difficult, lopsided time signatures and bizarre arrangements to not quite tap your foot to.
Battles, Dirty Projectors

Symphonic Post Rock
Ambient soundscapes. Orchestras. Walls of sound.
Godspeed You! Black Emperor, Sigur Ros

GRUNGE
The distortion and ferocity of hardcore punk and metal with angsty lyrics and more accessible tune-ship.
Mudhoney, Nirvana

Mathcore
Offshoot of doom metal.
The DIllinger Escape Plan

post grunge
Distorted guitar, angsty lyrics but easier on the ear.
Silverchair, Puddle of Mudd

INDIE POP
Indie rock fused with 60s influences for a more pop-oriented sound.
The Wedding Present, Orange Juice

britpop
Fusing the rock and pop elements of indie music and sold back to the major labels in the 1990s.
Oasis, Blur

DEATH DOOM
Growling incomprehensible vocals, double kick drum and sheets of guitars.
Paradise Lost, Anathema

RAP ROCK
White-style shouted rap, hardcore guitars over live hip-hop style beats.
Rage Against The Machine, Red Hot Chilli Peppers

MELODIC BLACK METAL
Reining in the distortion, a few more tunes, but no let-up on the obsession with death and destruction.
Satyricon, Dark Fortress

DEATHCORE
Heavy muted riffing, dissonance, growling and screaming. Melodic riffs in there somewhere.
Abscess, Unseen Terrrors

College Rock
Poppy but edgy guitar rock with artsy, poignant and jangly qualities.
REM, They Might Be Giants

Symphonic Black Metal
The addition of orchestral instruments and classical influences to the black metal.
Dimmu Borgir, Antestor

GOTH METAL
Aggressive guitar mushed with melancholic vibes, dark atmospheres & epic lyrics.
Evanescence, Paradise Lost

Melodic Death Metal
Reining in the distortion, a few more tunes, but no let-up on the obsession with death and destruction.
In Flames, Dark Tranquility

METAL CORE
All the ferocity of metal, with all the political posturing of hardcore punk.
Biohazard, Suicidal Tendencies

Gothic Black Metal
Operatic female vocals, ambient keyboards and dark guitaring.
Cradle of Filth, Moonspell

Technical Death Metal
Noise, plus prog-style tempo changes and bizarre time signatures.
Meshuggah, Suffocation

Drone Doom
Heavy, heavy, repetitive, slow. "Not unlike listening to an Indian raga in the middle of an earthquake"
Sunn O))), Earth

THRASH CORE
Incredibly fast punk songs with blasting beats and rebellious shouty lyrics.
Septic Death, Nuclear Assault

GRINDCORE
Very heavy guitars, very fast rhythms, very short songs (sometimes only seconds).
Napalm Death, Carcass

INDUSTRIAL METAL
Lots of drum machines. Lots of guitars. Lots of bleak lyrics. All with a tight computerised edge.
Ministry, Nine Inch Nails

MARTIAL INDUSTRIAL
Orchestral elements of classical music fused with rock music, parading and military uniforms.
Laibach, Death in June

BRUTAL DEATH METAL
Absurdly fast drumming, plus growling, shrieking and shredding guitars.
Spawn of Posession, Devourment

source: Wikipedia

Simple Part I

Think of the Children
% of children living in poverty

Denmark France Germany UK / Canada United States

source UNICEF 2007. Numbers rounded up.

Farty Animals
Annual methane emissions in equivalent CO2

source: UN Environmental Programme, theregister.co.uk

Who Reads the Most?
Amazon book stock as % of population size

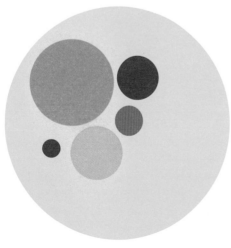

source: Data scraped from Amazon websites.

Wave Of Generosity
% of promised tsunami aid money actually paid

Greece 100%
New Zealand
Iceland UK Norway
Japan 90%
Australia Canada 75%
Portugal Netherlands
Italy France 50%
USA 35%
Germany 26%

source: OECD

Celebrities with Issues
Number of celebs behind each cause

Mostly male celebs

Equal men & women

Mostly female celebs

weapons reduction
veterans conservation organ donation addiction
physical challenges sports unemployment
fair trade disaster relief mental challenges
voter education human rights
literacy environment homelessness
children health HIV
refugees education cancer creative arts
depression & suicide
women poverty
peace family support hunger
adoptions & orphans animals abuse
rape & sexual abuse substance abuse missing children
gay & lesbian support

idea: Richard Rogers @ govcom.org // source: looktothestars.org

How Rich?
Yearly earnings of world's wealthiest nations as combined earnings of US states

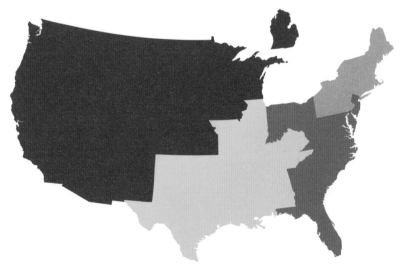

source: WorldBank 2007, ASecondHandConjecture.com.

Sex Education

% virgin students by university subject

0%　　　　　50%　　　　　100%

Studio Art

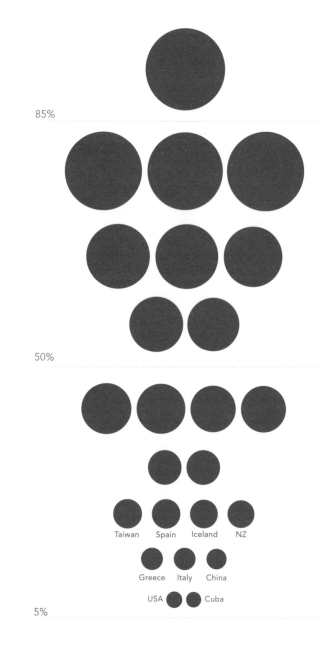

0%　　　　　50%　　　　　100%

Godless Swedes

% of atheists, agnostics & non-believers

85%

50%

Taiwan　Spain　Iceland　NZ

Greece　Italy　China

USA　　　Cuba

5%

source: MIT/Wellesley college magazine, *Counterpoint 2001*.

source: Adherents.com [via Swivel.com]. Upper limits in ranges used.

Net Increase
Internet traffic growth

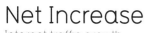

Entire internet per year
1993

Internet per second
2008

Internet per year, 2000

YouTube per month, 2008

source: Cisco.

Left Hand Path
Increased wealth of left-handed men

Does not apply to left-handed women.

source: Lafayette College and Johns Hopkins University study.

Bottoms Up
% of world's wealth owned by...

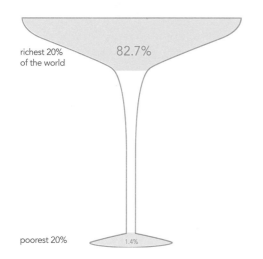

richest 20%
of the world

82.7%

poorest 20%

1.4%

source: UN

Clear Cut
Drop in HIV transmission in circumcised males

source: University Of Melbourne, BBC News

Excuse Us
Reasons for divorce

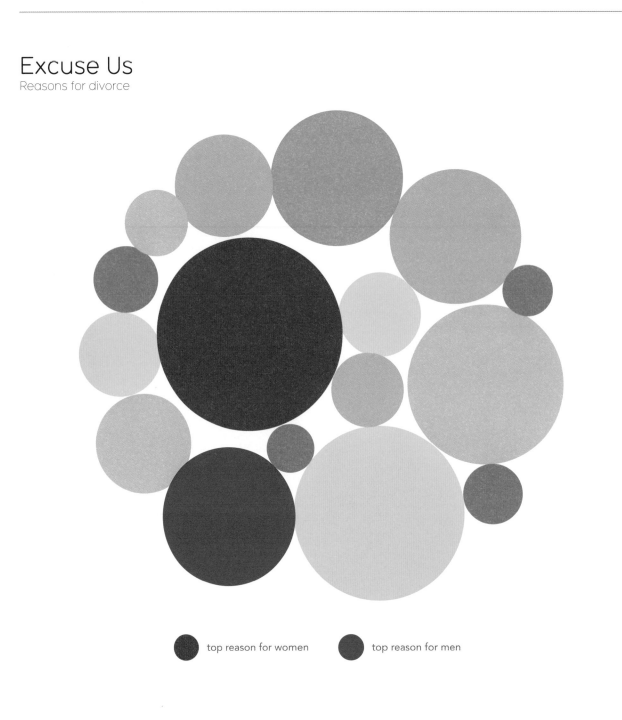

top reason for women top reason for men

source: Insidedivorce.com

National Hypochondriacs Service
Top health searches

UK

Sciatica Shingles
IBS Thyroid Back pain
Pregnancy
Kidney Infection Ringworm
Chickenpox
Thrush Anaemia
Glandular Fever
Diabetes

source: NHS Direct

USA

Stroke Asthma
Flu ADHD Hepatitis
Pregnancy
Headache Arthritis
Cancer
Herpes HIV
HPV

source: About.com.

France

Arthritis Migraine
Endometriosis Back pain
Anorexia
Hepatitis Hemorrhoids
Cancer
Thrush STDs
Hypertension

source: Doctissimo.fr

For Cod's Sake
Stocks of cod in the North Atlantic (100,000 tons)

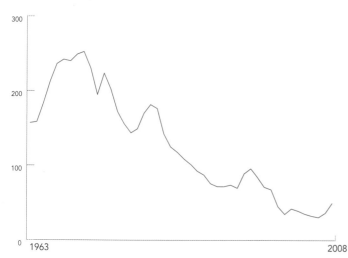

source: Fisheries Research Service

Ups and Downs
Cover vs. coverage

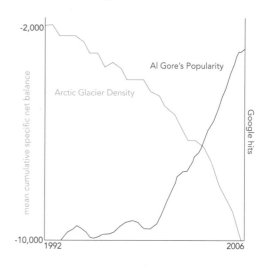

source: Google Insights

What is Consciousness?
Make up your own mind

A field that exists in its own parallel "realm" of existence outside reality so can't be seen.
(Substance Dualism)

A sensation that "grows" inevitably out of complicated brain states.
(Emergent Dualism)

A physical property of all matter, like electromagnetism, just not one the scientists know about.
(Property Dualism)

All matter has a psychic part. Consciousness is just the psychic part of our brain.
(Pan Psychism)

Simply mental states are physical events that we can see in brain scans.
(Identity Theory)

Consciousness and its states (belief, desire, pain) are simply functions the brain performs.
(Functionalism)

Literally just behaviour. When we behave in a certain way, we appear conscious.
(Behaviourism)

An accidental side-effect of complex physical processes in the brain.
(Epiphenomenalism)

Not sure. But quantum physics, over classical physics, can better explain it.
(Quantum Consciousness)

The sensation of your most significant thoughts being highlighted.
(Cognitivism)

Consciousness is just higher order thoughts (thoughts about other thoughts).
(Higher Order Theory)

A continuous stream of ever recurring phenomena, pinched like eddies into isolated minds.
(Buddhism)

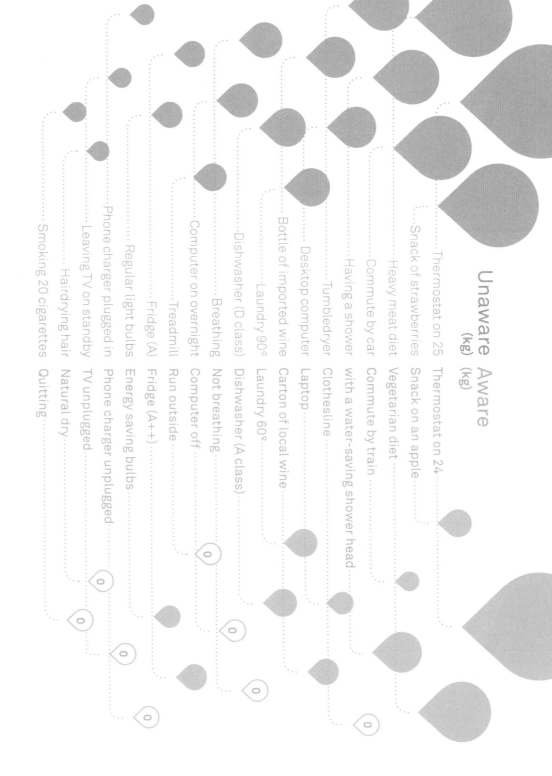

Unaware (kg) Aware (kg)

Thermostat on 25 — Thermostat on 24
Snack of strawberries — Snack on an apple
Heavy meat diet — Vegetarian diet
Commute by car — Commute by train
Having a shower — with a water-saving shower head
Tumbledryer — Clothesline
Desktop computer — Laptop
Bottle of imported wine — Carton of local wine
Laundry 90° — Laundry 60°
Dishwasher (D class) — Dishwasher (A class)
Breathing — Not breathing
Computer on overnight — Computer off
Treadmill — Run outside
Fridge (A) — Fridge (A++)
Regular light bulbs — Energy saving bulbs
Phone charger plugged in — Phone charger unplugged
Leaving TV on standby — TV unplugged
Hairdrying hair — Natural dry
Smoking 20 cigarettes — Quitting

source: UNESCO, Environmental Protection Agency, Energy Information Administration

including everyone in the UK & USA
4,187,280,000 tons

including everyone in the UK
907,244,000 tons
used per year

527,644,000
saved

including everyone in the UK & USA
1,752,000,000 tons
(Equivalent to Japan's annual
CO_2 emissions)

including everyone in the UK
379,600,000 tons
used per year

2,435,280,000 tons
saved
(equivalent to Russia & Japan's
total combined emissions per year)

"I want…"

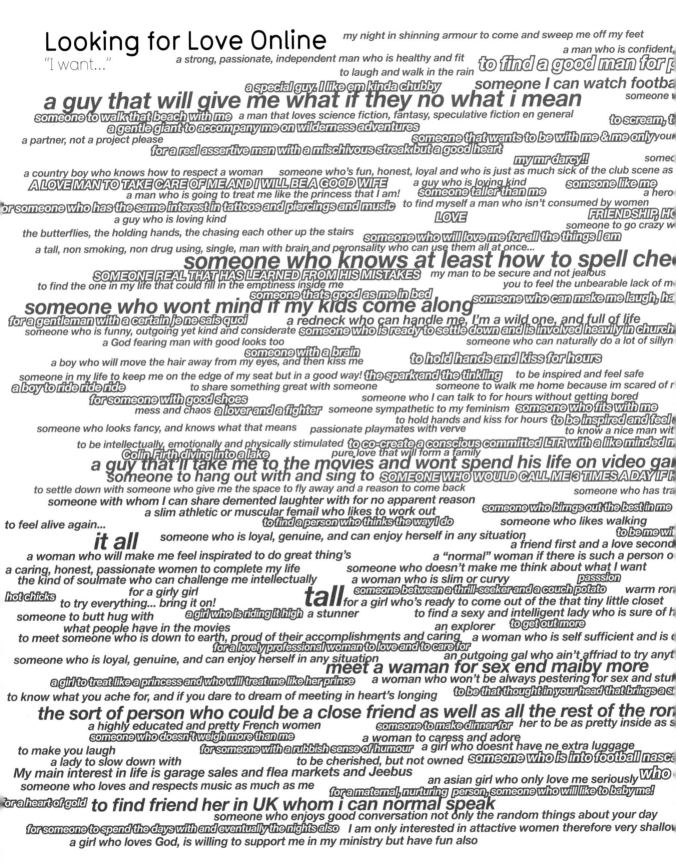

my night in shinning armour to come and sweep me off my feet

a man who is confident,

a strong, passionate, independent man who is healthy and fit

to find a good man for p

to laugh and walk in the rain

someone I can watch footba

a special guy. I like em kinda chubby

someone

a guy that will give me what if they no what i mean

someone to walk that beach with me a man that loves science fiction, fantasy, speculative fiction en general

to scream, t

a gentle giant to accompany me on wilderness adventures

someone that wants to be with me & me only your

a partner, not a project please

for a real assertive man with a mischivous streak but a good heart

my mr darcy!!

somed

a country boy who knows how to respect a woman someone who's fun, honest, loyal and who is just as much sick of the club scene as

A LOVE MAN TO TAKE CARE OF ME AND I WILL BE A GOOD WIFE a guy who is loving kind someone like me

a man who is going to treat me like the princess that I am! someone taller than me a hero

or someone who has the same interest in tattoos and piercings and music to find myself a man who isn't consumed by women

FRIENDSHIP, HO

a guy who is loving kind LOVE someone to go crazy w

the butterflies, the holding hands, the chasing each other up the stairs someone who will love me for all the things I am

a tall, non smoking, non drug using, single, man with brain and peronsality who can use them all at once…

someone who knows at least how to spell chee

SOMEONE REAL THAT HAS LEARNED FROM HIS MISTAKES my man to be secure and not jealous

to find the one in my life that could fill in the emptiness inside me you to feel the unbearable lack of m

someone thats good as me in bed someone who can make me laugh, ha

someone who wont mind if my kids come along

for a gentleman with a certain je ne sais quoi a redneck who can handle me, I'm a wild one, and full of life

someone who is funny, outgoing yet kind and considerate someone who is ready to settle down and is involved heavily in church

a God fearing man with good looks too someone who can naturally do a lot of sillyn

someone with a brain

a boy who will move the hair away from my eyes, and then kiss me to hold hands and kiss for hours

someone in my life to keep me on the edge of my seat but in a good way! the spark and the tinkling to be inspired and feel safe

a boy to ride ride ride to share something great with someone someone to walk me home because im scared of

for someone with good shoes someone who I can talk to for hours without getting bored

mess and chaos a lover and a fighter someone sympathetic to my feminism someone who fits with me

to hold hands and kiss for hours to be inspired and feel

someone who looks fancy, and knows what that means passionate playmates with verve to know a nice man wit

to be intellectually, emotionally and physically stimulated to co-create a conscious committed LTR with a like minded n

Colin Firth diving into a lake pure love that will form a family

a guy that'll take me to the movies and wont spend his life on video gar

someone to hang out with and sing to SOMEONE WHO WOULD CALL ME 3 TIMES A DAY IF H

to settle down with someone who give me the space to fly away and a reason to come back someone who has tra

someone with whom I can share demented laughter with for no apparent reason someone who birngs out the best in me

a slim athletic or muscular femail who likes to work out someone who likes walking

to feel alive again… to find a person who thinks the way I do to be me wi

it all someone who is loyal, genuine, and can enjoy herself in any situation a friend first and a love second

a woman who will make me feel inspirated to do great thing's a "normal" woman if there is such a person o

a caring, honest, passionate women to complete my life someone who doesn't make me think about what I want

the kind of soulmate who can challenge me intellectually a woman who is slim or curvy passsion

hot chicks for a girly girl someone between a thrill-seeker and a couch potato warm ror

to try everything… bring it on! ## tall for a girl who's ready to come out of the that tiny little closet

someone to butt hug with a girl who is riding it high a stunner to find a sexy and intelligent lady who is sure of h

what people have in the movies an explorer to get out more

to meet someone who is down to earth, proud of their accomplishments and caring a woman who is self sufficient and is c

for a lovely professional woman to love and to care for

someone who is loyal, genuine, and can enjoy herself in any situation an outgoing gal who ain't affriad to try anyt

meet a waman for sex end maiby more

a girl to treat like a princess and who will treat me like her prince a woman who won't be always pestering for sex and stu

to know what you ache for, and if you dare to dream of meeting in heart's longing to be that thought in your head that brings a s

the sort of person who could be a close friend as well as all the rest of the ror

a highly educated and pretty French women her to be as pretty inside as s

someone to make dinner for

someone who doesn't weigh more than me a woman to caress and adore

for someone with a rubbish sense of humour a girl who doesnt have ne extra luggage

a lady to slow down with to be cherished, but not owned someone who is into football nasca

My main interest in life is garage sales and flea markets and Jeebus who

an asian girl who only love me seriously

someone who loves and respects music as much as me for a maternal, nurturing person, someone who will like to baby me!

or a heart of gold ## to find friend her in UK whom i can normal speak

someone who enjoys good conversation not only the random things about your day

for someone to spend the days with and eventually the nights also I am only interested in attactive women therefore very shallov

a girl who loves God, is willing to support me in my ministry but have fun also

a man not a boy u should know by now what u want and who u are in life so lest talk if u tired of games
of high maintenance fake girls, enjoys books and parties

ect me
a man that is romantic and will surprise me at work with a flower

ith, while having beer and pizza, and the next night, dress up for an elegant dinner
s extremely open minded in everything he does

to be on a date with foreigner
my very own Tour Guide
p
a positive outgoing person!!!
someone to appreciate and work my senses (all 5)
someone with good/pure heart.
a man to meke me a wife
someone to have an adventure with
friends to play with me in Petawawa
ho will love me for all the things I am
her to be honest and true to me
a guy who will tell his mother I have beautiful eyes
to find a woman who knows what she want friends to play with me
meone with style and determination
a man or a woman
an affectionate ladie friend. Who doesn't mind a hug and kiss once twice or 3 times a day
TY, AND HUMOUR.
or someone that's not scared to let her self go
the highest passion
someone who knows how to have fun and is laid back and adventerous.
some company. Someone I can trust and talk to openly, someone I feel comfortable with
a man or a woman. I'm ready to settle down and start a family
someone who enjoys spending alot of time behind closed doors
for someone who wont get mad if I don't talk to them for three weeks
someone to walk beside me, not behind me or infront of me
A PERSON THAT IS NOT SCARED TO BE FREAKY!!
a woman who knows what she wants out of life
someone who is loving and caring
to make friends with foreigners, no matter what kind of people, but I only can speak English
a woman that doesn't want a serious committed relationship we can just get together when it's convenient for both of us
someone to show me the ropes. try anything at least once. help
to be loved and love you all night long strength, protection and heart
SOMEONE WHO CAN FILL MY EMPTINESS
someone that is interested in taking control
to have you in my life because you want me someone to get me motivated
someone that is secure in themselves and not afraid to be in an alternative relationship as I am not your typical guy
it to be really hard and aggressive
a lovely, sexy man to realize my fantasy to satiate my curiosity attention and praise
llant mentality spirituality and eternity someone to take it easy with me
No public humiliation please a top muscle man
serious minded men only, no fantasy seakers to find some one that can make me happy
a guy that will protect me when I am in danger and love me and hold me when I am sad and down
NT AWAY
al values money for medicine, books, school fees and funerals
a good man in my life richness but not only in the bank some one really bad, are you really bad?
HELP WITH A FIRST TIME to be seen all dressed up somebody with a HUMAN TOUCH someone to teach me
to be careful and to be able to trust you
a Masculine non panty wearing man someone to show me the other side of excitement
re discretion and a bit of extra understanding
to make my Master happy sir. someone with a sense of humour
someone to teach me
to show myself off wearing my bunny ears and letting guys tell me what to someone to introduce me to the game
a daddy type to keep me company
someone who isn't looking for a "daddy" or wanting to be one SO MUCH
zed that adult someone to make my life complete
a man that's may best friend as well as my love
nce someone to be very discreet and i hate to say it but you might have to teach me a thing or to
I don't like to be rude or judge other people, but if you're over 35 that's too old for me a pampering
that to take my time and really have some fun

tic stuff A WOMAN OF MY OWN, MY BLOOD. SHE SHOULD BE LOVING, CARING AND ABOVE ALL GOD FEARING
utside someone who is playful, and sensual, and who I can't get enough of
be a matador you to love me as a poet loves his sorrowful thoughts
fishing a 6ft tall brunette supermodel, with lots of money in the bank
n't mind critters and knows how to handle a horse, rope, gun
be a highway banditt, and rob things

Searches for phrases beginning 'I want' on popular dating sites

straight women straight men gay women gay men

source: Match.com, Guardian Soulmates, Matchmakers.com, Outpersonals.com

Rising Sea Levels

How long have we got?

years	rise
8000	80m

1000 20m

8m

7m

400 6m

100 5m

300 4m

200 3m

200 2m

100 1m

San Francisco

Lower Manhattan

Hamburg St. Petersburg

HOLLYWOOD

Los Angeles Amsterdam

Venice

total contributions

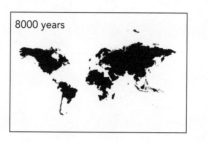

8000 years

Antarctic ice sheet
(S. Pole) 61m

Greenland ice sheet
7m

New York London Taiwan

New Orleans

Shanghai

South London

W. Arctic ice sheet 6m

800 years

100 years

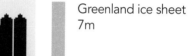

Heating ocean expanding
1m per century

Already happened

source: IPCC, UN Sea Levels Report, Realclimate.org, Telegraph.co.uk

Colours and Culture
The meanings of colours around the world

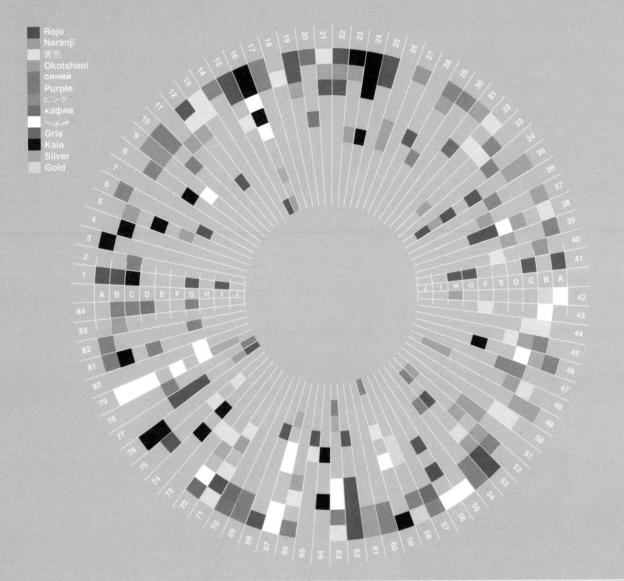

Legend (colours):
- Rojo
- Naranji
- 黄色
- Okotshani
- синий
- Purple
- ピンク
- кафяв
- أبيض
- Gris
- Kala
- Silver
- Gold

A American	
B Japanese	
C Hindu	
D Native American	
E Chinese	
F Asian	
G Eastern European	
H Muslim	
I African	
J South American	

1 Anger	18 Deceit	35 Good Luck	52 Life	69 Rationality
2 Art / Creativity	19 Desire	36 Gratitude	53 Love	70 Reliability
3 Authority	20 Earth	37 Growth	54 Loyalty	71 Repelling Evil
4 Bad Luck	21 Energy	38 Happiness	55 Luxury	72 Respect
5 Balance	22 Eroticism	39 Healing	56 Marriage	73 Royalty
6 Beauty	23 Eternity	40 Healthiness	57 Modesty	74 Self-cultivation
7 Calm	24 Evil	41 Heat	58 Money	75 Strength
8 Celebration	25 Excitement	42 Heaven	59 Mourning	76 Style
9 Children	26 Family	43 Holiness	60 Mystery	77 Success
10 Cold	27 Femininity	44 Illness	61 Nature	78 Trouble
11 Compassion	28 Fertility	45 Insight	62 Passion	79 Truce
12 Courage	29 Flamboyance	46 Intelligence	63 Peace	80 Trust
13 Cowardice	30 Freedom	47 Intuition	64 Penance	81 Unhappiness
14 Cruelty	31 Friendliness	48 Religion	65 Political Power	82 Virtue
15 Danger	32 Fun	49 Jealousy	66 Personal Power	83 Warmth
16 Death	33 God	50 Joy	67 Purity	84 Wisdom
17 Decadence	34 Gods	51 Learning	68 Radicalism	

source: Wikipedia, general web

Stages of You

Children grow in phases. Do adults too? If so, what are the stages? Some theories...

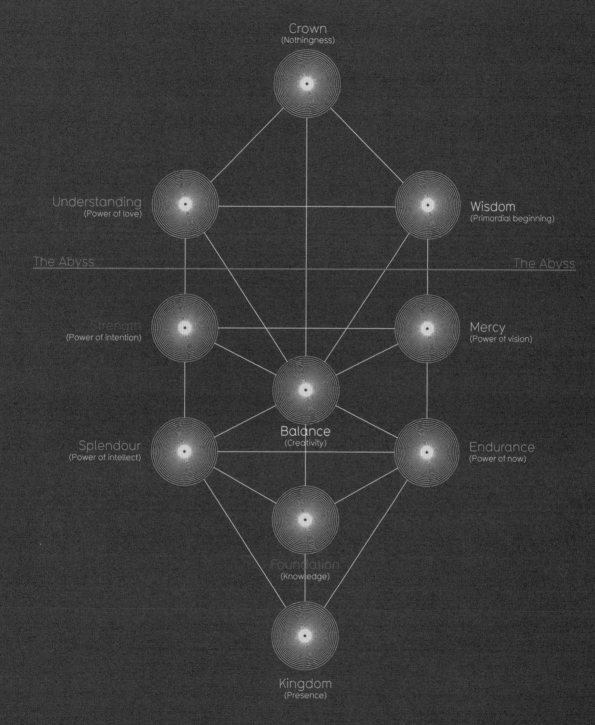

Crown
(Nothingness)

Understanding
(Power of love)

Wisdom
(Primordial beginning)

The Abyss

The Abyss

Strength
(Power of intention)

Mercy
(Power of vision)

Balance
(Creativity)

Splendour
(Power of intellect)

Endurance
(Power of now)

Foundation
(Knowledge)

Kingdom
(Presence)

The Tree Of Life

In Jewish Kabbalah, these are the ten stages through which the universe was created and also the ten qualities of God. As an adult grows, they ascend the tree and acquire these qualities for themselves.

CRITICS SAY: "Where's the evidence?"

source: Wikipedia

Sufism

In the mystical form of Islam, the soul or self (nafs) has seven degrees
of development, each with increasing purity.

The Pure Self
Self is entirely transcended. No ego
or separate self left. Only the Divine
exists. Any sense of individuality or
separateness is an illusion.

The Self Pleasing to God
Inner marriage of self and soul. All power to act comes from God.
You can do nothing by yourself. You no longer fear anything nor
ask for anything. Genuine inner unity and wholeness.

The Pleased Self
You are content with your lot, and pleased with even the difficulties and
trials of life, realizing that these difficulties come from God. Very different
from the usual way of experiencing the world (i.e. focused on seeking
pleasure and avoiding pain).

The Contented Self
The struggles of the earlier stages are basically over. The self is at peace. Old
desires and attachments still exist but are no longer binding. Grateful, trusting,
and adoring. One accepts difficulties in the same way one accepts benefits.
The ego-self begins to let go, allowing the individual to come more closely in
contact with the Divine.

The Inspired Self
Beginning to taste the joys of spiritual experience. Genuine pleasure from
prayer, meditation, and other spiritual activities, motivated by compassion,
service and morals. Though not free from desires and selfishness, their power
is significantly reduced. Emotional maturity is dawning.

The Regretful Self
Insight dawns. The negative effects of a habitually self-centred
approach to the world becomes apparent. Wants and desires still
dominate. But now you can see your faults. Regret and a desire for
change grow. Attempts to follow higher impulses follow – not
always successfully.

The Commanding Self
A false personality created by parents,
school and culture. Selfish, controlling
and lacking compassion. Must be
recognized and by-passed
(not destroyed) to grow.

The Arc Of Ascent

self

Source: Sufi (Laleh Bakhtair), Sufi.org, Wikipedia, Idries Shah

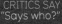

The Seven Chakras

In this Eastern system, you develop by mastering life-force energy expressed through certain energy centres or "chakras" (roughly centred on various glands and organs). Inbalances in these energy wheels create feelings of blockage and dissatisfaction.

Crown (Sahasrara)
Pituitary gland. Awareness, wisdom, clarity.

Third Eye (Ajna)
Pineal gland. Intuition, clarity, thought.

Throat (Vishuddha)
Thyroid. Communication, fluency, creativity.

Heart (Anahata)
Thymus. Compassion, love, passion.

Solar Plexus (Manipura)
Islets of langerhans. Power, will, growth.

Sacral (Svadisthana)
Testes / Ovaries. Pleasure, desire, activity.

Base (muladhara)
Perineum. Stability, sex, sensuality.

CRITICS SAY
"There's no mystical energy-field controls my destiny."

Maslow's "Hierarchy Of Needs"

Psychologist Abraham Maslow believed that adult growth occurs in seven stages. But only after certain needs are fulfilled in your life.

self-transcendence
HELPING OTHERS SELF-DETERMINE

self-determination
FREEDOM, INTEGRITY, CREATIVITY

self-esteem
ACHIEVEMENT, COMPETENCE, CONFIDENCE, SELF-RESPECT

esteem from others
RECOGNITION, APPRECIATION, RESPONSIBILITY, STATUS, REPUTATION

social needs
FAMILY, FRIENDS, COMMUNITY, LOVE, BELONGING, AFFECTION, INTIMACY

security
SAFETY, STABILITY, WORK, PROTECTION FROM CRIME

physical
FOOD, SHELTER, WATER, WARMTH, HEALTH

CRITICS SAY
"Little evidence. Fundamental human needs don't change over time and certainly can't be ranked in a hierarchy."

source: Wikipedia, Sufi.org, IdriesShah.com

Spiral Dynamics

Measures how people think. The intensity with which you embrace or reject each coloured value system reveals how high you are up the development spiral. Can also be applied to societies and cultures.

Developed by Professor Clare Graves, Dr Don Beck and Chris Cowan

Yellow Autonomous

Behaviour Ecological thinking. **Embraces** Change and chaos. Self-directed. **Attitude** See the big picture. Life is learning. **Decision-making** Highly principled. Knowledge based. Admire The Competent. **Seek** Integrity. **Love** Natural systems, knowledge, multiplicity. **Want** Self-knowledge. **Hide** Attachment. **Good side:** Free. Wise. Aware. **Bad side:** Overly intellectual, excessively sceptical, angst ridden.

Orange Achiever

Behaviour Strategic. Scientific thinking. Competes for success. Driven. Competitive. **Attitude** Goal orientated. Play to win. Survival of the fittest. **Decisions** Bottom line. Test options for best results. Consult experts. **Admire** The successful. **Seek** Affluence. Prosperity. Rational truth. **Love** Success, status. **Wants** Self-expression. **Hide** Lies **Good side:** Great communication and creativity. Risk taking. Optimistic. **Bad side:** Workaholic. Babbling. Fearful.

Red Egocentric

Behaviour Self-centred. **Attitude** Do what you want, regardless. Live for the moment. The World is a jungle. Might makes right. **Decisions based on** what gets respect, what feels good now. **Admire** The powerful. **Seek** Power, glory and revenge. **Love** Glitz, conquest, action. **Want** Self-definition. **Hide** Shame. **Good side:** Spontaneous, purposeful. **Under pressure:** Dominating, blaming, aggressive. **Bad side:** Passive, sluggish fearful.

Beige Instinctive

Behaviour Instinctive. Materialistic. Greedy. Fearful. **Attitude** Do what you can to stay alive. **Seek** Food, water, warmth, security.

Turquoise Whole View

Behaviour Holisic intuitive thinking. **Attitude** Global. Harmonious. An ecology of perspectives. **Decision-making** Flow. Blending. Looking up and downstream. Long range. **Admire** Life! **Seek** Interconnectedness. Peace in an incomprehensible world. **Love** Information. Belonging. Doing.

Green Communitarian

Behaviour Consensus-seeking. Harmony within the group. Accepting. Dialogue. **Attitude** Everybody is equal. **Decision-making** Consensus. Collaborative. Accept everyone's input. **Admires** The charismatic. **Seeks** Inner peace with caring community. **Love** Affection, good relationships, beneficial resolution. **Want** Self-reflection. **Hide** Doubts. **Good side:** Listens well. Receptive. Perceptive, imaginative. **Bad side:** "Politically correct", inauthenticity.

Blue Absolutist

Behaviour Authoritarian. Cautious. Careful. Fit in. Discipline. Faith. **Attitude** Only one right way. **Decision-making** based on obeying rules, following orders, doing "right". **Admire** The righteous. **Seek** Peace of mind. **Love** Everything in its right place. **Want** Self-acceptance. **Hide** Grief. **Good side:** Balanced, compassionate. **Bad side:** Needy, possessive, jealous, bitter, critical.

Purple Tribal

Behaviour Impulsive. Honour the "old ways". **Attitude** Self-gratifying. **Decision-making** Based on custom and tradition. **Seek** Safety, security. **Admire** The clan. **Hide** Guilt. **Good side:** Fluid with a healthy sexuality. **Bad side:** Overly emotional, obsessive, frigid, impotent, numb.

CRITICS SAY: "Says who? Exact characteristics for advance stages are unclear and speculative."

source: spiraldynamics.net, wikipedia

Loevinger's Stages of Self Development

Psychologist Loevinger's system emphasizes the maturing of conscience. Social rules govern most people's personal decisions. But if differences appear between social rules and your behaviour, you must adapt to resolve the conflict, i.e. you have to grow.

	Opportunist	Diplomat	Expert
DEFINED BY	mistrust & manipulation	the group (tribe, family, nation)	knowledge
POSITIVES	energetic	dependable	ideas & solutions
SELF DEFINITION	self-centred	self-in-group	self-autonomy
ACTION	whatever	obeying	doing
INTERESTS	domination, control	neatness, status, reputation	efficiency, improvement, perfection
THINKING	black & white	concrete	watertight
BEHAVIOUR	opportunistic	controlled	superior
WORLD VIEW	hostile, dangerous place	conformist, fundamentalist	rational, scientific
LOOKING FOR	rewards	acceptance	perfection
MORALITY	for self-interest only	given by the group	self-righteous
LANGUAGE HABITS	polarities: good/bad, fun/boring	superlatives, platitudes, clichés	"yes but..."
COMMON FLAWS	selfish	hostility to "outsiders"	selfish
FEAR OF	being overpowered	disapproval, rejection	loss of uniqueness
DEFENCES	blaming, distortion	suppression, projection, idealization	intellectualizing, hostile humour, blaming tools
SOCIALLY	two-faced, hostile	facilitator, socialite	seek to stand out from th crowd
RELATIONSHIPS	exploitative, volatile	useful for status	useful or not?
WHEN OPPOSED	tantrums, harsh retaliation	meekly accept	argumentative, belittling opinionated

Achiever	Individualist	Strategist	Alchemist
independence	unconventionality	strength & autonomy	complexity, authenticity
conviction, fairness, enthusiasm	inspiring & spontaneous	insightful, principled, balanced	charismatic authentic leaders
self-in-society	self as individual	self-determination	transparent self
perfecting	being & feeling	integrating	playing, reinventing
reasons, causes, goals, effectiveness	unique personal achievements	patterns, trends, processes, complexity	problems of language and meaning
rational, sceptical	holistic	visionary	intuitive
challenging, supportive	creative	highly collaborative, spontaneous	free
postmodern, scientific	paradoxical, no need to explain everything	multi-faceted, ambiguous	choatic
root causes	uniqueness	authenticity	truths
self-chosen	non-judgement, almost amoral	deeply principled, will sacrifice self for values	very high moral standards
ask lots of "why" questions	contrasting ideas, vivid language	complex, lyrical	fluid orators
exhaustion, over-extension, self-criticism	can appear aloof & unapproachable	impatient with theirs & others development	feeling better than others
failure, loss of control	self-deception	not fulfilling their potential	fearless
rationalization, self-criticism	sublimation, spiritualization	suppression, humour, altruism	sublimation, humour
genuinely friendly	fun!	great communicators	can talk to anyone
diverse, intense & meaningful	intense & mutually rewarding	vital for intimacy & growth	deeply empathic
"we agree to differ"	respecful, differences are celebrated	tolerant, insightful, responsive	empathetic

CRITICS SAY: The "self" is a complex of developing parts, not governed by a single factor.

source: Susanne Cook-Greuter, Ego Development: Nine Levels Of Increasing Embrace, Wikipedia

K10
Core Duo
Sony JS160
Playstation III

TP X300
Core
Wii

TP Z60
Alienware ALX
VAIO XL2
Xbox 360

TP X41
Sony FW
Shuttle SV24
Gamecube

VIAO C1
Pentium IV

TP 570
Presario 5000
Pavillion 6835
Xbox

ThinkPad 770
K7 "Athlon"
Pentium III
Dreamcast
Playstation II

Compaq Deskpro 4000
Gateway TV/PC

Toshiba Satellite
Pentium II

AMD K5
Sega Saturn

ThinkPad 300
IBM Aptiva
IBM PC 300

PS/2 L40SX
Toshiba 3400
SuperH
Hitachi

Compaq Presario
Pentium Mini Tower
Jaguar
N64

PS2 / 25 PS2 / 65
gameboy pocket
Playstation

PS/2 70
RIM
CDi

IBM 5140
Amstrad PCW
ZX88
PC Engine
lynx
megadrive
neogeo
STE
Amiga 3000

PS/2 30
Compaq Deskpro 386

IBM PS/2 60
gameboy
ST2
Amiga 2000

HP 110
XT 286
128
mastersystem
SNES
1040 ST

Amstrad 1512
MSX2

IBM 5155
IBM AT
Amstrad CPC 464
Spectrum+
QL
7800
1200XL
Atari ST

compaq portable
MSX
NES
130XE
C128

IBM 5150
Spectrum
Timex 2068

IBM XT
Timex 1000 ZX81
5200
1200XL
Commodore C64

ColecoVision
MZ80B

ZX80
Atari 400/800
VIC 20

MZ80K
Atari 2600

8086
Intel
Z80
Zilog
Commodore PET
6502
MOS

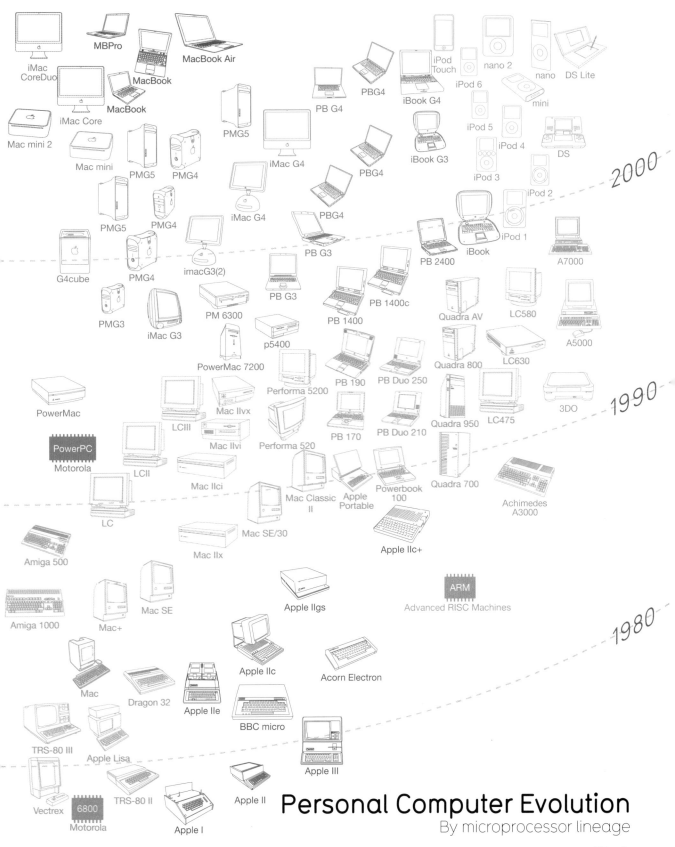

Personal Computer Evolution
By microprocessor lineage

source: Wikipedia

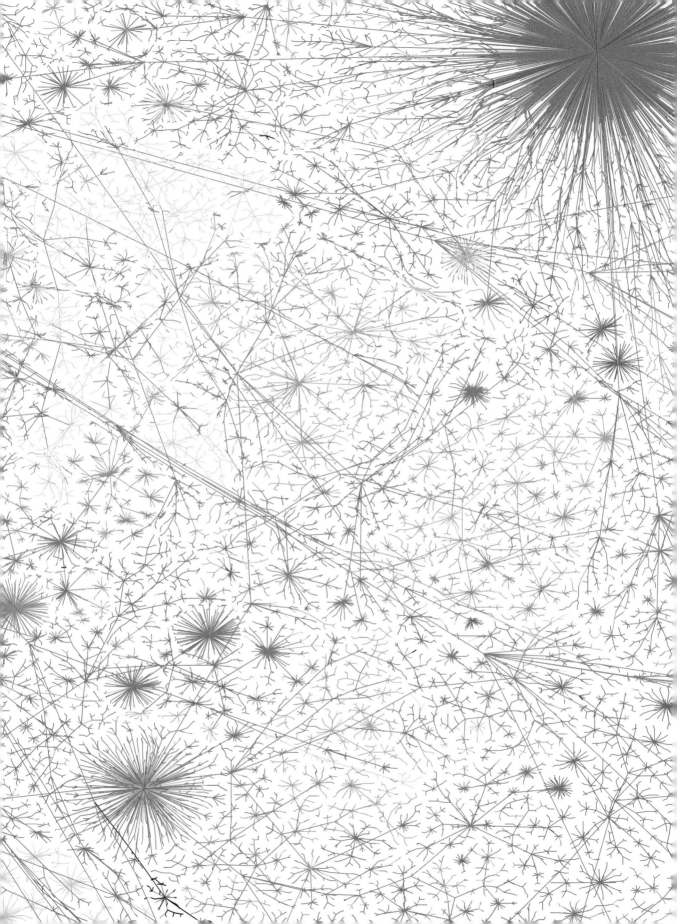

The One Machine
Map of the internet

Each node is a router on
the internet.

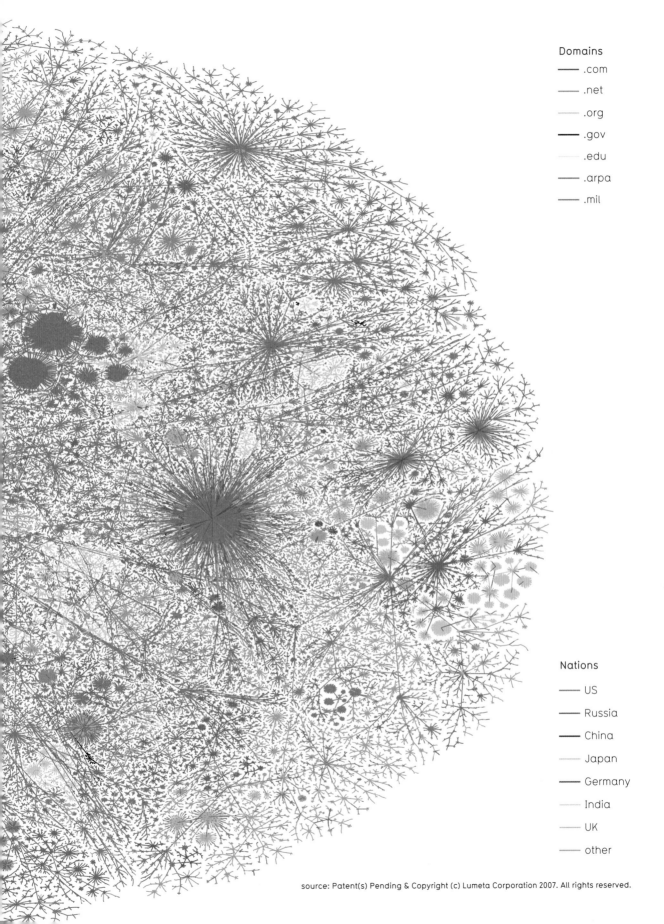

Domains

- —— .com
- —— .net
- —— .org
- —— **.gov**
- —— .edu
- —— .arpa
- —— .mil

Nations

- —— US
- —— Russia
- —— China
- —— Japan
- —— Germany
- —— India
- —— UK
- —— other

Internet Virals
How many you seen?

1996

MR T
A-Team star embarks on ironic post career with risible rap.

The Oracle of Bacon
Six degrees of separation applied to unremarkable actor.

1997

JenniCAM
19-year-old girl installs webcam. Inspires millions of pornographers.

TimeCube.com
Ranting racist homophobe claims the world is a cube.

1998

Bert is Evil
Good name of **Sesame Street** stalwart besmirched in worrying detail.

2000

Y2K
Glad you filled your cellar with batteries and bottled water?

Bonsai Kitten
Miniature cat spoof taken seriously by the hard of thinking.

Demotivators
The power of negative thinking.

6 Years of Noah
Unhappy looking narcissist takes picture of self every day for six years.

Dancing Baby
Symbolized Ally McBeal's body clock, and enthralled tiresome office dullards.

2001

Troops
Star Wars met **Cops**.

2005

Loose Change
Convincingly well-made 9/11 conspiracy documentary is alarmingly popular.

Man vs. Bear
Orange-trousered man fights bear for tinned salmon.

Hot or Not
Simple human rating concept anticipates online dating craze.

The Maze Game
Linda Blair booby trap scares millions of players.

2004

Mullets Galore
Billy Ray Cyrus to Bill Hicks. Two haircuts, zero dignity.

End of the World
Rudimentary animation explains global nuclear policy with comedy voiceover.

I Kiss You
Low rent simpleton's homepage that allegedly provided inspiration for Borat.

2003

Blair Witch Project
Pioneering website promotes low budget film, inadvertently sets industry template.

Hampster Dance
Rudimentary animation of dancing rodents pre-empts a billion wasted hours.

2002

Robot Dance
Imagine if Napoleon Dynamite had discovered robotic dancing instead.

MySpace: The Movie
Tiresome spoof of social networking vagaries. Ten minutes too long.

YouTube Launched

Xiao Xiao
Stick men kick each other about.

All Your Base Are Belong To Us
Video game dialogue lost in translation.

Peter Pan Guy
Man models homemade Peter Pan costumes for no discernible reason.

Diet Coke and Mentos
Oversized mints added to fizzy drinks with explosive results. Science.

We're Not Afraid
We're actually absolutely terrified. Please don't kill us, terrorist scum.

One Red Paperclip
Gurning redneck turns paperclip into house via grossly improbable trades.

Million Dollar Homepage
Clever sod pays way through university by selling pixels.

2006

Fred
Hyperactive six-year-old boy video blogs super-maniacally

Chuck Norris Facts
Fact-based deification of bearded action star.

Chad Vader
Darth's younger brother Chad work at a supermarket.

Evolution of Dance
Rubber-legged slaphead performs history of dance in six minutes.

99m views

The Show / Ze Frank
Manic American talks crap for a year.

Ask a Ninja
Stream of consciousness from man in a burkha.

Real Ultimate Power
A boy called Robert who can't stop thinking about ninjas.

Crank That Soulja Boy
It's not music, it's just noise.

40.7m views

Black Dorm Boys
Two Chinese boys mime banal pop song. Friend ignores them.

Nintendo Sixty-FOOOUR
Kids go feral upon receiving underperforming games console.

Daft Hands
Daft Punk song dubbed by tattooed hands . Yes, you read that correctly.
25.6m views

I Like Turtles
Random kid at fair proclaims love for turtles.

Weezer's Pork & Beans
Music video features every single viral reference since 1990.

Hasselhoff's "Hooked on a Feeling"
In Germany this is considered high art.

Will it Blend?
iPhone destroyed in modern take on baby in a blender.

Hot for Words
Hot Russian philologist gets lots of hits talking about 'word origins'.
Loads of views

Snakes on a Plane
Internet hype fails to prevent box-office flop.

Charlie bit my finger
Charlie bit me!
60.7m views

Little Superstar
He's small, he's Indian and he's dancing.

Thriller
Murderers and rapists re-enact seminal Wacko Jacko video.
19.2m views

Kicking a Wall
Essex boy kicks wall, breaks ankle, queries evolution.

Leeroy Jenkins
Online roleplayer shouts his character's name. Rest of society remains oblivious.

Rick Roll
Pete Waterman reminds us again how he invented music.

Big Dog
Eerie robot dog frightens entire world.

Benny Lava
Indian Michael Jackson dances hilariously on high mountain range.

Free Hugs Campaign
Do-gooder invade personal space. Don't touch me.
33.3m views

Drunk Hasselhoff
Baywatch star wrestles with burger. Where's KITT now?

I'm Fking Matt Damon**
Comedienne Sarah Silverman sings about her sexual relations with a celebrity..

Star Wars Kid
Fat kid throws himself into enthusiastic lightsaber routine, ruins life.

Stephen Colbert at Whitehouse Dinner
US comedian Colbert makes Bush squirm.

Miss Teen South Carolina
Miss Teen USA 2007 displays limited grasp of geography.
30.7m views

Evil look baby
Baby gives evil look.

Sneezing Panda
Baby panda causes mother to buck with mansized sneeze.

Chocolate Rain
Po-faced song about racism is hilarious.
29.9m views

Leave Britney Alone!
Eye-linered Britney fan wrapped in sheet.

2008

Hahaha
Small baby laughs like Satan with a head cold.
66.3m views

2007

I Can Haz Cheezburger?
Kittens plus illiterate slogans excite world

Don't tase me, bro!
Nobody likes students but this may have been an over-reaction.

300 PG Version
Modified **300** trailer promotes dental hygiene.

Beatbox Flute
Handsome beatboxing flautist chooses dire track to debut superpowers.

Otters Hold Hands
Otters hold hands while floating. Entire world stops to watch.

Dramatic Chipmunk
Prairie dog turns menacingly towards the camera.

The Last Lecture
Respected professor gives final lecture before dying. Powerful stuff.

celebs
crazies
cute
funny
irony
kittens
mash-up
one-offs
ninjas
scary
sexxxxy
song/dance
star wars
wow!

source: Wikipedia, dipity.com/tatercakes/Internet_Memes

You Tubes
Your personal info online

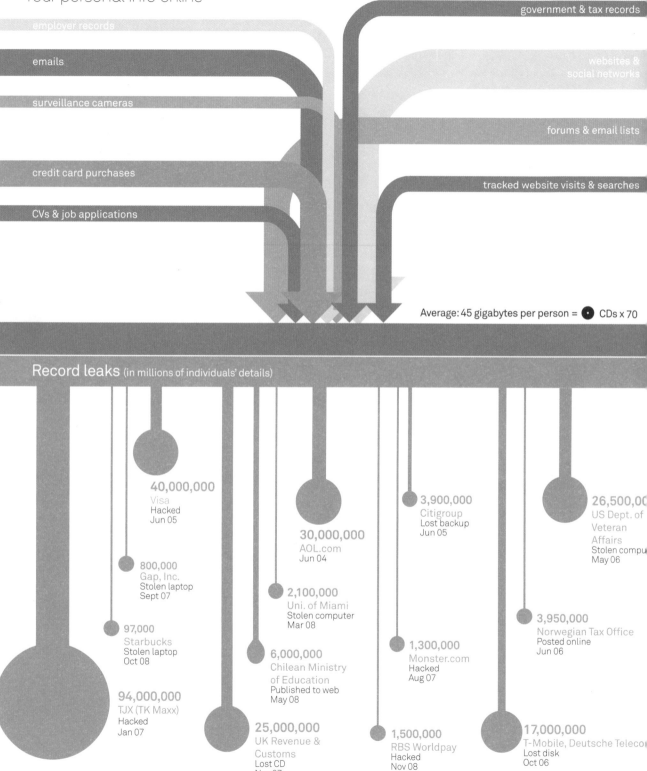

government & tax records

employer records

emails

websites &
social networks

surveillance cameras

forums & email lists

credit card purchases

tracked website visits & searches

CVs & job applications

Average: 45 gigabytes per person = ● CDs x 70

Record leaks (in millions of individuals' details)

40,000,000
Visa
Hacked
Jun 05

800,000
Gap, Inc.
Stolen laptop
Sept 07

97,000
Starbucks
Stolen laptop
Oct 08

94,000,000
TJX (TK Maxx)
Hacked
Jan 07

2,100,000
Uni. of Miami
Stolen computer
Mar 08

6,000,000
Chilean Ministry
of Education
Published to web
May 08

25,000,000
UK Revenue &
Customs
Lost CD
Nov 07

30,000,000
AOL.com
Jun 04

3,900,000
Citigroup
Lost backup
Jun 05

1,300,000
Monster.com
Hacked
Aug 07

1,500,000
RBS Worldpay
Hacked
Nov 08

26,500,00
US Dept. of
Veteran
Affairs
Stolen compu
May 06

3,950,000
Norwegian Tax Office
Posted online
Jun 06

17,000,000
T-Mobile, Deutsche Teleco
Lost disk
Oct 06

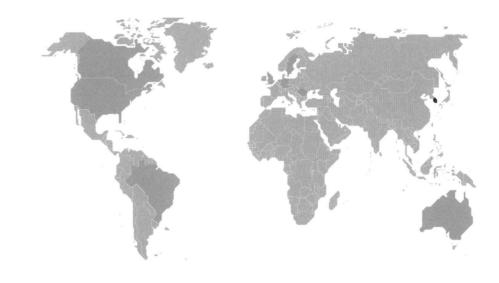

Digital blackmarket prices

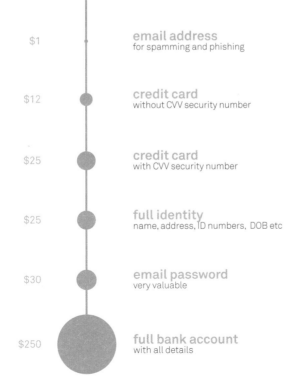

$1 — **email address**
for spamming and phishing

$12 — **credit card**
without CVV security number

$25 — **credit card**
with CVV security number

$25 — **full identity**
name, address, ID numbers, DOB etc

$30 — **email password**
very valuable

$250 — **full bank account**
with all details

Leaky routes

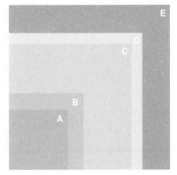

A inside job (11%)

B lost CD or other media (13%)

C accidental web leak (23%)

D lost or stolen computer (25%)

E hacked (28%)

source: Infowatch.com, Datalossdb.org, ITRC, Forbes, Wikipedia

In 25 Words or Less
Most common words used by (in)famous columnists

George Monbiot
Guardian

change government
every nations now
just
people
world power
new even
also last global much
climate years
means public companies

a mention of "I" every 246 words

Richard Littlejohn
Daily Mail

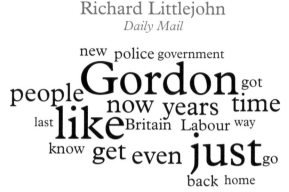

new police government
people Gordon got
now years time
like
last Britain Labour way
know get even just go
back home

117 words

Oh the Agony
Most common words used by noted advice specialists

Pamela Stephenson Connolly
Guardian

intercourse well
try feel good life
often may
therapy make sex
many
experience sexual need
seek men
relationship way partner
ask people help
women

Dear Abby
syndicated

right person time
go know people
now
feel life make
sure thank tell
may like someone
however also please parents much
one better
husband might family
two

Data scrape of columns from Jan 1st 2007–Dec 2008. Common words ("and", "to", "were", "there" etc) and duplicate political terms excluded. Wordle.net used to establish word frequen

Christopher Hitchens
Freelance

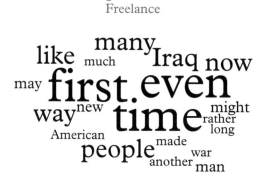

like many Iraq now
much
may first.even
way new time might
rather long
American made
people another war man

271 words

Thomas Friedmann
New York Times

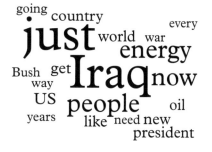

going country every
just world war
Bush energy
US get Iraq now
people oil
years like need new
president

103 words

Miriam Stoppard
Daily Mirror

make feel get need want
relationship love life family
give know put keep children
just one
people Christmas
even
time day much may salt
good things like new food

Self Help
Book titles & subtitles

living new
Earth life journey
inspirational miracles
book four
guide spiritual
happiness
course healing
purpose wisdom
belief within
health power

source: Guardian.co.uk, NYTimes.com, DailyMail.co.uk, DailyMirror.co.uk, ChristopherHitchens.com, Wordle.net

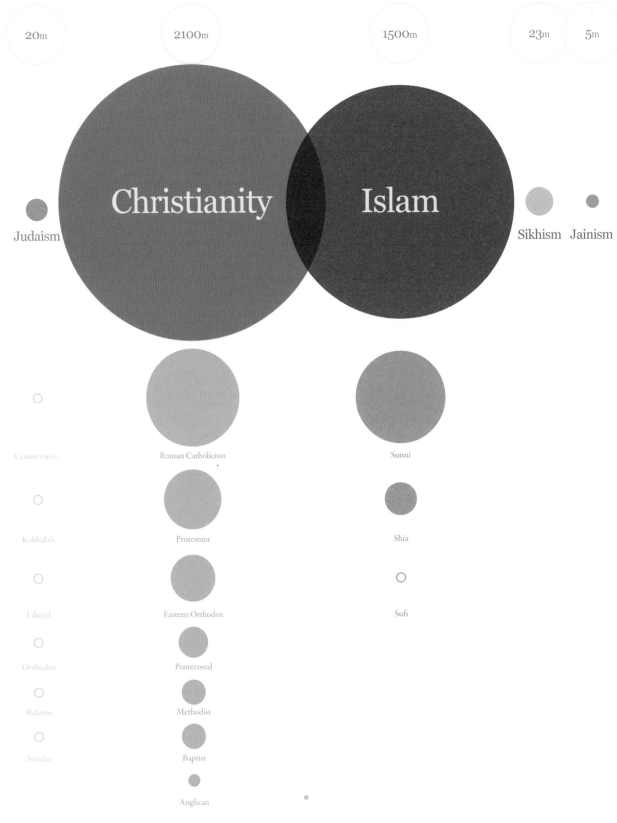

20m

2100m

1500m

23m 5m

Christianity Islam

Judaism

Sikhism Jainism

Conservative Roman Catholicism Sunni

Kabbalah Protestant Shia

Liberal Eastern Orthodox Sufi

Orthodox Pentecostal

Reform Methodist

Secular Baptist

Anglican

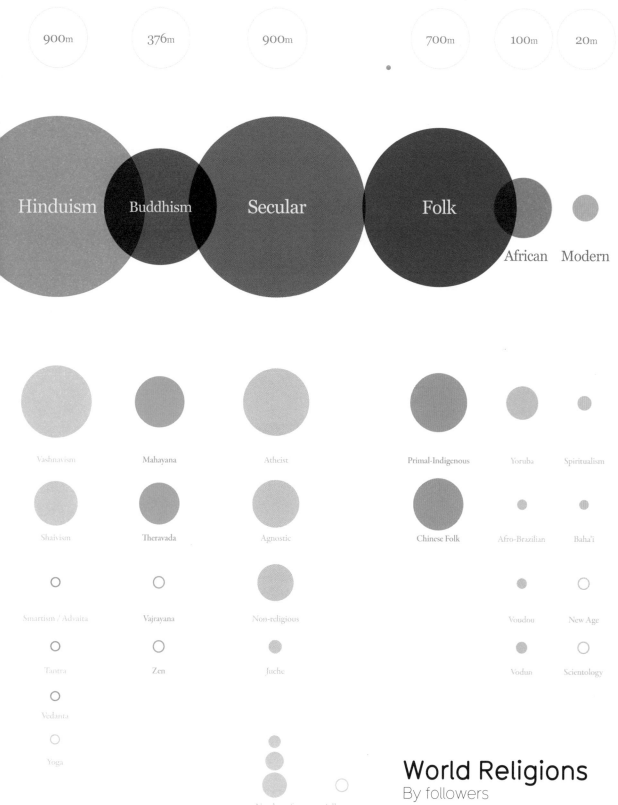

900m 376m 900m 700m 100m 20m

Hinduism Buddhism Secular Folk African Modern

Vashnavism Mahayana Atheist Primal-Indigenous Yoruba Spiritualism

Shaivism Theravada Agnostic Chinese Folk Afro-Brazilian Baha'i

Smartism / Advaita Vajrayana Non-religious Voudou New Age

Tantra Zen Juche Vodun Scientology

Vedanta

Yoga

Number of adherents Adherents unknown

World Religions
By followers

source: Adherents.com

Moral Matrix

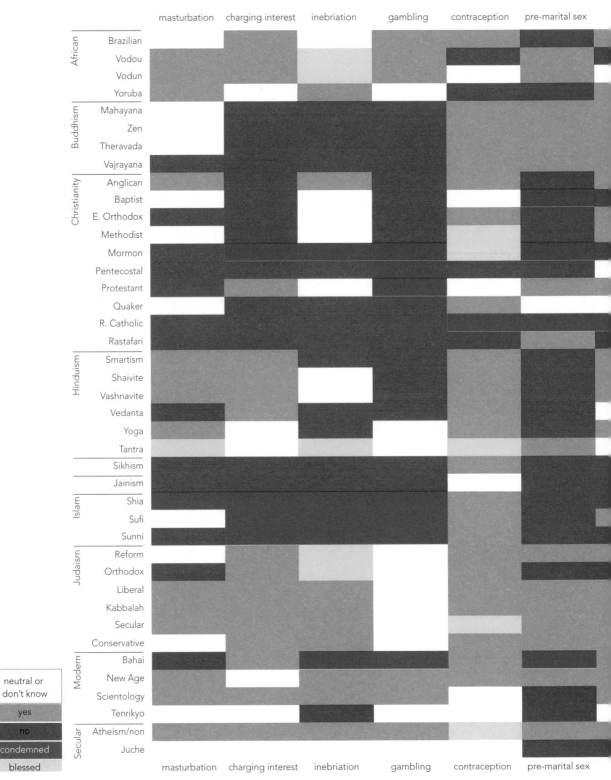

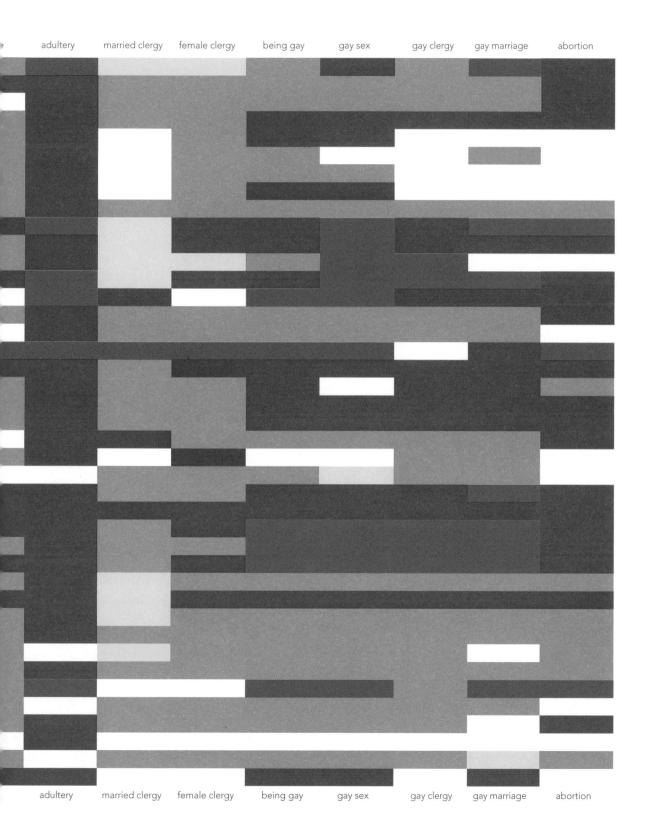

adultery married clergy female clergy being gay gay sex gay clergy gay marriage abortion

adultery married clergy female clergy being gay gay sex gay clergy gay marriage abortion

source: Wikipedia, Adherents.com

The Carbon Dioxide Cycle

Yearly manmade vs natural carbon emissions in gigatons (g)

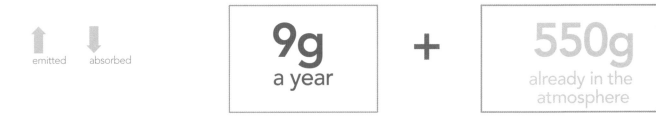

emitted absorbed

9g
a year

+

550g
already in the
atmosphere

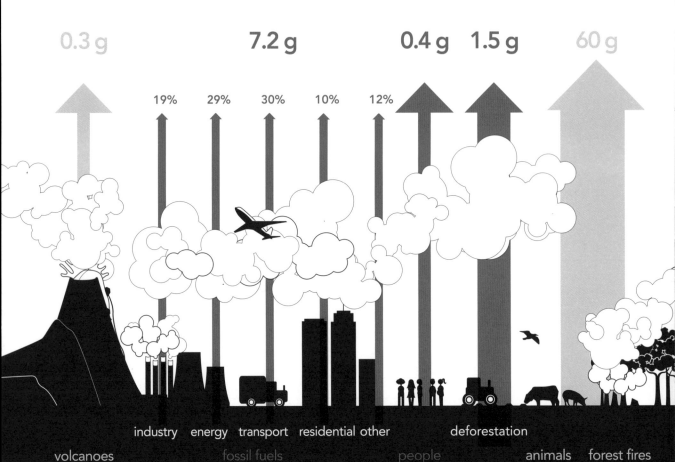

0.3 g 7.2 g 0.4 g 1.5 g 60 g

19% 29% 30% 10% 12%

industry energy transport residential other deforestation

volcanoes fossil fuels people animals forest fires

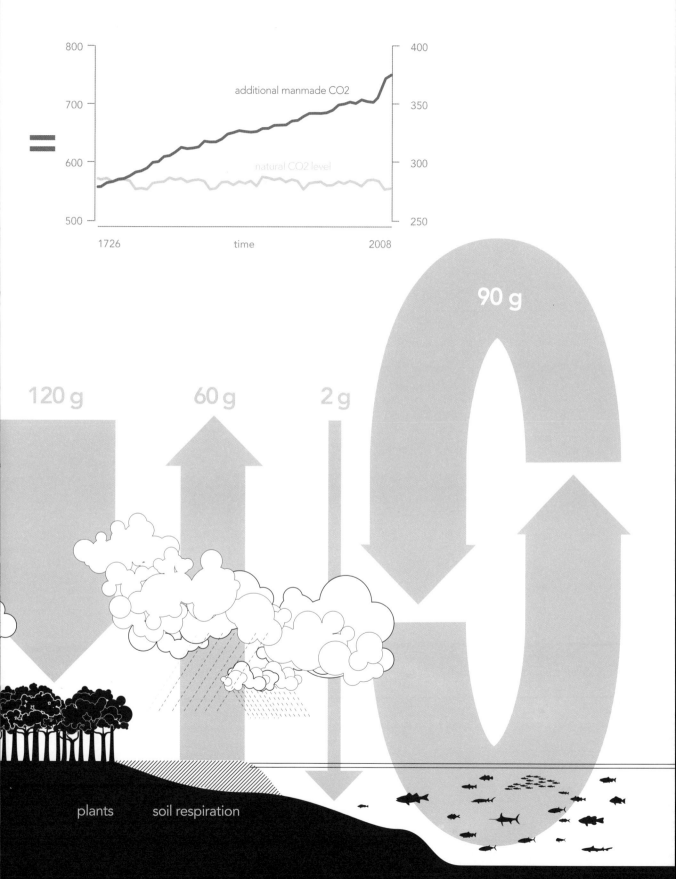

800 — 400

additional manmade CO2

700 — 350

600 — 300

natural CO2 level

500 — 250

1726 time 2008

90 g

120 g 60 g 2 g

plants soil respiration

source: UNESCO Scope , IPCC 2007, Wikipedia, Realclimate.org

1250 MB/s

same bandwidth as a: computer network

125 MB/s

USB key

Low Resolution
Amount of sensory information reaching the brain per second

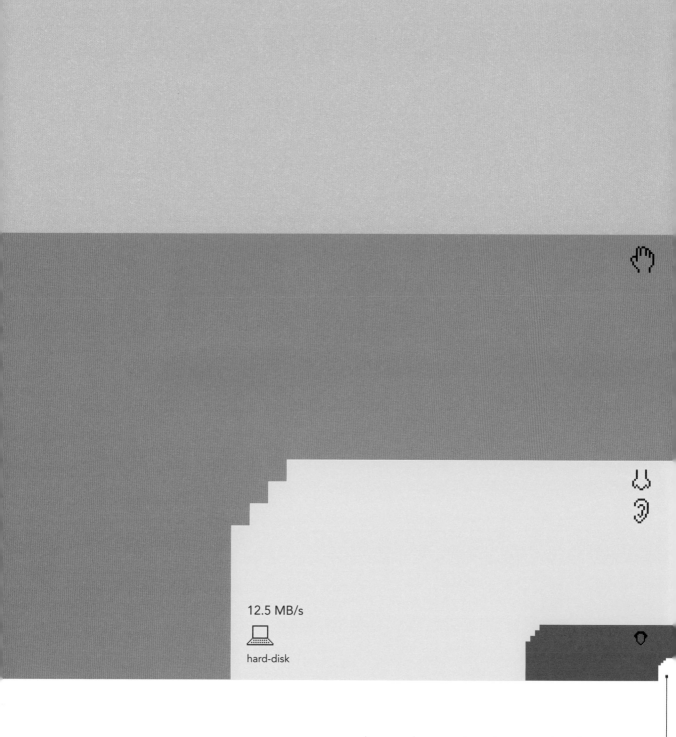

12.5 MB/s

hard-disk

Amount consciously perceived (0.045%)

source: Tor Nørretranders, The User Illusion: Cutting Consciousness Down to Size

Taste Buds
Complementary tastes

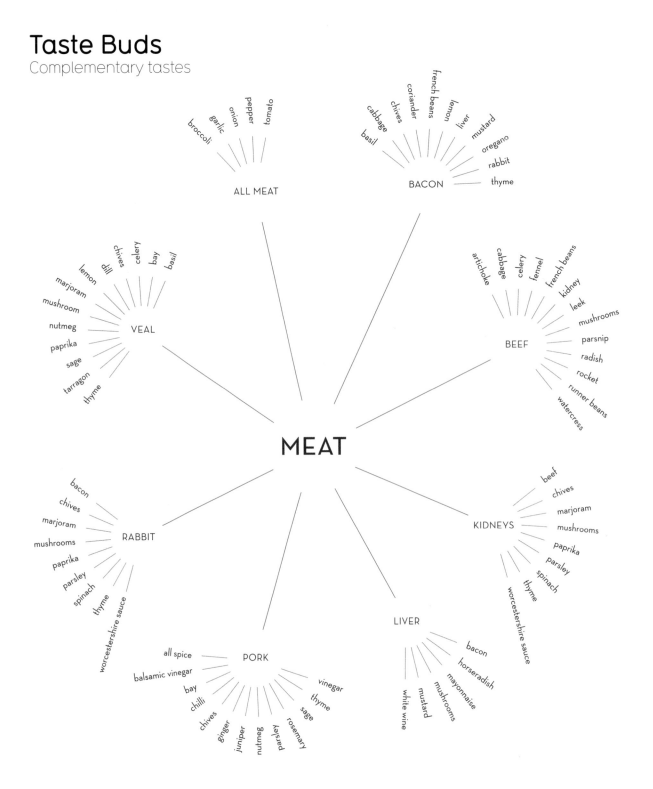

ALL MEAT
- broccoli
- garlic
- onion
- pepper
- tomato

BACON
- basil
- cabbage
- chives
- coriander
- french beans
- lemon
- liver
- mustard
- oregano
- rabbit
- thyme

VEAL
- lemon
- dill
- chives
- celery
- bay
- basil
- marjoram
- mushroom
- nutmeg
- paprika
- sage
- tarragon
- thyme

BEEF
- artichoke
- cabbage
- celery
- fennel
- french beans
- kidney
- leek
- mushrooms
- parsnip
- radish
- rocket
- runner beans
- watercress

MEAT

RABBIT
- bacon
- chives
- marjoram
- mushrooms
- paprika
- parsley
- spinach
- thyme
- worcestershire sauce

KIDNEYS
- beef
- chives
- marjoram
- mushrooms
- paprika
- parsley
- spinach
- thyme
- worcestershire sauce

PORK
- all spice
- balsamic vinegar
- bay
- chilli
- chives
- ginger
- juniper
- nutmeg
- parsley
- rosemary
- sage
- thyme
- vinegar

LIVER
- white wine
- mustard
- mushrooms
- mayonnaise
- horseradish
- bacon

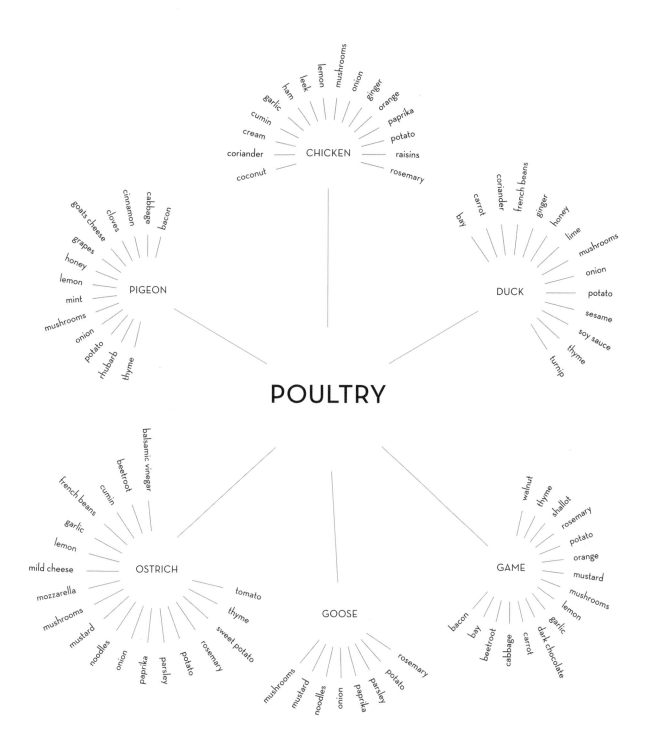

POULTRY

CHICKEN
garlic, ham, leek, lemon, mushrooms, onion, ginger, orange, paprika, potato, raisins, rosemary, coriander, cream, cumin, coconut

DUCK
bay, carrot, coriander, french beans, ginger, honey, lime, mushrooms, onion, potato, sesame, soy sauce, thyme, turnip

PIGEON
goats cheese, cloves, cinnamon, cabbage, bacon, grapes, honey, lemon, mint, mushrooms, onion, potato, rhubarb, thyme

OSTRICH
balsamic vinegar, beetroot, cumin, french beans, garlic, lemon, mild cheese, mozzarella, mushrooms, mustard, noodles, onion, paprika, parsley, potato, rosemary, sweet potato, thyme, tomato

GOOSE
mushrooms, mustard, noodles, onion, paprika, parsley, potato, rosemary

GAME
walnut, thyme, shallot, rosemary, potato, orange, mustard, mushrooms, lemon, garlic, dark chocolate, carrot, cabbage, beetroot, bay, bacon

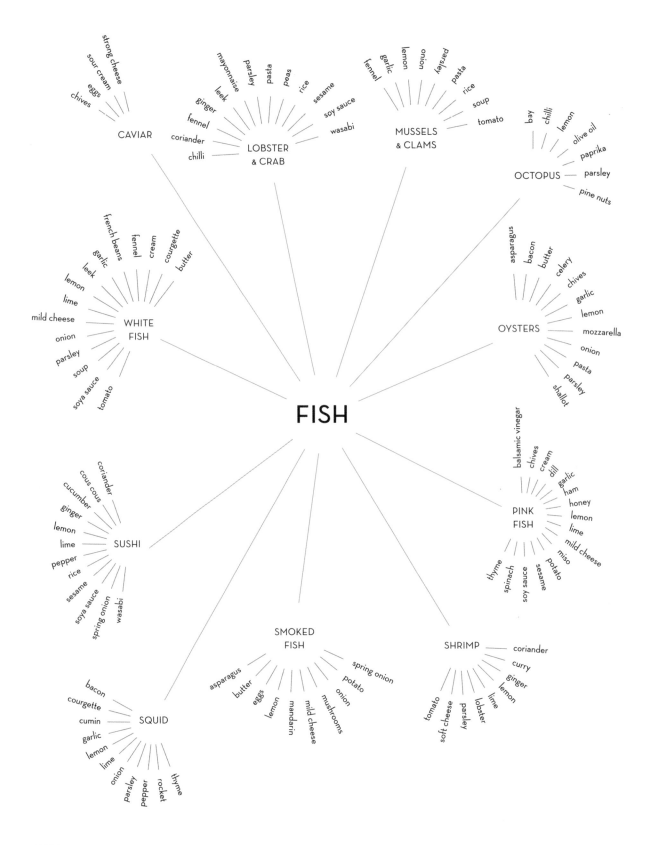

FISH

CAVIAR
- chives
- eggs
- sour cream
- strong cheese

LOBSTER & CRAB
- chilli
- coriander
- fennel
- ginger
- leek
- mayonnaise
- parsley
- pasta
- peas
- rice
- sesame
- soy sauce
- wasabi

MUSSELS & CLAMS
- fennel
- garlic
- lemon
- onion
- parsley
- pasta
- rice
- soup
- tomato

OCTOPUS
- bay
- chilli
- lemon
- olive oil
- paprika
- parsley
- pine nuts

WHITE FISH
- french beans
- garlic
- fennel
- cream
- courgette
- butter
- leek
- lemon
- lime
- mild cheese
- onion
- parsley
- soup
- soya sauce
- tomato

OYSTERS
- asparagus
- bacon
- butter
- celery
- chives
- garlic
- lemon
- mozzarella
- onion
- pasta
- parsley
- shallot

SUSHI
- coriander
- cous cous
- cucumber
- ginger
- lemon
- lime
- pepper
- rice
- sesame
- soya sauce
- spring onion
- wasabi

PINK FISH
- balsamic vinegar
- chives
- cream
- dill
- garlic
- ham
- honey
- lemon
- lime
- mild cheese
- miso
- potato
- sesame
- soy sauce
- spinach
- thyme

SQUID
- bacon
- courgette
- cumin
- garlic
- lemon
- lime
- onion
- parsley
- pepper
- rocket
- thyme

SMOKED FISH
- asparagus
- butter
- eggs
- lemon
- mandarin
- mild cheese
- mushrooms
- onion
- potato
- spring onion

SHRIMP
- coriander
- curry
- ginger
- lemon
- lime
- lobster
- parsley
- soft cheese
- tomato

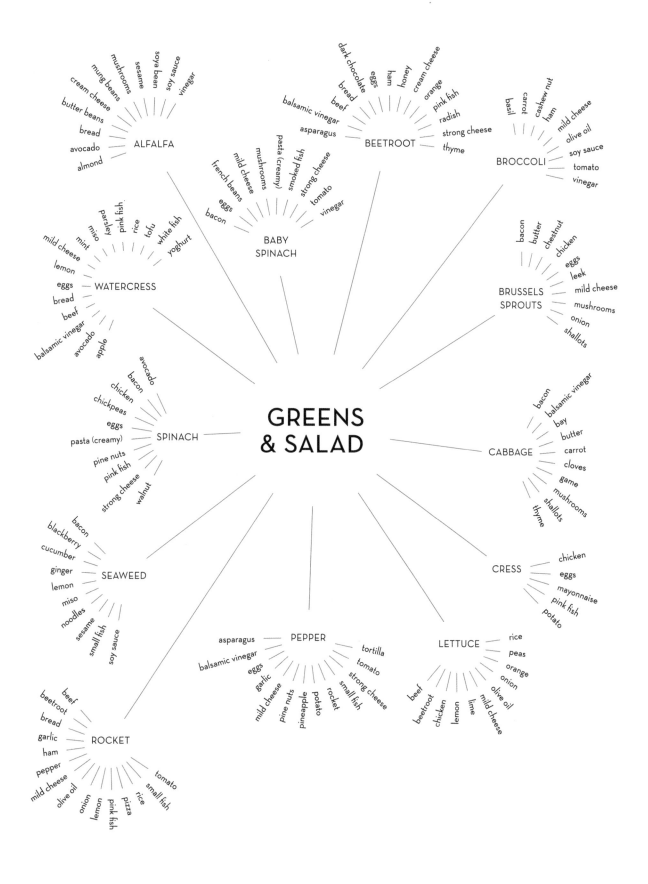

GREENS & SALAD

ALFALFA
soya bean, sesame, soy sauce, vinegar, mushrooms, mung beans, cream cheese, butter beans, bread, avocado, almond

BABY SPINACH
pasta (creamy), smoked fish, strong cheese, tomato, vinegar, mushrooms, mild cheese, french beans, eggs, bacon

BEETROOT
dark chocolate, eggs, ham, honey, cream cheese, orange, pink fish, radish, strong cheese, thyme, bread, beef, balsamic vinegar, asparagus

BROCCOLI
carrot, cashew nut, ham, mild cheese, olive oil, soy sauce, tomato, vinegar, basil

WATERCRESS
parsley, pink fish, rice, tofu, white fish, yoghurt, mint, miso, mild cheese, lemon, eggs, bread, beef, balsamic vinegar, avocado, apple

BRUSSELS SPROUTS
bacon, butter, chestnut, chicken, eggs, leek, mild cheese, mushrooms, onion, shallots

SPINACH
avocado, bacon, chicken, chickpeas, eggs, pasta (creamy), pine nuts, pink fish, strong cheese, walnut

CABBAGE
bacon, balsamic vinegar, bay, butter, carrot, cloves, game, mushrooms, shallots, thyme

SEAWEED
bacon, blackberry, cucumber, ginger, lemon, miso, noodles, sesame, small fish, soy sauce

CRESS
chicken, eggs, mayonnaise, pink fish, potato

PEPPER
asparagus, balsamic vinegar, eggs, garlic, mild cheese, pine nuts, pineapple, potato, rocket, small fish, strong cheese, tomato, tortilla

LETTUCE
rice, peas, orange, onion, olive oil, mild cheese, lime, lemon, chicken, beetroot, beef

ROCKET
beef, beetroot, bread, garlic, ham, pepper, mild cheese, olive oil, onion, lemon, pink fish, pizza, rice, small fish, tomato

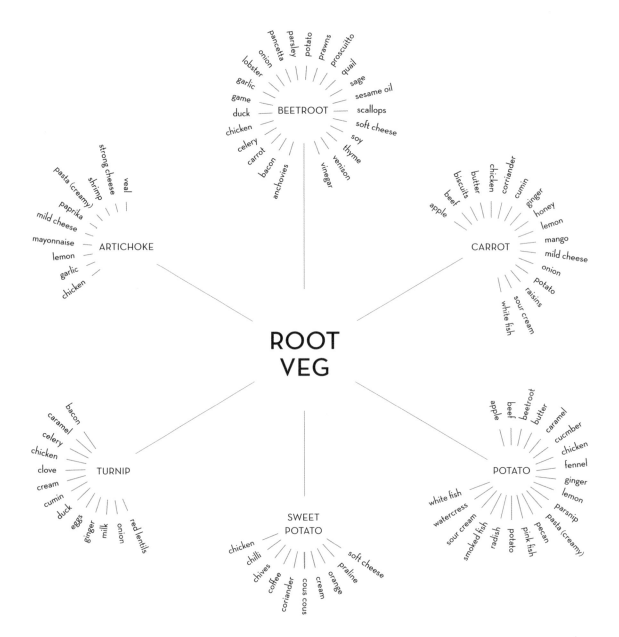

ROOT
VEG

BEETROOT — onion, pancetta, parsley, potato, prawns, proscuitto, quail, sage, sesame oil, scallops, soft cheese, soy, thyme, venison, vinegar, anchovies, bacon, carrot, celery, chicken, duck, game, garlic, lobster

ARTICHOKE — strong cheese, shrimp, veal, pasta (creamy), paprika, mild cheese, mayonnaise, lemon, garlic, chicken

CARROT — chicken, coriander, cumin, ginger, honey, lemon, mango, mild cheese, onion, potato, raisins, sour cream, white fish, butter, biscuits, beef, apple

TURNIP — bacon, caramel, celery, chicken, clove, cream, cumin, duck, eggs, ginger, milk, onion, red lentils

SWEET POTATO — chicken, chilli, chives, coffee, coriander, cous cous, cream, orange, praline, soft cheese

POTATO — apple, beef, beetroot, butter, caramel, cucmber, chicken, fennel, ginger, lemon, parsnip, pasta (creamy), pecan, pink fish, potato, radish, smoked fish, sour cream, watercress, white fish

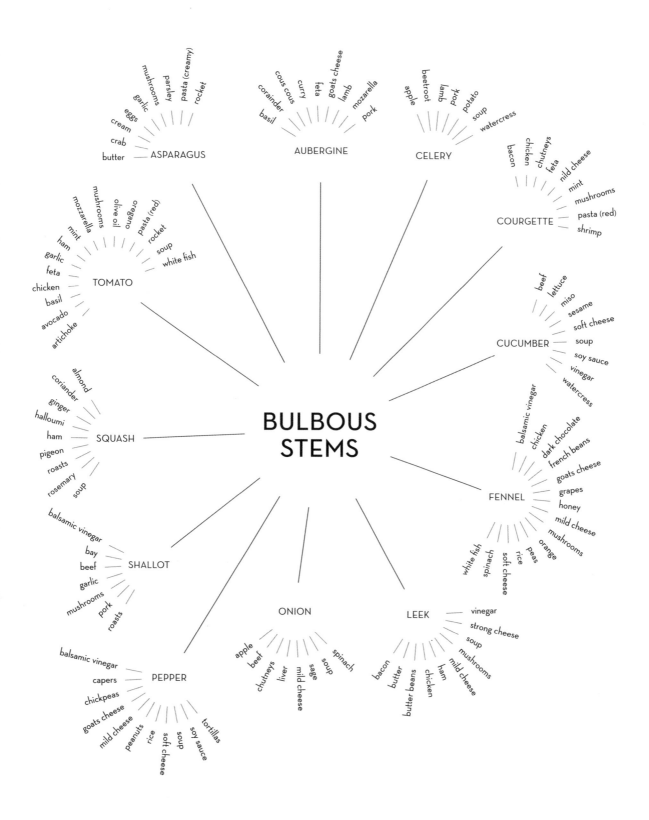

BULBOUS STEMS

ASPARAGUS
butter, crab, cream, eggs, garlic, mushrooms, parsley, pasta (creamy), rocket

AUBERGINE
basil, coriander, cous cous, curry, feta, goats cheese, lamb, mozzarella, pork

CELERY
apple, beetroot, lamb, pork, potato, soup, watercress

COURGETTE
bacon, chicken, chutneys, feta, mild cheese, mint, mushrooms, pasta (red), shrimp

TOMATO
mozzarella, mushrooms, olive oil, oregano, pasta (red), rocket, soup, white fish, mint, ham, garlic, feta, chicken, basil, avocado, artichoke

CUCUMBER
beef, lettuce, miso, sesame, soft cheese, soup, soy sauce, vinegar, watercress

SQUASH
almond, coriander, ginger, halloumi, ham, pigeon, roasts, rosemary, soup

FENNEL
balsamic vinegar, chicken, dark chocolate, french beans, goats cheese, grapes, honey, mild cheese, mushrooms, orange, peas, rice, soft cheese, spinach, white fish

SHALLOT
balsamic vinegar, bay, beef, garlic, mushrooms, pork, roasts

LEEK
vinegar, strong cheese, soup, mushrooms, mild cheese, ham, chicken, butter beans, butter, bacon

ONION
apple, beef, chutneys, liver, mild cheese, sage, soup, spinach

PEPPER
balsamic vinegar, capers, chickpeas, goats cheese, mild cheese, peanuts, rice, soft cheese, soup, soy sauce, tortillas

source: general internet and bbc.co.uk/food

Extinct

Most endangered species

Vertebrate Index

A Amur Tiger
B Black Rhino
C Cheetah
D Schomburgk's Deer
E Asian Elephant
F Island Grey Fox
G Giant Panda
H Huemul
I Northern Bald Ibis
J Jacamar (Three Toed)
K Kokako
L Black-cheeked Lovebird
M Marbled Murrelet

N Lesser Nothura
O Forest Owlet
P Panamint Alligator Lizard
Q Queensland Snake-Lizard
R R. Silus (Gastric Brooding Frog)
S Louisiana Pine Snake
T Golden Toad
U Utila Iguana
V Vaquita
W Wide Sawfish
X X. Yunnanensis (Kunming Nase)
Y Yangtze River Dolphin
Z Zebra Shark

Vertebrate Category

Mammals

Birds

Reptiles / Amphibians

Marine Vertebrates

Years

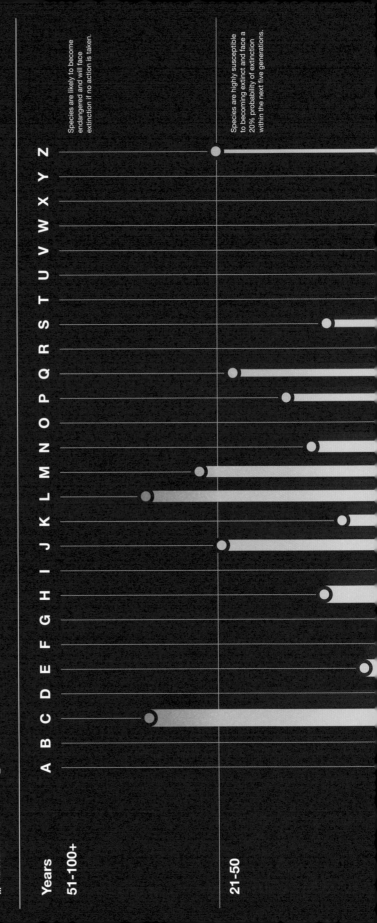

51-100+

A B C D E F G H I J K L M N O P Q R S T U V W X Y Z

Species are likely to become
endangered and will face
extinction if no action is taken.

Species are highly susceptible
to becoming extinct and face a
20% probability of extinction
within the next five generations.

21-50

Species are extremely susceptible
to becoming extinct in the wild and
face imminent extinction within
three generations unless further
action is taken to preserve them.

Every member of a species has
died and is no longer present.

Extinct

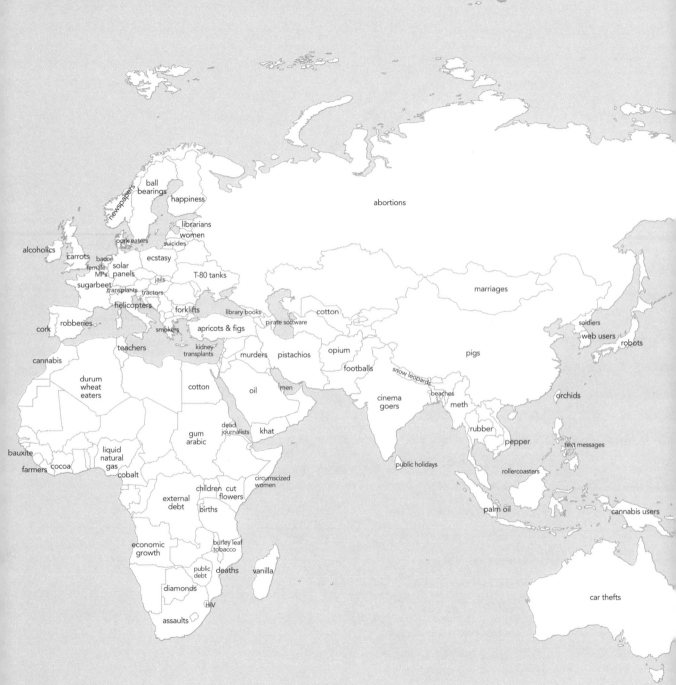

newspapers
ball bearings
happiness
librarians
women
suicides
ecstasy
pork eaters
alcoholics
carrots
bacon
female MPs
solar panels
jails
sugarbeet
transplants
tractors
T-80 tanks
abortions
marriages
helicopters
forklifts
library books
cotton
cork
robberies
smokers
apricots & figs
pirate software
soldiers
web users
robots
teachers
kidney transplants
murders
pistachios
opium
pigs
cannabis
durum wheat eaters
cotton
oil
men
footballs
snow leopards
orchids
gum arabic
dead journalists
khat
cinema goers
beaches
meth
bauxite
liquid natural gas
rubber
pepper
text messages
farmers
cocoa
cobalt
public holidays
rollercoasters
circumscized women
children
cut flowers
palm oil
cannabis users
external debt
births
economic growth
burley leaf tobacco
public debt
deaths
vanilla
diamonds
HIV
car thefts
assaults

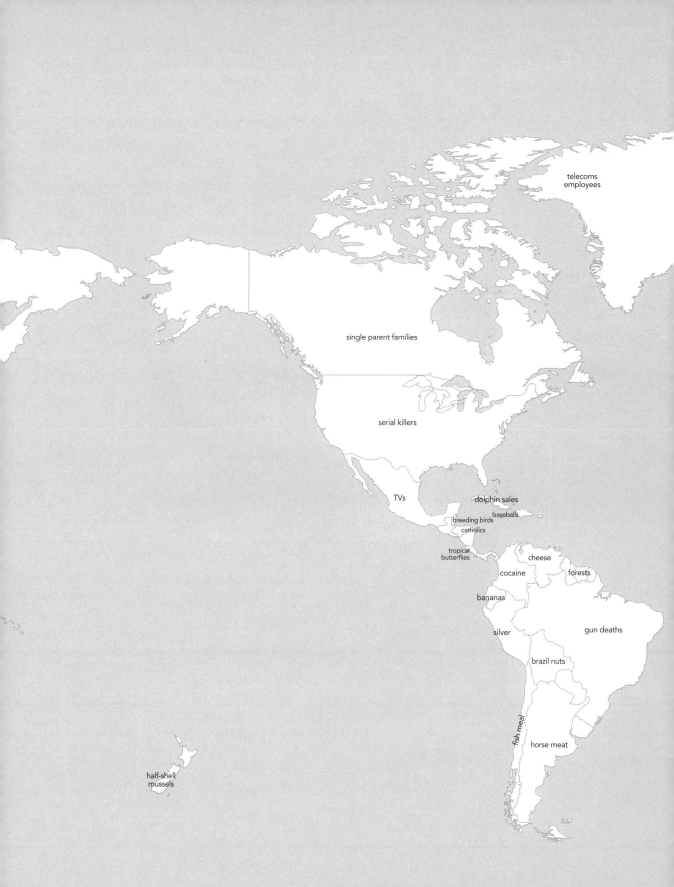

telecoms employees

single parent families

serial killers

TVs

dolphin sales

baseballs

breeding birds

catholics

tropical butterflies

cheese

cocaine

forests

bananas

silver

gun deaths

brazil nuts

fish meat

horse meat

half-shell mussels

source: per capita data from Newscientist.com, Unstats.un.org, NationMaster.com

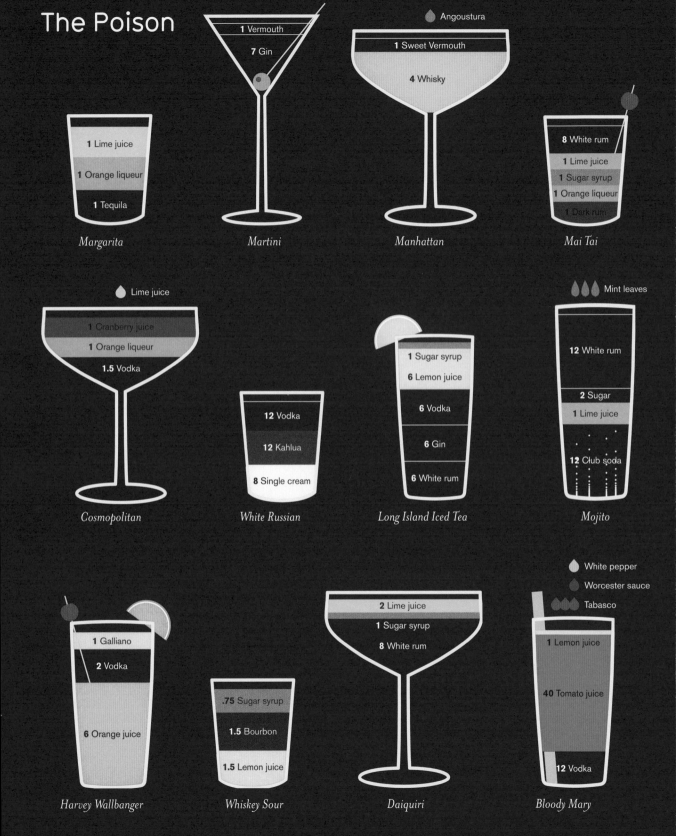

The Poison

Margarita
1 Lime juice
1 Orange liqueur
1 Tequila

Martini
1 Vermouth
7 Gin

Manhattan
Angoustura
1 Sweet Vermouth
4 Whisky

Mai Tai
8 White rum
1 Lime juice
1 Sugar syrup
1 Orange liqueur
1 Dark rum

Cosmopolitan
Lime juice
1 Cranberry juice
1 Orange liqueur
1.5 Vodka

White Russian
12 Vodka
12 Kahlua
8 Single cream

Long Island Iced Tea
1 Sugar syrup
6 Lemon juice
6 Vodka
6 Gin
6 White rum

Mojito
Mint leaves
12 White rum
2 Sugar
1 Lime juice
12 Club soda

Harvey Wallbanger
1 Galliano
2 Vodka
6 Orange juice

Whiskey Sour
.75 Sugar syrup
1.5 Bourbon
1.5 Lemon juice

Daiquiri
2 Lime juice
1 Sugar syrup
8 White rum

Bloody Mary
White pepper
Worcester sauce
Tabasco
1 Lemon juice
40 Tomato juice
12 Vodka

The Remedy
Hangover cures from around the world

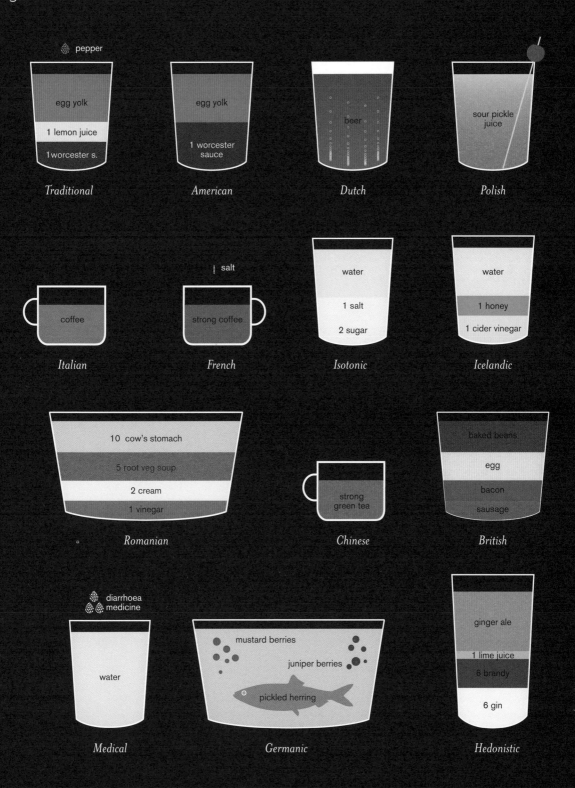

pepper

egg yolk
1 lemon juice
1 worcester s.

Traditional

egg yolk
1 worcester sauce

American

beer

Dutch

sour pickle juice

Polish

coffee

Italian

salt

strong coffee

French

water
1 salt
2 sugar

Isotonic

water
1 honey
1 cider vinegar

Icelandic

10 cow's stomach
5 root veg soup
2 cream
1 vinegar

Romanian

strong green tea

Chinese

baked beans
egg
bacon
sausage

British

diarrhoea medicine

water

Medical

mustard berries
juniper berries
pickled herring

Germanic

ginger ale
1 lime juice
6 brandy
6 gin

Hedonistic

source: Google

Salad Dressings
All in proportion

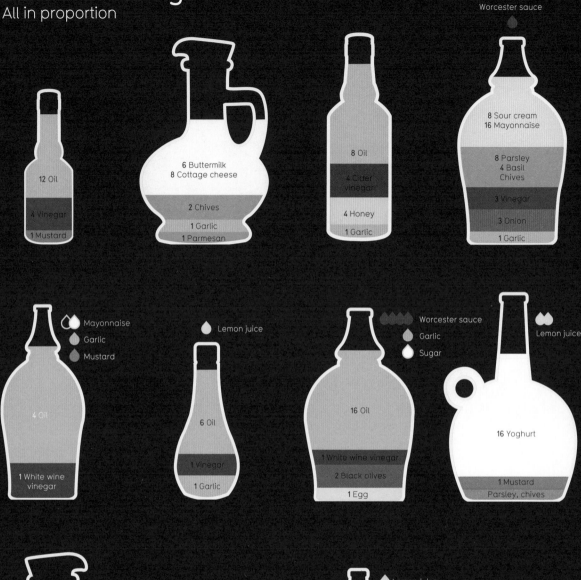

Worcester sauce

12 Oil
4 Vinegar
1 Mustard

6 Buttermilk
8 Cottage cheese
2 Chives
1 Garlic
1 Parmesan

8 Oil
4 Cider vinegar
4 Honey
1 Garlic

8 Sour cream
16 Mayonnaise
8 Parsley
4 Basil
Chives
3 Vinegar
3 Onion
1 Garlic

Mayonnaise
Garlic
Mustard

4 Oil
1 White wine vinegar

Lemon juice

6 Oil
1 Vinegar
1 Garlic

Worcester sauce
Garlic
Sugar

16 Oil
1 White wine vinegar
2 Black olives
1 Egg

Lemon juice

16 Yoghurt
1 Mustard
Parsley, chives

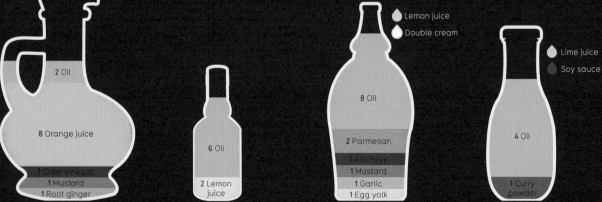

2 Oil
8 Orange juice
1 Cider vinegar
1 Mustard
1 Root ginger

6 Oil
2 Lemon juice

Lemon juice
Double cream

8 Oil
2 Parmesan
1 Anchovy
1 Mustard
1 Garlic
1 Egg yolk

Lime juice
Soy sauce

4 Oil
1 Curry powder

source: Google

Not Nice
Food colourings linked to unpleasant health effects

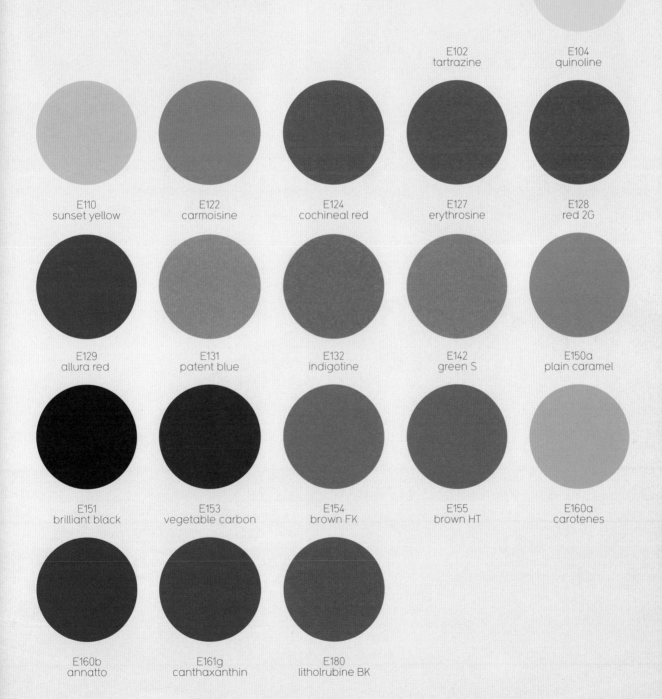

E102
tartrazine

E104
quinoline

E110
sunset yellow

E122
carmoisine

E124
cochineal red

E127
erythrosine

E128
red 2G

E129
allura red

E131
patent blue

E132
indigotine

E142
green S

E150a
plain caramel

E151
brilliant black

E153
vegetable carbon

E154
brown FK

E155
brown HT

E160a
carotenes

E160b
annatto

E161g
canthaxanthin

E180
litholrubine BK

source: Centre For Science In The Public Interest, Cspinet.org

20th Century Death

What's killed the most?

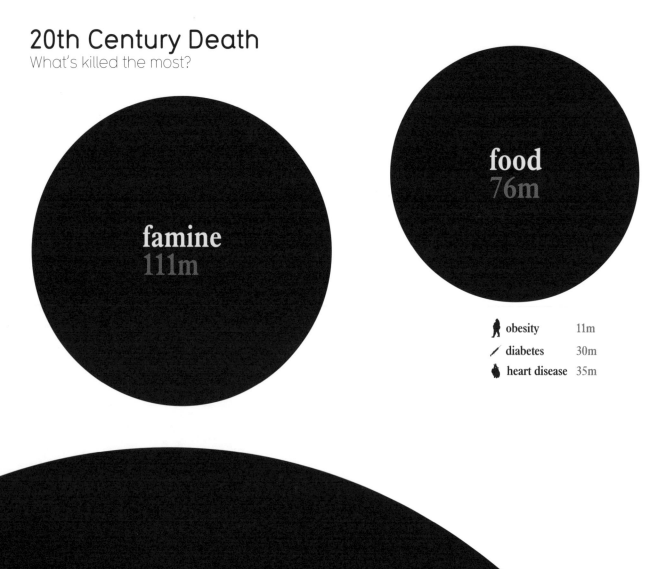

famine
111m

food
76m

🚶 obesity 11m
／ diabetes 30m
🫀 heart disease 35m

disease
1390m

smallpox
500m

measles
200m

meningitis
190m

tuberculosis
150m

whooping cough
30m

influenza
30m

HIV
25m

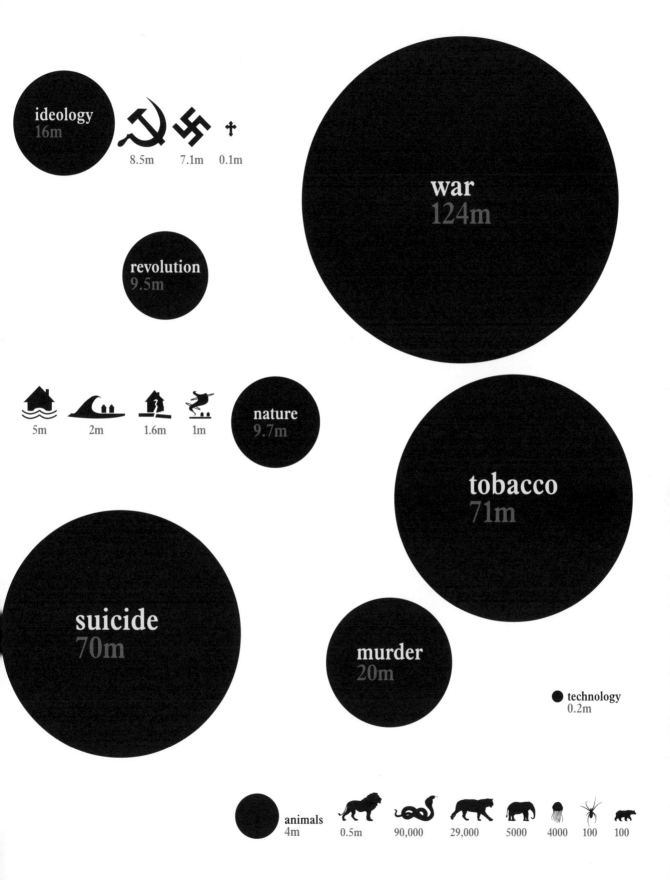

ideology
16m

8.5m 7.1m 0.1m

revolution
9.5m

war
124m

5m 2m 1.6m 1m

nature
9.7m

tobacco
71m

suicide
70m

murder
20m

technology
0.2m

animals
4m

0.5m 90,000 29,000 5000 4000 100 100

source: Internet and wikipedia. Data very coarse. Some guesswork and extrapolation

THE GLOBAL WARMING SCEPTICS

We don't believe there is any credible evidence that mankind's activities are the cause of global warming - if that's even happening at all. There's only circumstantial evidence of a link between carbon dioxide levels and rising global temperatures.

THE SCIENTIFIC CONSENSUS

The earth's climate is rapidly warming. The cause is a thickening layer of carbon dioxide pollution, caused by humanity's activities. It traps heat in the atmosphere, creating a "greenhouse effect" which heats the earth. A rise in global temperatures of 3 to 9 degrees will cause devastation.

Rising CO2 levels are not always linked with rising temperatures

Because of extreme weather, Arctic temperature is often a dramatic barometer of global climate. But the temperatures there match poorly with human CO2 emissions.

A single graph for a single small area is not enough evidence

You can't draw conclusions about the warming of the whole planet just by looking at a small area. It's like comparing apples and pears. It's impossible to tell what caused the warming of the Arctic in the 1930. Or whether it's the same mechanism that's causing global warming today.

Arctic temperature

CO² levels

fossil fuel usage

gas
oil
coal

1.0°C

0.0

-1.0°C

1880 1940 2000

source: Polyakov et al 2002. NASA

In the past, CO2 rises have occured after temperature rises

Recognise this from *The Inconvenient Truth*? Al Gore famously showed that temperature and CO2 are clearly linked back over 400,000 years. But if you zoom in....

...you see that CO2 levels rise 800 years after the temperature does. This massive lag proves that CO2 can't cause global warming!

We don't claim CO2 caused temperature rises in the past

We say, because of its greenhouse effect, CO2 makes natural temperature rises worse. Much worse in fact.

Historically, global warming cycles last 5000 years. The 800 year lag only shows that CO2 did not cause the first 16% of warming. The other 4200 years were likely to have been caused by a CO2 greenhouse effect.

Global temperatures

CO² levels

400 350 300 250 200 150 100 50 0

thousands of years ago

source: Vostok ice core, Petit et al 2002

800 years

5000 years

We don't even have accurate temperature records

90% of temperature recording stations are on land. 70% of the world's surface is ocean. Cities and towns heat the atmosphere around land-based weather stations enough to distort the record of historical temperatures. It's called the urban heat island effect. And it's why we can't trust temperature records.

We do have accurate temperature records

Distortion of temperature records is a very real phenomenon. But it's one climate scientists are well aware of. Detailed filters are used to remove the effect from the records.

Global weather recording stations

source: National Environmental Satellite Data and Information Service

It was actually hotter in medieval times than today

Between AD 800 and 1300 was a Medieval Warm Period where temperatures were very high. Grapes were grown in England. The Vikings colonized Greenland. This occurred centuries before we began pumping CO2 into the atmosphere.
More proof that CO2 and temperature are not linked. Because of this - and to make 20th century warming look unique - UN scientists constantly play down this medieval period in their data.

It was hotter in some areas of the world and not in others

This was likely a local warming, rather than a global warming, equivalent to warming today. Ice cores show us that there were periods of both cold and warmth at the time. And there's no evidence it affected the south hemisphere at all. The records also show that the earth may have been slightly cooler (by 0.03 degrees Celsius) during the 'medieval warm period' than today

source: NESDIS (smoothed data)

The famous "hockey stick" temperature graph has been discredited

Made famous by Al Gore, the "hockey stick" graph shows that 20th century temperatures are showing an alarming rise. But the hockey stick appears or disappears depending on the statistical methods employed. So unreliable has it become that the UN's International Panel On Climate Change dropped it from their 2007 report.

Reworked, enhanced versions still show the "hockey stick" shape

The hockey stick is 8 years old. There are dozens of other newer, more detailed temperature reconstructions. Each one is different due to different methods and data. But they all show similar striking patterns: the 20th century is the warmest of the entire record. And that warming is most dramatic after 1920 (when industrial activity starting releasing CO2 into the atmosphere).

The Original "Hockey Stick"

A Modern "Hockey Stick" Graph

source: Author's composite Briffa
Anmann & Wahl 2003 Mann 1998

THE GLOBAL WARMING SCEPTICS

THE SCIENTIFIC CONSENSUS

Ice core data is unreliable

A lot of our temperature records come from measuring the gases trapped in ice cores. These are segments of deep ice unmelted for hundreds of thousands of years. The trapped air inside acts as "photographs" of the contents of the atmosphere going back millennia. But ice-cores are not "closed systems" that preserve ancient air perfectly. Air can get in and out. Water can also absorb the gases, changing the result. And deep ice is under huge amounts of pressure. Enough to squeeze gas out. All in all this adds up to make ice cores unreliable.

Ice records are reliable.

Ice core data is taken from many different samples to reduce errors. Also, other evidence (temperature records, tree rings etc) back these readings up. All these results combined make the records very reliable.

The predictions of future global warming don't depend on ice cores. But ice cores do show that the climate is sensitive, changes in cycles and that CO2 has a strong influence.

Overall, CO2 levels from different ice cores are remarkably similar.

When the evidence doesn't fit, the scientists edit the evidence

Ice core data from Siple in the Arctic shows the concentrations of CO2 in the atmosphere in 1890 to be 328 parts per million. However, according to the consensus, that level was not reached until 1973. So the rise in CO2 levels happens 83 years too early.

To fix it, scientists moved the graph 83 years to the right to make the data exactly fit.

Scientists correct their results when new evidence comes to light

No other ice core data in the world shows CO2 levels rising above 290 parts per million in the last 650,000 years. It's possible it might have happened for a year or a day. But consistently, no.

Some areas of ice are more porous than others. At Siple, the more recent shallow ice was quite porous. So new air was able to circulate quite far down. That affected the record.

We detected and compensated for this. That's why the data has been shifted.

CO2 levels ice at Siple (Arctic)

the original data

the adjusted data

328 ppm

350

300

250

1744 1878 1891 1953 2000

Source: Neftel 1985, Friedli 1986

CO2 only stays in the atmosphere for 5 to 10 years, not the 50–200 years stated by UN scientists

The ocean absorbs the CO2 so it can't accumulate to dangerous levels in the atmosphere. In fact, the oceans are so vast they can absorb 50 times as much CO2 as there is in the atmosphere - more than all the fossil fuels on the planet!

Conclusion: humans can't have been emitting CO2 fast enough to account for all the extra CO2 in the atmosphere.

When you take the entire complex ocean-climate system into account 50-200 years is more accurate

CO2 is absorbed in 5 to 10 years by the *shallow* ocean. Not the deep ocean. It takes 50-200 years for CO2 to be mixed into the deep ocean where it stays. CO2 in the shallow ocean however is prone to escaping back into the atmosphere. So CO2 absorbed by the ocean often comes straight back out again.

Also the more carbon the ocean absorbs, the less it's able to absorb. It becomes saturated. It's a very complex process. But if you take the entire ocean-climate system, full absorption of atmospheric CO2 takes around 50,000 years.

CO² absorption by the oceans

CO²
atmos

shallow ocean — "fertilizer" for plankton · dissolved as carbonic acid — 5-10 years

deep ocean — dead plankton · shells, bones — 50-200 years

SCEPTICAL CONCLUSION

Man-made CO2 cannot be driving climate change

Whatever affects global temperatures and causes global warming is not CO2. Whatever the cause, it works like this. The cause affects the climate balance. Then the temperature changes accordingly. The oceans then adjust over a period of decades and centuries. Then the balance of CO2 in the atmosphere increases.

So the global panic about CO2 causing global warming is baseless and fear-mongering. The UN's reports on the matter are biased, unscientific and alarmist.

CONSENSUS CONCLUSION

Man-made CO2 is driving climate change this time.

We don't claim that greenhouse gases are the major cause of the ice ages and warming cycles. What drives climate change has long been believed to be the variation in the earth's orbit around the sun over thousands of years.

In a normal warming cycle, the sun heats the earth, the earth gets hotter. The oceans warm up releasing huge amounts of CO2. This creates a greenhouse effect that makes warming much, much more intense.

That's why humanity's release of CO2 is so perilous. We're out of step with the natural cycle. And we haven't even got to the stage where the oceans warm up.

Behind Every Great Man...
Dictators' wives

	Nadezhda Alliluyeva	Eva Braun	Yang Kaihui	Imelda Marcos	Mirjana (Mira) Markovic
Wife					
Husband	Stalin	Hitler	Mao	Marcos	Milosevic
Pre-marital occupation	clerk	assistant and model	communist!	beauty queen	professor of sociology
How they met	her father sheltered Stalin in 1911 after he escaped from Siberian exile	she was assistant to his personal photographer	her father was Mao's teacher	whirlwind courtship during "holy week"	at school, she borrowed his card to rent *Antigone* from the library, Oh yeah?
Years of marriage	13	about 40 minutes	8	35	32
Children	2		3	4	2
Rumoured quality of marriage	strained and violent	changeable	troubled	good	very good
Political power rating	none	(1 fist)	none	(4 fists)	(3 fists)
Key governmental roles	none	none	prominent female member of party	Governor of Manila, Ambassador plenipotentiary	puppet-master, leader of "Yugoslav United Left"
Style rating	none	(4 shoes)	(4 shoes)	(5 shoes)	(5 shoes)
Nickname	none	The Rolleiflex Girl	none	The Steel Butterfly	The Red Witch
Notable talents	none - super dull	photography, athletics	very intelligent	none	politics
Trademark/idiosyncracy	left-handed	nude sunbathing	feminist	very ostentatious and flamboyant	would berate her husband in front of state officials, wore only black Versace
Obsessions and pathologies	suicide	lots of make-up	good communitists don't covet material things	shoes, clothes, paintings	media products, plastic surgeons, rich friends
Most salacious rumour	she was Stalin's daughter	she was pregnant when she died OR she didn't sleep in the same room as Hitler	said she would have killed herself when she and Mao divorced if she didn't have kids	sent a plane to pick up white sand from Australia for her beach resort	ordered the murder of Ivan Stambolic, a rival to her husband. Had at least four officials killed after they disagreed with her. Disappeared a journalist who criticised her.
Reason for death	officially "appendicitis" - really, shot	suicide - bit into a cyanide capsule	publicly executed by the Nationalists	still alive	still alive

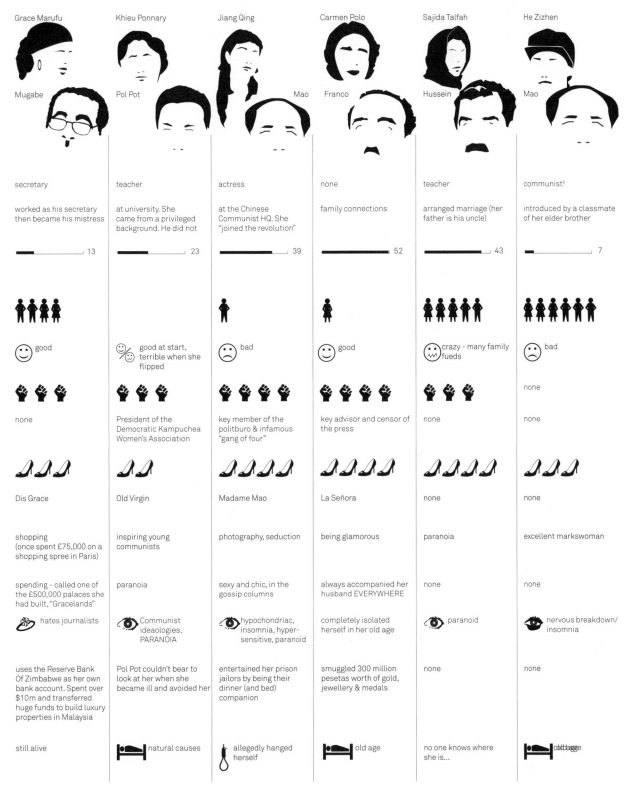

Grace Marufu / Mugabe

secretary

worked as his secretary then became his mistress

———— 13

:) good

Dis Grace

shopping (once spent £75,000 on a shopping spree in Paris)

spending - called one of the £500,000 palaces she had built, "Gracelands"

hates journalists

uses the Reserve Bank Of Zimbabwe as her own bank account. Spent over $10m and transferred huge funds to build luxury properties in Malaysia

still alive

Khieu Ponnary / Pol Pot

teacher

at university. She came from a privileged background. He did not

———— 23

:) good at start, terrible when she flipped

President of the Democratic Kampuchea Women's Association

Old Virgin

inspiring young communists

paranoia

Communist ideaologies, PARANOIA

Pol Pot couldn't bear to look at her when she became ill and avoided her

natural causes

Jiang Qing / Mao

actress

at the Chinese Communist HQ. She "joined the revolution"

———— 39

:(bad

key member of the politburo & infamous "gang of four"

Madame Mao

photography, seduction

sexy and chic, in the gossip columns

hypochondriac, insomnia, hyper-sensitive, paranoid

entertained her prison jailors by being their dinner (and bed) companion

allegedly hanged herself

Carmen Polo / Franco

family connections

———— 52

:) good

key advisor and censor of the press

La Señora

being glamorous

always accompanied her husband EVERYWHERE

completely isolated herself in her old age

smuggled 300 million pesetas worth of gold, jewellery & medals

old age

Sajida Talfah / Hussein

teacher

arranged marriage (her father is his uncle)

———— 43

crazy - many family fueds

paranoia

paranoid

no one knows where she is...

He Zizhen / Mao

communist!

introduced by a classmate of her elder brother

———— 7

:(bad

excellent markswoman

nervous breakdown/ insomnia

old age

source: Wikipedia

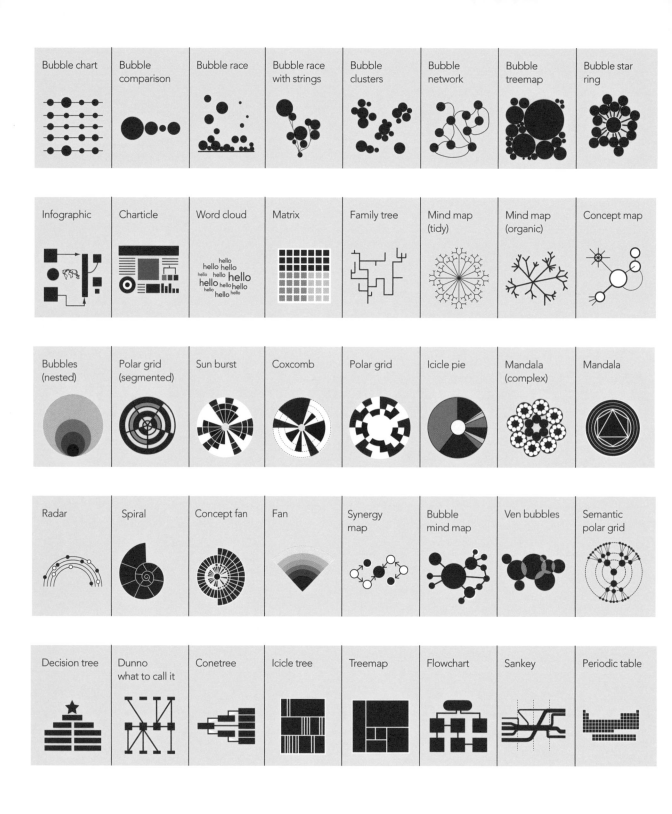

Types of Information Visualization

source: Edward Tufte, visual-literarcy.org

Pass the...

A table of condiments that periodically go bad

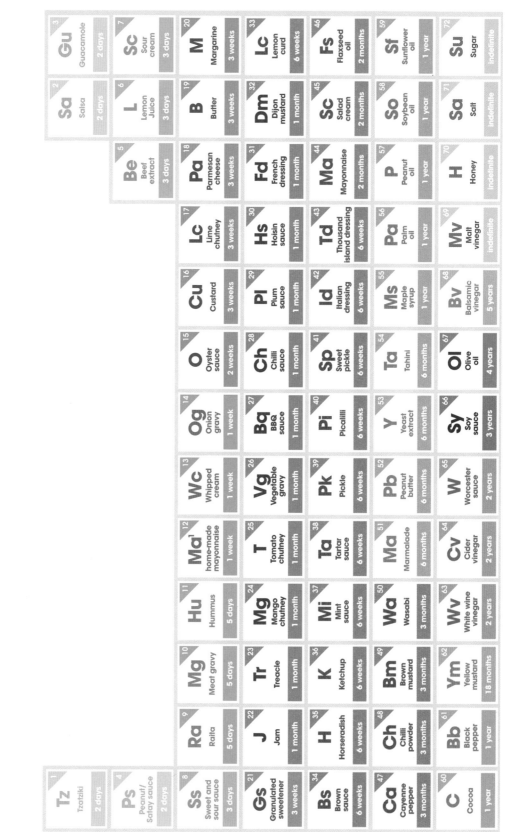

idea: Internet Apocryphal // source: Google

NATURE vs. NURTURE

NATURE

Your genes control everything. Hair colour. Behaviour. Intelligence. Personality. Sure, environment has a role, but it's your genes that rule you.

NURTURE

You learn pretty much everything you do. From standing and walking to talking and socializing. Your environment and your choices make you who you are…

NURTURE: The evidence for that ancient lifestyle is complete guesswork.

NATURE: Most behaviour is genetic. Genes for speech, empathy and even altruism all evolved when we lived as hunter-gatherers on the ancient grasslands of Africa.

NURTURE: Nah. Those "structures" could simply be projections of human interpretation on the brain. Behavior isn't genetically evolved. We learn it.

NATURE: The proof is in the brain. It has evolved "modules" for all human abilities, even for religious experience!

NURTURE: Dogs, maybe. But complex human behaviour like musical ability or humour? C'mon. These are learnt. In fact, learning, we now know, changes the physical structure of the brain! So much for genes.

NATURE: Oh yeah? Animal breeders know it takes only a few generations of controlled mating to influence behaviours like fierceness or tameness in dogs.

NURTURE: Most genetic expression, from traits to behaviours, are triggered by your environment. Nurture comes first!

NATURE: Genes change the brain too. And at a more fundamental level, before your so-called "choices" come in. Try "deciding" to override a genetic expression. You can't! Hah!

NURTURE: Yeah it's fashionable to say that yes. But, even after years of study, researchers have failed to turn up a single gene for mental illness or depression.

NATURE: Okay then, what about behavioural problems such as depression, mental illness and autism? They're all highly inheritable.

Ahhhh, but behavioural disorders like autism are highly inheritable. In identical twins, if one twin is autistic, the other has a 60% chance of being autistic. In non-identical twins the chance is only 5%. That goes for intelligence too.

In autism, maybe. But you can't then stretch it to all behaviour and certainly not intelligence. Intelligent parents *teach* their kids to be intelligent.

But don't intelligent parents also provide the genes for high IQ? Twins separated at birth are often remarkably similar in IQ and personality, even when they haven't met. This proves there are genetic influences for everything. Even taste in music!

Yeah but if it was all genes, you'd expect identical twins to be 100% the same. Figures for IQ may be high. But it's way less to non-existent for other traits like personality.

But identical twins reared apart become more alike, even when they haven't met. That means that genes must shape our personalities.

Hmmmmmm. Many studies of twins are flawed and biased. Often they just compare identical twins reared apart after birth. They don't use "controls" of unrelated people with the same background as the twins to check that age, gender, ethnicity and cultural environment are not also influencing personality. The whole field is biased.

Pffff.

Grrrrr!

CONCLUSION
50-50

Both nature and nurture each contribute (in arguable proportions) to who we are. They also "speak the same language". That is, they both change the structure of the brain. In summary, humans are dynamic creative organisms. Learning and experience amplify the effect of genes on behaviour.

source: Skeptic.com

Postmodernism

Postmodernism is pretty much a buzz word now. Anything – and everything – can be described as postmodern now. The design of a building. The samples used in a record. The layout of a page. The collective mood of a generation. Cultural or political fragmentation. The rise of blogging and crowd-wisdom. Anything that starts with the word "meta". But what does it mean?

In art, where it all began, it's a style of sorts. Ironic and parodying. Very playful and very knowing. Knowing of history, culture, and often knowing of itself. Postmodern art and entertainment is often self-conscious. It calls attention to itself as a piece of art, or a production, or something constructed. A character who knows they are a character in a novel, for example. Or even the appearance of an author in their own book. (Like me, David, writing this. Hello.)

Overall, postmodern art says there's no difference between refined and popular culture, "high" or "low" brow. It rejects genres and hierarchies. Instead, it embraces complexity, contradiction, ambiguity, diversity, interconnectedness, and criss-crossing referentiality.

The idea is: let's not pretend that art can make meaning or is even meaningful. Let's just play with nonsense.

All of this springs from the discovery of a new relationship to truth. In a postmodern perspective, truth is a not single thing "out there" to be discovered. Instead truth must be assembled or constructed. Sometimes, it's constructed visibly, from many different components (i.e. scientists gathering results of multiple studies). Other times, it happens invisibly by society, or by cultural mechanisms and other processes that can't be easily seen by the individual.

So when somone "speaks the truth", what they are saying is actually an assemblage of their schooling, their cultural background, and the thoughts and opinions they've absorbed from their environment. In a way, you could say that their culture is speaking through them.

For that reason, it becomes more accurate and safer, in postmodern times, to assemble truth with the help of other people, rather than just decide it independently.

A clear example of this is the scientific method. Any scientist can do an experiment and declare a discovery about the world. But teams of other scientists must verify or "peer-review" that truth before it's safe to accept it. The truth here has been assembled by many people.

All the time, though, there is an understanding that even this final "truth" may well just be temporary or convenient, a place-holder to be changed or binned later on. (Well, that *should* be the case. Even scientific discoveries have a tendency to harden into dogma.)

If you accept this key postmodern insight, then immediately it becomes impossible for any individual to have a superior belief. There's no such thing as "absolute truth". No one "knows" the truth. Or can have a better truth than someone else. If an individual – or a group, organization or government – does claims to have truth and declares that truth to you, they are likely to be attempting to overpower and control you.

Confusingly, these kinds of entities are known as "Modernist". Modernity is all about order and rationality. The more ordered a society is, Modernists believe, the better it functions. If "order" is superior, then anything that promotes "disorder" has to be wrong. Taken to an extreme, that means anything different from the norm – ideas, beliefs, people – must be excluded. Or even destroyed. In the history of Western culture this

has usually meant anyone non-white, non-male, non-heterosexual and non-rational.

This is one reason why tension still erupts between holders of "absolute truth" (say the Church) and postmodern secular societies. Or between an entity like an undemocratic government which seeks to control its populace and the internet, a truly postmodern piece of technology. This is because postmodernity has a powerful weapon that can very easily and very quickly corrode Modernist structures built on "old-fashioned" absolute truth: *deconstruction*.

If all truth is constructed, then deconstruction becomes useful. Really useful. If you deconstruct something, its meanings, intentions and agendas separate and rise to the surface very quickly – and everything quickly unravels.

Take a novel for example. You can deconstruct the structure of the text, and the personality of the characters. Then you can deconstruct the author's life story, their psychological background, and their culture and see how that influenced the text. If you keep going, you can start on the structure of human language and thought. Beyond that, a vast layer of human symbols. Beyond that ... well, you can just keep going...

Belief systems and modernist structures protect themselves from threats like deconstruction with "grand narratives". These are compelling stories to explain and justify why a certain belief system exists. They work to gloss over and mask the contradictions, instabilities and general "scariness" inherent in nature and human life.

Liberate the entire working class. Peace on Earth. There is one true God. Hollywood is one big happy family. History is progress. One day we will know everything. These are all grand narratives.

All modern societies – even those based on science – depend on these myths. Postmodernism rejects them on principle. Instead it goes for "mini-narratives", stories that explain small local events – all with an awareness that any situation, no matter how small, reflects in some way the global pattern of things. Think global, act local, basically.

So a postmodern society, unglossed-over by a grand narrative, must embrace the values of postmodernity as its key values. That means that complexity, diversity, contradiction, ambiguity, and interconnectedness all become central. In social terms that means a lack of obvious hierarchies (equal rights for all), embracing diversity (multi-culturalism), and that all voices should be heard (consensus). Interconnectedness is reflected in our technology and communications. In the 21st century anything that cannot be stored by a computer ceases to be knowledge.

That's the goal anyway. There are pitfalls. Runaway postmodernism creates a grey goo of no-meaning. Infinite consensus creates paralysis. Over-connection leads to saturation. Too much diversity leads to disconnection. Complexity to confusion.

So in the midst of all this confusion and noise and diversity, without a grand narrative, who are you? Postmodern personal values are not moral but instead values of participation, self-expression, creativity. The focus of spirituality shifts from security in absolute given truth to a search for significance in a chaotic world. The idea that there is anything stable or permanent disappears. The floor drops away. And you are left there, playing with nonsense.

source: constructed from Wikipedia, an essay by Mary Klages, University of Colorado, Wisegeek.com

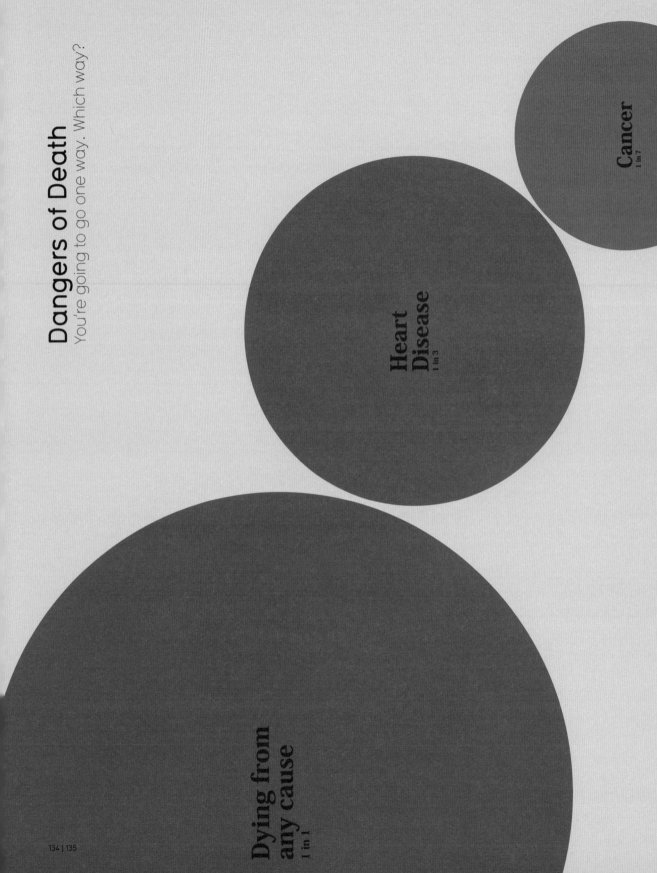

Dangers of Death
You're going to go one way. Which way?

Cancer
1 in 7

Heart Disease
1 in 3

Dying from any cause
1 in 1

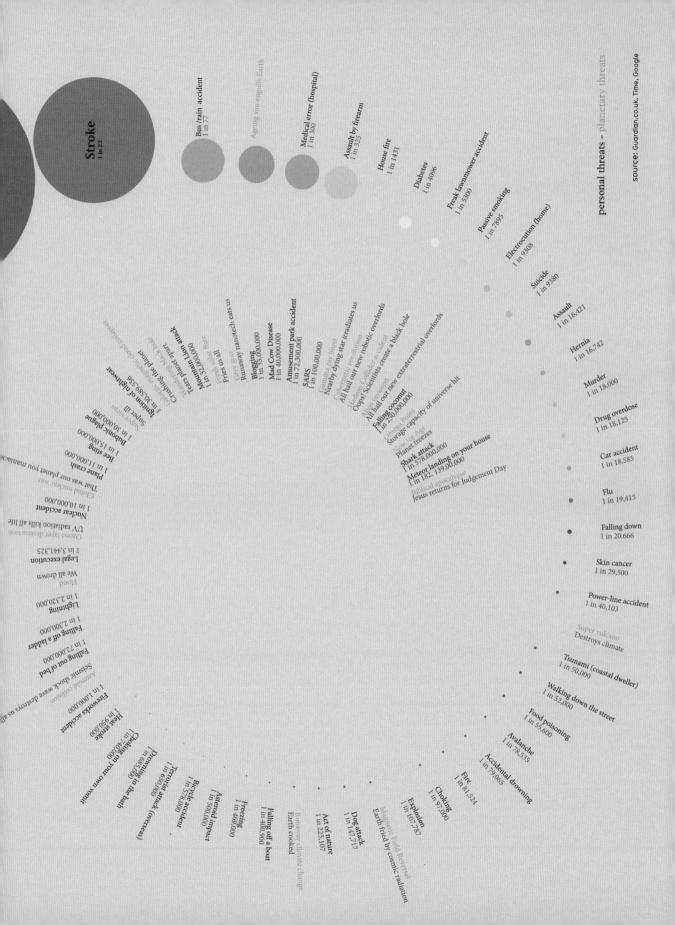

Stroke
1 in 23

Bus /train accident
1 in 77

Ageing sun engulfs Earth

Medical error (hospital)
1 in 300

Assault by firearm
1 in 325

House fire
1 in 1431

Diabetes
1 in 4096

Freak lawnmower accident
1 in 5300

Passive smoking
1 in 7895

Electrocution (home)
1 in 9308

Suicide
1 in 9380

Assault
1 in 16,421

Hernia
1 in 16,742

Murder
1 in 18,000

Drug overdose
1 in 18,125

Car accident
1 in 18,585

Flu
1 in 19,415

Falling down
1 in 20,666

Skin cancer
1 in 29,500

Power-line accident
1 in 40,103

Super volcano
Destroys climate

Tsunami (coastal dweller)
1 in 50,000

Walking down the street
1 in 52,000

Food poisoning
1 in 55,600

Avalanche
1 in 78,535

Accidental drowning
1 in 79,065

Fire
1 in 81,524

Choking
1 in 97,000

Explosion
1 in 107,787

Magnetic Field Reversal
Earth fried by cosmic radiation

Dog attack
1 in 147,717

Runaway climate change
Earth cooked

Act of nature
1 in 225,107

Falling off a boat
1 in 400,900

Freezing
1 in 469,000

Asteroid impact
1 in 500,000

Bicycle accident
1 in 578,000

Terrorist attack (overseas)
1 in 650,000

Drowning in the bath
1 in 685,500

Drowning in your own vomit
1 in 740,000

Choking on your vomit
1 in 950,000

Heat stroke
1 in 1,000,000

Fireworks accident
1 in 1,000,000

Asteroid collision
Seismic shock wave destroys us all

Falling out of bed
1 in 72,000

Falling off a ladder
1 in 2,300,000

Lightning
1 in 2,320,000

Flood
We all drown

Legal execution
1 in 3,441,325

Ozone layer destruction
UV radiation kills all life

Nuclear accident
1 in 10,000,000

Global nuclear war
That was our planet you maniacs

Plane crash
1 in 11,000,000

Bee sting
1 in 15,000,000

Bubonic plague
1 in 30,000,000

Super virus
Ill

Ignition of nightwear
1 in 30,589,556

Galactic black hole
Crushing the planet

Windmill black hole
Tears planet apart

Mountain Lion attack
1 in 32,000,000

Freak solar flare
Fries us all

Grey goo
Runaway nanotech eats us

Blogging
1 in 35,000,000

Mad Cow Disease
1 in 40,000,000

Amusement park accident
1 in 72,300,000

SARS
1 in 100,00,000

Gamma ray burst
Nearby dying star irradiates us

Cybernetic revolution
All hail our new robotic overlords

Hadron Collider accident
Oops! Scientists create a black hole

Alien invasion
All hail our new extraterrestrial overlords

Falling coconut
1 in 250,000,000

Omega Point
Storage capacity of universe hit

New Ice Age
Planet freezes

Shark attack
1 in 578,000,000

Meteor landing on your house
1 in 182, 139,00,000

Biblical apocalypse
Jesus returns for Judgement Day

personal threats – planetary threats

source: Guardian.co.uk, Time, Google

Google Insights
The intensity of certain search terms compared

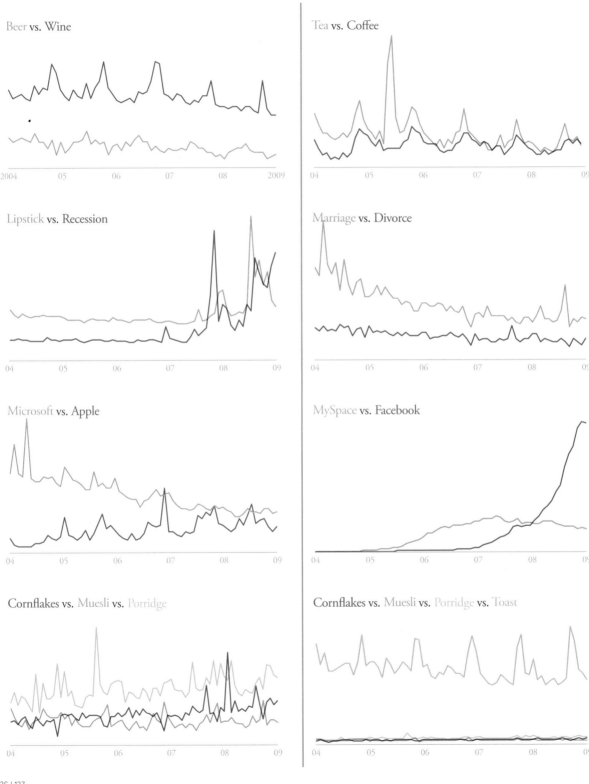

Beer vs. Wine

Tea vs. Coffee

Lipstick vs. Recession

Marriage vs. Divorce

Microsoft vs. Apple

MySpace vs. Facebook

Cornflakes vs. Muesli vs. Porridge

Cornflakes vs. Muesli vs. Porridge vs. Toast

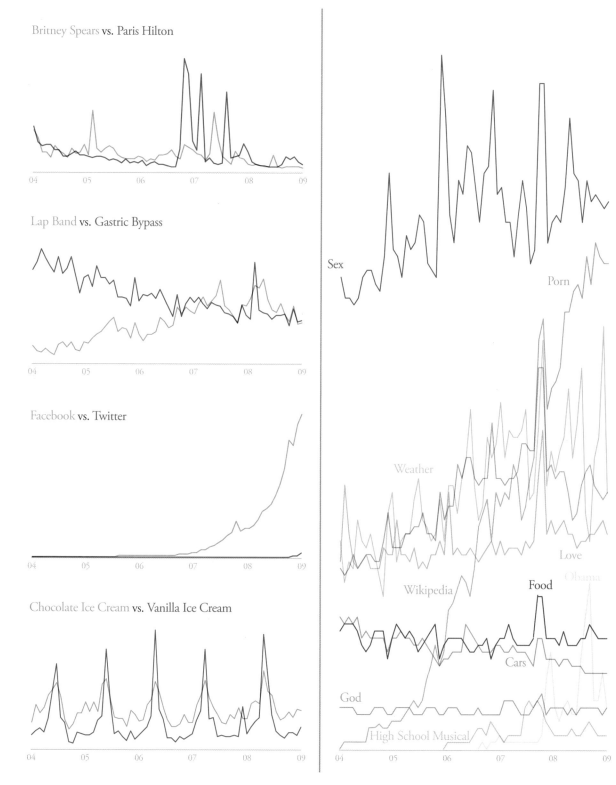

What's Better Than Sex?
PTO for the answer

Britney Spears vs. Paris Hilton

04 05 06 07 08 09

Lap Band vs. Gastric Bypass

04 05 06 07 08 09

Facebook vs. Twitter

04 05 06 07 08 09

Chocolate Ice Cream vs. Vanilla Ice Cream

04 05 06 07 08 09

Sex

Porn

Weather

Love

Wikipedia

Food

Obama

Cars

God

High School Musical

04 05 06 07 08 09

source: Google Insights

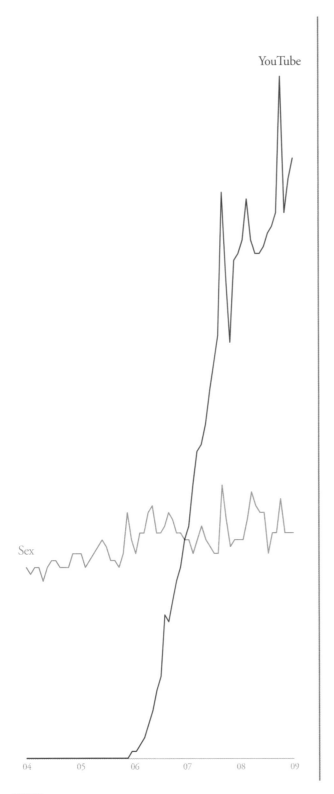

YouTube

Sex

04 05 06 07 08 09

Kyoto Targets

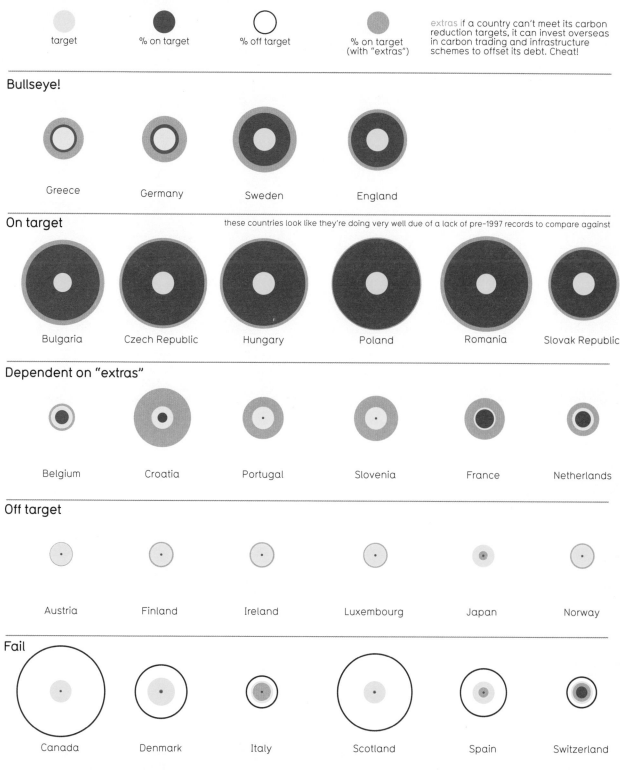

target

% on target

% off target

% on target
(with "extras")

extras if a country can't meet its carbon
reduction targets, it can invest overseas
in carbon trading and infrastructure
schemes to offset its debt. Cheat!

Bullseye!

Greece

Germany

Sweden

England

On target

these countries look like they're doing very well due of a lack of pre-1997 records to compare against

Bulgaria

Czech Republic

Hungary

Poland

Romania

Slovak Republic

Dependent on "extras"

Belgium

Croatia

Portugal

Slovenia

France

Netherlands

Off target

Austria

Finland

Ireland

Luxembourg

Japan

Norway

Fail

Canada

Denmark

Italy

Scotland

Spain

Switzerland

Despite Kyoto, the EU's carbon emmissions will increase by 1% by 2012

source: European Environment Agency

The Varieties of Romantic Relationship

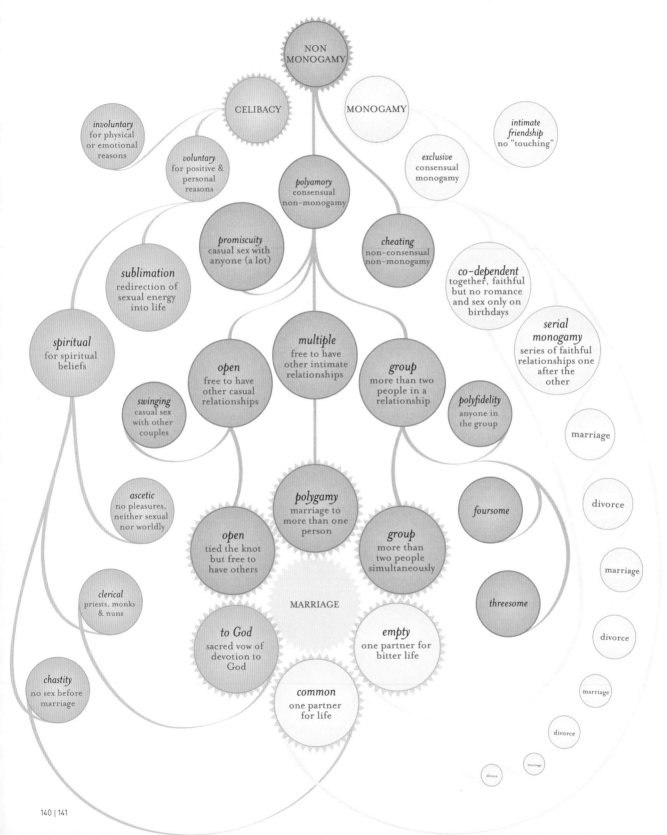

NON MONOGAMY

CELIBACY

MONOGAMY

involuntary
for physical
or emotional
reasons

voluntary
for positive &
personal
reasons

*intimate
friendship*
no "touching"

exclusive
consensual
monogamy

polyamory
consensual
non-monogamy

promiscuity
casual sex with
anyone (a lot)

cheating
non-consensual
non-monogamy

sublimation
redirection of
sexual energy
into life

co-dependent
together, faithful
but no romance
and sex only on
birthdays

spiritual
for spiritual
beliefs

multiple
free to have
other intimate
relationships

*serial
monogamy*
series of faithful
relationships one
after the
other

open
free to have
other casual
relationships

group
more than two
people in a
relationship

swinging
casual sex
with other
couples

polyfidelity
anyone in
the group

marriage

ascetic
no pleasures,
neither sexual
nor worldly

divorce

polygamy
marriage to
more than one
person

foursome

open
tied the knot
but free to
have others

group
more than
two people
simultaneously

marriage

clerical
priests, monks
& nuns

threesome

MARRIAGE

divorce

to God
sacred vow of
devotion to
God

empty
one partner for
bitter life

chastity
no sex before
marriage

common
one partner
for life

marriage

divorce

marriage

divorce

The Evolution of Marriage in the West

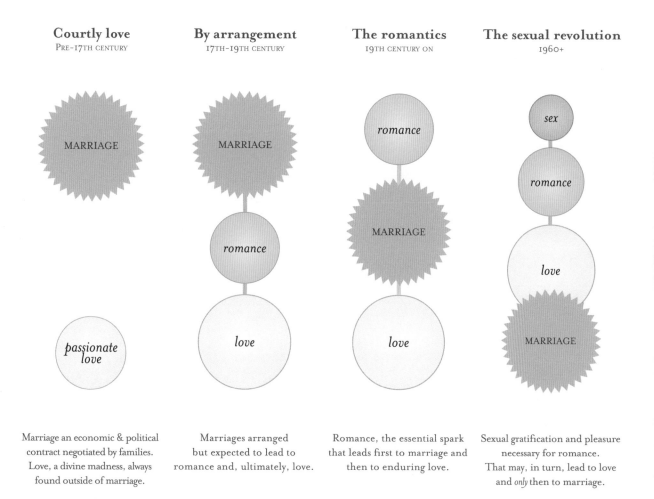

Courtly love	By arrangement	The romantics	The sexual revolution
PRE-17TH CENTURY	17TH-19TH CENTURY	19TH CENTURY ON	1960+

MARRIAGE

MARRIAGE

romance

sex

romance

MARRIAGE

romance

passionate love

love

love

love

MARRIAGE

Marriage an economic & political contract negotiated by families. Love, a divine madness, always found outside of marriage.

Marriages arranged but expected to lead to romance and, ultimately, love.

Romance, the essential spark that leads first to marriage and then to enduring love.

Sexual gratification and pleasure necessary for romance. That may, in turn, lead to love and *only* then to marriage.

source: Wikipedia

30 Years Makes A Difference

LAKE CHAD

THE ARAL SEA

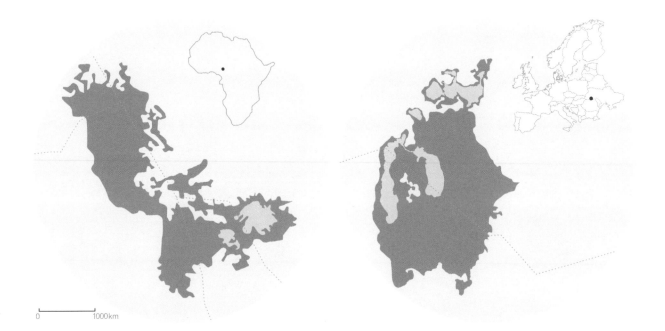

0 1000km

OZONE HOLE

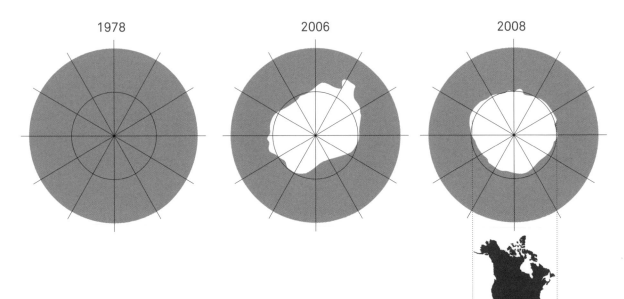

1978 2006 2008

NORTH POLAR ICE CAP

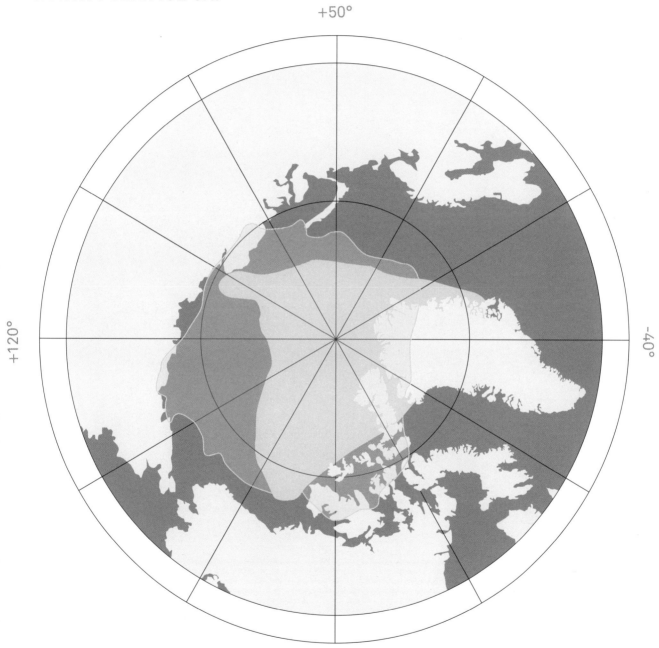

+50°

+120°

-40°

-130°

source: NASA

.com china.de china.org china.org.cn cisco.com clarin.com cnn.com collegehumor.com crailtap.com cyberpresse.ca dagbladet.no dailykos.com dailymotion.com de.wikipedia.org delfi.lt democr
nomist.com ehowa.com ehrensenf.de elmundo.es elotrolado.net elpais.com elpais.es en.wikipedia.org en.wikipedia.org/wiki/tiananmen_square_protests_of_1989 english.gov.cn espn.com express
gamespot.com gay.com gayromeo.com geenstijl.nl globo.com google.be google.ca google.ch google.cn google.co.uk google.com google.com.cn google.de google.es google.fr google.it google
mail.com hp.com hs.fi ya.ru ibm.com idealista.com ign.com imdb.com index.hu indymedia.org infowars.com itchmo.com lachschon.de lamermelculo.com last.fm lds.org lemonde.fr level.ro libertad
clip.com mitbbs.com msn.com msnbc.com myspace.com nasa.gov nba.com neopets.com newgrounds.com news.bbc.co.uk nhl.com nintendo.com nu.nl nytimes.com on.net.mk one.lt onet.pl or
o-canada.ca reddragon.pl rense.com repubblica.it runescape.com sapo.pt seznam.cz sina.com skype.com slashdot.org sohu.com somethingawful.com sony.com spiegel.de stern.de studivz.de s
.br usa.com usa.gov userfriendly.org vatican.va vg.no washingtonpost.com web.de wenxuecity.com whatreallyhappened.com whitehouse.com whitehouse.gov whitehouse.org wikipedia.com wiki
o yahoo.com yahoo.com.cn yahoo.com.hk yahoo.com.tw yahoo.fr yandex.ru yle.fi youtube.com ytmnd.com zh.wikipedia.org 01net.com 163.com 2ch.net 4chan.org 6park.com addictinggames.com
apunto.com bbc.co.uk bbc.com bbspot.com bebo.com bild.de blogger.com boingboing.net bundesregierung.de bundestag.de cbc.ca china.ch china.cn china.com china.de china.org china.org.c
motion.de.wikipedia.org delfi.lt democracy.com democraticunderground.com deviantart.com digg.com dirty.ru disney.com dn.se drudgereport.com e-gold.com ebaumsworld.com ebay.com
anmen_square_protests_of_1989 english.gov.cn espn.com expressen.se facebook.com fark.com fbi.gov flickr.com fok.nl fotolog.com foxnews.com free.fr freerepublic.com freetibet.org friendster.c
gle.co.uk google.com google.com.cn google.de google.es google.fr google.it google.nl google.pl google.se gov.cn greatfirewallofchina.org greatwallofchina.org greenpeace.org guardian.co.uk hat
media.org infowars.com itchmo.com lachschon.de lamermelculo.com last.fm lds.org lemonde.fr level.ro libertaddigital.com livejournal.com lunarstorm.se maddox.xmission.com mail.ru marca
n.gov nba.com neopets.com newgrounds.com news.bbc.co.uk nhl.com nintendo.com nu.nl nytimes.com on.net.mk one.lt onet.pl orf.at orkut.com parano.be penny-arcade.com perezhilton.com p
bblica.it runescape.com sapo.pt seznam.cz sina.com skype.com slashdot.org sohu.com somethingawful.com sony.com spiegel.de stern.de studivz.de suchar.net svd.se svt.se tagesschau.de teri
gov userfriendly.org vatican.va vg.no washingtonpost.com web.de wenxuecity.com whatreallyhappened.com whitehouse.com whitehouse.gov whitehouse.org wikipedia.com wikipedia.de wikipe
oo.com yahoo.com.cn yahoo.com.hk yahoo.com.tw yahoo.fr yandex.ru yle.fi youtube.com ytmnd.com zh.wikipedia.org 01net.com 163.com 2ch.net 4chan.org 6park.com addictinggames.com aft
om asahi.com barrapunto.com bbc.co.uk bbc.com bbspot.com bebo.com bild.de blogger.com boingboing.net bundesregierung.de bundestag.de cbc.ca china.ch china.cn china.com china.de china.ch
bladet.no dailykos.com dailymotion.com de.wikipedia.org delfi.lt democracy.com democraticunderground.
undo.es elotrolado.net elpais.com elpais.es en.wikipedia.org en.wikipedia.org/wiki/tiananmen_square_
tibet.org friendster.com gaiaonline.com gamefaqs.com gamespot.com gay.com gayromeo.com geenstijl.
gle.se gov.cn greatfirewallofchina.org greatwallofchina.org greenpeace.org guardian.co.uk hattrick.org
infowars.com itchmo.com lachschon.de lamermelculo.com last.fm lds.org lemonde.fr level.ro
atokyo.com meneame.net microsoft.com miniclip.com mitbbs.com msn.com msnbc.com
on.net.mk one.lt onet.pl orf.at orkut.com parano.be penny-arcade.com perezhilton.com
nse.com repubblica.it runescape.com sapo.pt seznam.cz sina.com skype.com slashdot.
erra.com.br terra.es theonion.com thoonsen.com tibet.com traffic4u.nl tw.yahoo.com
xuecity.com whatreallyhappened.com whitehouse.com whitehouse.gov whitehouse.
.com xanga.com yahoo.cn yahoo.co.jp yahoo.com yahoo.com.cn yahoo.com.hk
net 4chan.org 6park.com addictinggames.com aftonbladet.se amazon.com
om asahi.com barrapunto.com bbc.co.uk bbc.com bbspot.com bebo.
bc.ca china.ch china.cn china.com china.de china.org china.org.cn
erpresse.ca dagbladet.no dailykos.com dailymotion.com de.wikipedia.
antart.com digg.com dirty.ru disney.com dn.se drudgereport.com e-gold.
wa.com ehrensenf.de elmundo.es elotrolado.net elpais.com elpais.
anmen_square_protests_of_1989 english.gov.cn espn.com expressen.se
fark.com fbi.gov flickr.com fok.nl fotolog.com foxnews.com free.
epublic.com freetibet.org friendster.com gaiaonline.com gamefaqs.com
espot.com gay.com gayromeo.com geenstijl.nl globo.com google.be
gle.ca google.ch google.cn google.co.uk google.com google.
n.cn google.de google.es google.fr google.it google.nl
gle.pl google.se gov.cn greatfirewallofchina.org
twallofchina.org greenpeace.org guardian.
k hattrick.org heise.de hi5.com homestar
ner.com hotmail.com hp.com hs.fi ya.ru ibm.
idealista.com ign.com imdb.com index.hu
media.org infowars.com itchmo.com
schon.de lamermelculo.com last.fm lds.org
onde.fr level.ro libertaddigital.com livejournal.
lunarstorm.se maddox.xmission.com mail.ru
ca.com marca.es mcdonalds.com megatokyo.
meneame.net microsoft.com miniclip.com
obs.com msn.com msnbc.com myspace.com nasa.
nba.com neopets.com newgrounds.com news.bbc.co.
hl.com nintendo.com nu.nl nytimes.com on.net.mk one.lt
.pl orf.at orkut.com parano.be penny-arcade.com perezhilton.
photobucket.com politicallyincorrect.de prisonplanet.com
epwnage.com racocatala.cat radio-canada.ca reddragon.pl rense.
n repubblica.it runescape.com sapo.pt seznam.cz sina.com skype.
slashdot.org sohu.com somethingawful.com sony.com spiegel.de
n.de studivz.de suchar.net svd.se svt.se tagesschau.de terra.
erra.es theonion.com thoonsen.com tibet.com traffic4u.nl tw.
oo.com tweakers.net un.org uol.com.br usa.com usa.gov
friendly.org vatican.va vg.no washingtonpost.com web.de
xuecity.com whatreallyhappened.com whitehouse.com whitehouse.
whitehouse.org wikipedia.com wikipedia.de wikipedia.org wordpress.
worldofwarcraft.com wow-europe.com wp.pl wretch.cc wwe.com xanga.
yahoo.cn yahoo.co.jp yahoo.com yahoo.com.cn yahoo.com.hk yahoo.com.
ahoo.fr yandex.ru yle.fi youtube.com ytmnd.com zh.wikipedia.org 01net.com 163.
2ch.net 4chan.org 6park.com addictinggames.com aftonbladet.se amazon.com
esty.com amnesty.org amnestyinternational.org antro.cl aol.com apple.com as.com asahi.com
apunto.com bbc.co.uk bbc.com bbspot.com bebo.com bild.de blogger.com boingboing.net
desregierung.de bundestag.de cbc.ca china.ch china.cn china.com china.de china.org china.org.cn
o.com clarin.com cnn.com collegehumor.com crailtap.com cyberpresse.ca dagbladet.no dailykos.com
de.wikipedia.org delfi.lt democracy.com democraticunderground.com deviantart.com digg.com dirty.ru disney.com dn.se drudgereport.com e-gold.com
ebaumsworld.com ebay.com ebay.de economist.com ehowa.com ehrensenf.de elmundo.es elotrolado.net elpais.com elpais.es en.wikipedia.org
en.wikipedia.org/wiki/tiananmen_square_protests_of_1989 english.gov.cn espn.com expressen.se facebook.com fark.com fbi.gov flickr.com
fok.nl fotolog.com foxnews.com free.fr freerepublic.com freetibet.org friendster.com gaiaonline.com gamefaqs.com gamespot.com gay.com
gayromeo.com geenstijl.nl globo.com google.be google.ca google.ch google.cn google.co.uk google.com google.com.cn google.de
google.es google.fr google.it google.nl google.pl google.se gov.cn greatfirewallofchina.org greatwallofchina.org greenpeace.org
guardian.co.uk hattrick.org heise.de hi5.com homestarrunner.com hotmail.com hp.com hs.fi ya.ru ibm.com idealista.com ign.com
imdb.com index.hu indymedia.org infowars.com itchmo.com lachschon.de lamermelculo.com last.fm lds.org lemonde.fr level.ro
libertaddigital.com livejournal.com lunarstorm.se maddox.xmission.com mail.ru marca.
megatokyo.com meneame.net microsoft.com miniclip.com mitbbs.
myspace.com nasa.gov nba.com neopets.com newgrounds.
nu.nl nytimes.com on.net.mk one.lt onet.pl orf.at orkut.com
photobucket.com politicallyincorrect.de prisonplanet.com
pl rense.com repubblica.it runescape.com sapo.pt
somethingawful.com sony.com spiegel.de stern.de
com.br terra.es theonion.com thoonsen.com tibet.
uol.com.br usa.com usa.gov userfriendly.
wenxuecity.com whatreallyhappened.
wikipedia.com wikipedia.de wikipedia.
europe.com wp.pl wretch.cc wwe.
com yahoo.com.cn yahoo.
youtube.com ytmnd.com

"buddha stretches a thousand hands" / "censorship jail" / "chinese central propaganda department" / "chinese democracy movement" / "brutal torture" / "user" / "brain wash" / "blocking" / "anti-society" / "anti-communist" / "gedhun choekyi nyima" / "genocide" / "hong zhi" / "human rights" / "june 4th" / "lun gong" / "mein kam pf" / "news black out" / "no-limit browser" / "oppression" / "persecution" / "political dissident" / "red terror" / "re-educa...

protests_of_1989 english.gov.cn espn.com expressen.se facebook.
nl globo.com google.ca google.ch google.cn google.co.
heise.de hi5.com homestarrunner.com hotmail.com hp.com h
libertaddigital.com livejournal.com lunarstorm.se maddox.
myspace.com nasa.gov nba.com neopets.com newgrou
photobucket.com politicallyincorrect.de prisonplanet.c
org sohu.com somethingawful.com sony.com spiegel
tweakers.net un.org uol.com.br usa.com usa.gov use
org wikipedia.com wikipedia.de wikipedia.org word
yahoo.com.tw yahoo.fr yandex.ru yle.fi y
amnesty.com amnesty.org amnesty
com bild.de blogger.com boingb
cisco.com clarin.com cnn.com
org delfi.lt democracy.com de
com ebaumsworld.com ebay
es en.wikipe

com marca.es mcdonalds.
com msn.com msnbc.com
com news.bbc.co.uk nhl.com
parano.be penny-arcade.com per
purepwnage.com racocatala.cat radio-canada.
seznam.cz sina.com skype.com slashdot.org
studivz.de suchar.net svd.se svt.se tagessch
com traffic4u.nl tw.yahoo.com tweakers.ne
org vatican.va vg.no washingtonpost.com
com whitehouse.com whitehouse.gov wh
org wordpress.com worldofwarc
com xanga.com yahoo.co
com.hk yahoo.com.tw yahoo.com.tw yahoo.com
zh.wikipedia.org 01net.co

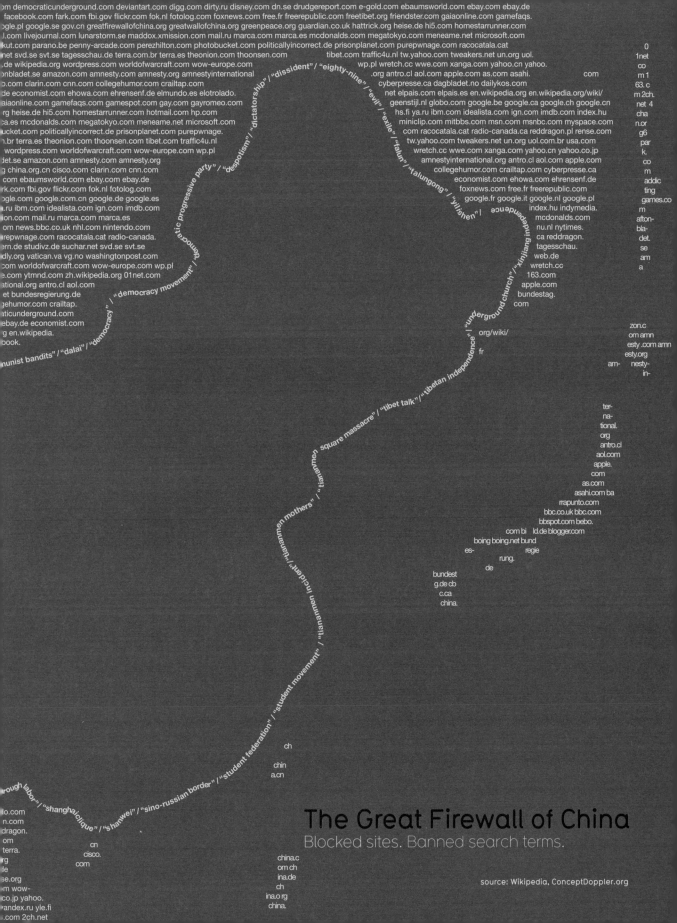

The Great Firewall of China
Blocked sites. Banned search terms.

source: Wikipedia, ConceptDoppler.org

Better Than Bacon
The real centre of the Hollywood universe

A study of over 1 million films and actors at oracleofbacon.org has revealed a series of actors who are way better connectors for the game Six Degrees Of Kevin Bacon than Mr Bacon himself.

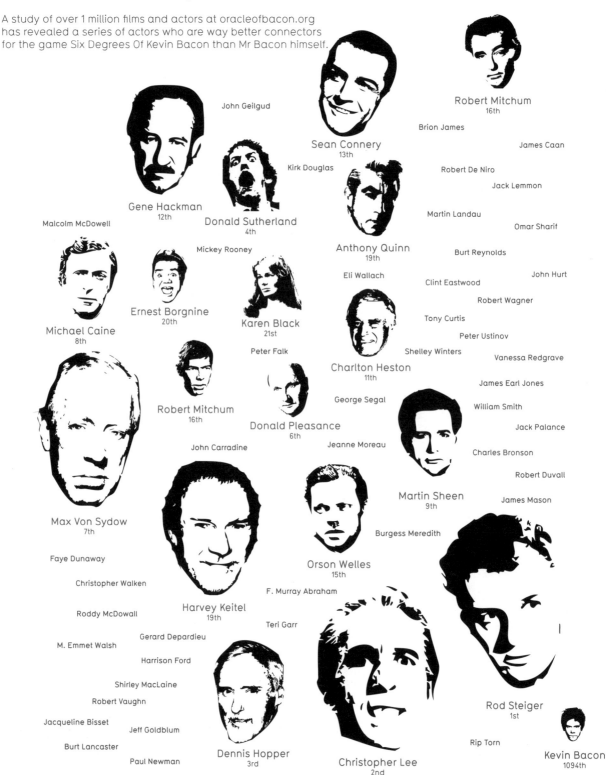

John Geilgud

Robert Mitchum
16th

Brion James

James Caan

Sean Connery
13th

Kirk Douglas

Robert De Niro

Jack Lemmon

Martin Landau

Omar Sharif

Gene Hackman
12th

Donald Sutherland
4th

Anthony Quinn
19th

Burt Reynolds

Malcolm McDowell

Mickey Rooney

Eli Wallach

John Hurt

Clint Eastwood

Robert Wagner

Tony Curtis

Peter Ustinov

Michael Caine
8th

Ernest Borgnine
20th

Karen Black
21st

Shelley Winters

Vanessa Redgrave

Charlton Heston
11th

Peter Falk

James Earl Jones

William Smith

George Segal

Jack Palance

Robert Mitchum
16th

Donald Pleasance
6th

Jeanne Moreau

Charles Bronson

John Carradine

Robert Duvall

James Mason

Max Von Sydow
7th

Martin Sheen
9th

Burgess Meredith

Faye Dunaway

Orson Welles
15th

Christopher Walken

F. Murray Abraham

Roddy McDowall

Harvey Keitel
19th

Teri Garr

M. Emmet Walsh

Gerard Depardieu

Harrison Ford

Shirley MacLaine

Robert Vaughn

Rod Steiger
1st

Jacqueline Bisset

Jeff Goldblum

Burt Lancaster

Dennis Hopper
3rd

Rip Torn

Kevin Bacon
1094th

Paul Newman

Christopher Lee
2nd

source: OracleOfBacon.org

What are the chances?
Cancer survival rates compared with the US

average chance of survival		chances of survival (compared to US)				chances of survival (compared to US)			average chance of survival	
		US	UK	EU		EU	UK	US		
bladder	67%								80%	lymph glands (Hogdkin's disease)
bone marrow	30%								64%	lymph glands (Non-Hodgkin's)
brain	26%								14%	oesophagus
breast	65%								50%	ovarian
cervical	60%								5%	pancreatic
colorectal	50%								80%	prostate
kidney	62%								80%	skin (melanomas)
larynx	38%								21%	stomach
leukaemia	50%								90%	testicular
liver	7.6%								90%	thyroid
lung	16%								87%	uterine

source: The Lancet, Office For National Statistics, Cancer Research

Some Things You Can't Avoid
Characteristics and behaviours that increase the likelihood of certain ailments

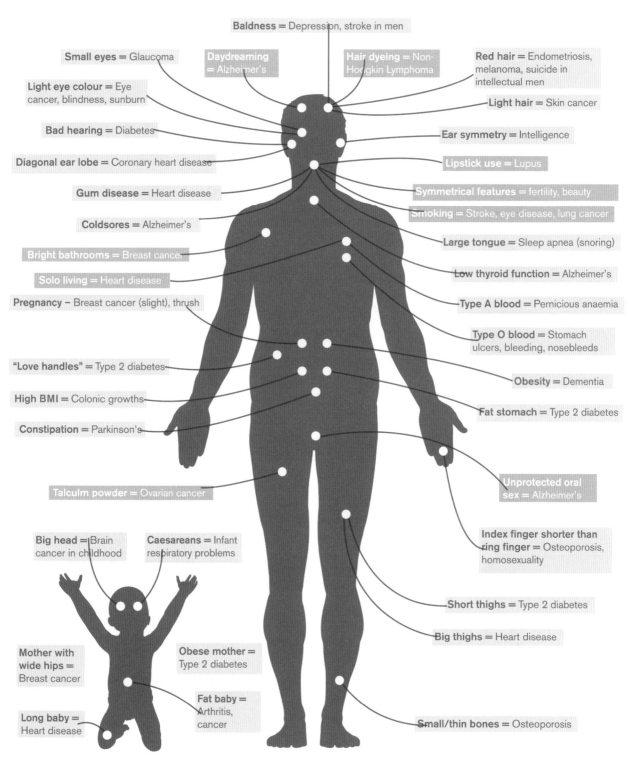

Baldness = Depression, stroke in men

Small eyes = Glaucoma

Daydreaming = Alzheimer's

Hair dyeing = Non-Hodgkin Lymphoma

Red hair = Endometriosis, melanoma, suicide in intellectual men

Light eye colour = Eye cancer, blindness, sunburn

Light hair = Skin cancer

Bad hearing = Diabetes

Ear symmetry = Intelligence

Diagonal ear lobe = Coronary heart disease

Lipstick use = Lupus

Gum disease = Heart disease

Symmetrical features = fertility, beauty

Coldsores = Alzheimer's

Smoking = Stroke, eye disease, lung cancer

Bright bathrooms = Breast cancer

Large tongue = Sleep apnea (snoring)

Solo living = Heart disease

Low thyroid function = Alzheimer's

Pregnancy – Breast cancer (slight), thrush

Type A blood = Pernicious anaemia

Type O blood = Stomach ulcers, bleeding, nosebleeds

"Love handles" = Type 2 diabetes

Obesity = Dementia

High BMI = Colonic growths

Fat stomach = Type 2 diabetes

Constipation = Parkinson's

Unprotected oral sex = Alzheimer's

Talculm powder = Ovarian cancer

Index finger shorter than ring finger = Osteoporosis, homosexuality

Big head = Brain cancer in childhood

Caesareans = Infant respiratory problems

Short thighs = Type 2 diabetes

Big thighs = Heart disease

Mother with wide hips = Breast cancer

Obese mother = Type 2 diabetes

Long baby = Heart disease

Fat baby = Arthritis, cancer

Small/thin bones = Osteoporosis

Or decrease the likelihood

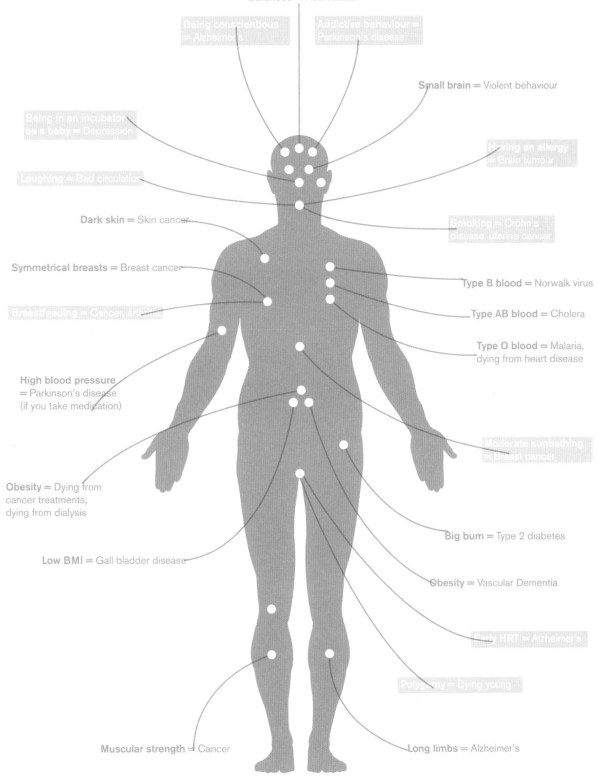

Baldness = Heart attack

Being conscientious = Alzheimer's

Addictive behaviour = Parkinson's disease

Small brain = Violent behaviour

Being in an incubator as a baby = Depression

Having an allergy = Brain tumour

Laughing = Bad circulation

Dark skin = Skin cancer

Smoking = Crohn's disease, uterine cancer

Symmetrical breasts = Breast cancer

Type B blood = Norwalk virus

Type AB blood = Cholera

Breastfeeding = Cancer, arthritis

Type O blood = Malaria, dying from heart disease

High blood pressure = Parkinson's disease (if you take medication)

Obesity = Dying from cancer treatments, dying from dialysis

Moderate sunbathing = Breast cancer

Big bum = Type 2 diabetes

Low BMI = Gall bladder disease

Obesity = Vascular Dementia

Early HRT = Alzheimer's

Polygamy = Dying young

Muscular strength = Cancer

Long limbs = Alzheimer's

source: PubMed, Medscape.com, HealthDay, biomedicine.org, eupedia.com, Reuters, yale.edu, NHSdirect.nhs.uk

By Descent
Decreased risk – increased risk

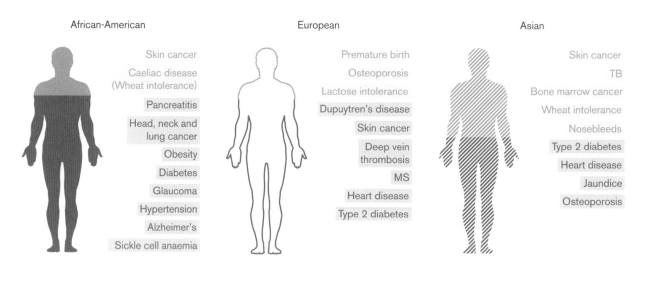

African-American

Skin cancer
Caeliac disease
(Wheat intolerance)
Pancreatitis
Head, neck and
lung cancer
Obesity
Diabetes
Glaucoma
Hypertension
Alzheimer's
Sickle cell anaemia

European

Premature birth
Osteoporosis
Lactose intolerance
Dupuytren's disease
Skin cancer
Deep vein
thrombosis
MS
Heart disease
Type 2 diabetes

Asian

Skin cancer
TB
Bone marrow cancer
Wheat intolerance
Nosebleeds
Type 2 diabetes
Heart disease
Jaundice
Osteoporosis

By Gender
Decreased risk – increased risk

Female

Skin cancer
Caeliac disease
(Wheat intolerance)
Pancreatitis
Head, neck and
lung cancer
Obesity
Diabetes
Glaucoma
Hypertension
Alzheimer's
Sickle cell anaemia

Male

Premature birth
Osteoporosis
Lactose intolerance
Dupuytren's disease ——— thickening of the tissues
of the palm causing the
fingers to bend inwards
Skin cancer
Deep vein
thrombosis
MS
Heart disease
Type 2 diabetes

source: PubMed, Medscape.com, HealthDay, biomedicine.org, eupedia.com, Reuters, yale.edu, NHSdirect.nhs.uk

Body By

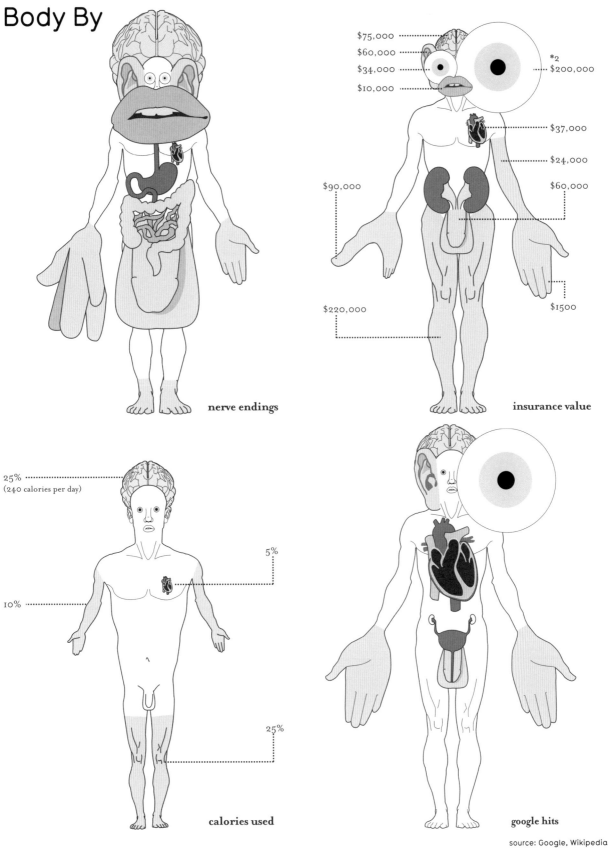

nerve endings

insurance value

$75,000
$60,000
$34,000
$10,000

*2
$200,000

$37,000

$24,000

$90,000

$60,000

$220,000

$1500

calories used

25%
(240 calories per day)

5%

10%

25%

google hits

source: Google, Wikipedia

Microbes Most Dangerous
By survival time outside the body

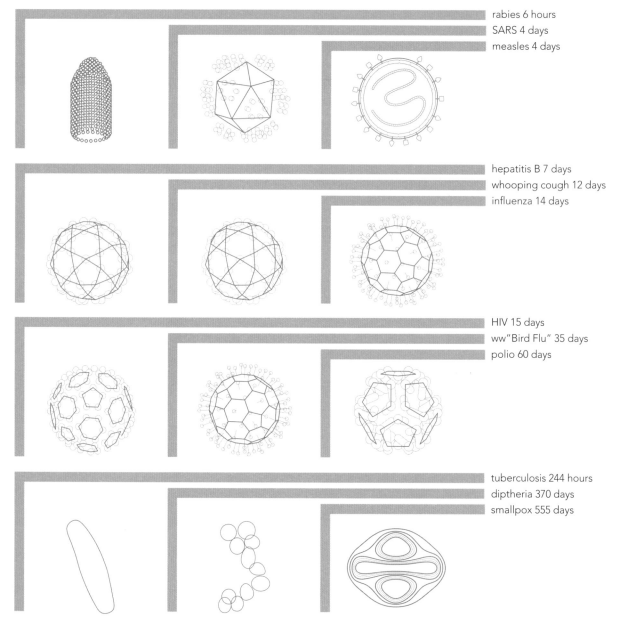

rabies 6 hours
SARS 4 days
measles 4 days

hepatitis B 7 days
whooping cough 12 days
influenza 14 days

HIV 15 days
ww"Bird Flu" 35 days
polio 60 days

tuberculosis 244 hours
diptheria 370 days
smallpox 555 days

source: Centre For Disease Control & Prevention, NewScientist.com. Design inspired by Geigy.

Cosmetic Ingredients
Shampoo. Suntan lotion. Soap. Cleanser. Lipstick.

CHLORHEXIDINE DIGLUCONATE, **1,4-DIOXANE**, ACETATE, ACETONE, ACETYLATED LANOLIN ALCOHOL, ACRYLATES COPOLYMER, ACRYLATES / OCTYLPROPENAMIDE COPOLYMOR, ALCOHOL DENAT, ALCOHOL SD-40, ALGAE/SEAWEED EXTRACT, ALLANTOIN, ALPHA HYDROXY ACID, ALPHA LIPOIC ACID, ALPHA-ISOMETHYL IONONE, AMMONIUM LAURETH SULFATE, AMMONIUM LAURYL SULPHATE, ANIGOZANTHOS FLAVIDUS (BLOODWORT), ARACHIDYL PROPIONATE, ASCORBIC ACID, ASCORBYL PALMITATE, BEESWAX, BENZALKONIUM CHLORIDE, BENZOIC ACID, **BENZOYL PEROXIDE**, BENZYL SALICYLATE, **BETA HYDROXY ACID (SALICYLIC ACID), BORIC ACID,** BUTYL METHOXYDIBENZOYLMETHANE, **BUTYLATED HYDROXYANISOLE,** BUTYLENE GLYCOL DICAPRYLATE/DICRAPATE, BUTYLPARABEN, BUTYLPHENYL METHYLPROPIONAL, C12-15 ALKYL BENZOATE, CAFFEINE, CAMPHOR, CARBOMERS (934, 940, 941, 980, 981), CARICA PAPAYA (PAPAYA), CARMINE, CARNAUBA WAX, CAVIAR (ROE EXTRACT), CELLULOSE, CERAMIDES, CETALKONIUM CHLORIDE, **CETEARETH,** CETEARYL ALCOHOL, CHAMOMILLA RECUTITA (CHAMOMILE), CL 14700 (E125), CL 191140 (YELLOW 5 ALUMINIUM LAKE), CITRONELLOL, COCAMIDE MEA, **COCAMIDOPROPYL BETAINE,** COLLAGEN, **COUMARIN,** CYCLIC (HYDROXY) ACID, CYCLOMETHICONE, D&C RED NO. 6 BARIUM LAKE, **DIETHANOLAMINE (DEA),** DIETHYLHEXYL BUTAMIDO TRIAZONE, DIEMETHICONE, DIOCTYL SODIUM SULFOSUCCINATE, DISODIUM COCOAMPHODIACETATE, DISODIUM LAURYL PHENYL ETHER DISULFONATE, **DMDM HYDANTOIN,** EDTA, ELASTIN, ELLAGIC ACID, ETHYL ALCOHOL (ETHANOL), ETHYLPARABEN, EUGENOL, **FD&C YELLOW NO. 5 ALUMINUM LAKE,** GLYCERIN, GLYCERYL STEARATE SE, GLYCINE, GLYCOGEN, GLYCOL STEARATE, **GLYCOLIC ACID,** GRAPE SEED EXTRACT, GREEN TEA EXTRACT (CAMELLIA SINENSIS), HEXYL CINNAMAL, HYALURONIC ACID, **HYDROGEN PEROXIDE,** HYDROLYZED COLLAGEN, **HYDROQUINONE,** HYDROXYLSOHEXYL 3-CYCLOHEXENE CARBOXALDEHYDE, **ISOPROPYL ALCOHOL,** ISOPROPYL ISOSTEARATE, ISOPROPYL IANOLATE, ISOPROPYL MYRISTATE, ISOPROPYL PALMITATE, ISOSTEARAMIDOPROPYL ETHYLDIMONIUM ETHOSULFATE, ISOSTEARIC ACID KAOLINE (CHINA CLAY), KOJIC ACID, L-ERGOTHIONEINE, **LACTIC ACID,** LAMINARIA DIGITATA (HORSEHAIR KELP), LANOLIN, LECITHIN, LICORICE EXTRACT (BHT), LIGHT MINERAL OIL, **LIMONENE, LINALOOL,** LINOLEAMIDOPROPYL, LINOLEIC ACID, LYSINE, **METHYLISOTHIAZOLINONE, METHYLPARABEN,** MINERAL OIL, MYRISTYL MYRISTATE, MYRTRIMONIUM BROMIDE, OCTOCRYLENE, **OCTYL METHOXYCINNAMATE,** OCTYL PALMITATE, OCTYLDODECANOL, OLEYL ALCOHOL, **OXYBENZONE (BENZOPHENONE-3), PABA (PARAA-AMINOBENZOIC ACID),** PADIMATE O, PANTHENOL, **PARABEN,** PARAFFIN, **PARFUM,** PC-DIMONIUM CHLORIDE PHOSPHATE, **PEG-40 CASTOR OIL,** PETROLATUM, **PHENOXYETHANOL,** PHENYL TRIMETHICONE, PHENYLBENZIMIDAZOLE SULFONIC ACID, **PHTHALATES,** POLY HYDROXY ACID, POLYBUTENE, PROLINE, **PROPYLENE GLYCOL, PROPYLPARABEN, QUATERNIUM-15,** RESVERATROL, RETINOL (ALSO VITAMIN A), RETINYL PALMITATE, RETINAL PALMITATE POLYPEPTIDE, ROSE HIPS, **SALYCYLIC ACID,** SILICONE (DIMETHYL SILICONE), **SILICA,** SILK POWDER, SILK PROTEINS, SODIUM ACRYLATES/C10-30 ALKYL ACRYLATE CROSSPOLYMER, SODIUM BICARBONATE, **SODIUM BORATE,** SODIUM CETEARYL SULFATE, SODIUM CHLORIDE, **SODIUM FLUORIDE,** SODIUM HYALURONATE, SODIUM LAUREL SULFATE, **SODIUM LAURETH SULFATE,** SODIUM LAURYL SULFATE, SODIUM METHACRYLATE, SORBIC ACID, SORBITOL (MINERAL OIL), STEARIC ACID, SULFUR, TALC, TAPIOCA STARCH, TARTARIC ACID, TITANIUM DIOXIDE, TOCOPHERYL ACETATE, **TRICLOSAN,** TRIDECETH-12, TRIMETHOXYCAPRYLYLSILANE, TRISODIUM EDTA, TYROSINE, VITAMIN A (RETINOL), **VITAMIN B, VITAMIN C (CITRIC ACID),** VITAMIN D, VITAMIN E (TOCOPHEROL), WATER, WHITE PETROLATUM, WHITE WAX, XANTHAN GUM

GOOD FINE OKAY NASTY TOXIC DEADLY

source: CosmeticDatabase.com, Environmental Working Group

Things That'll Give You Cancer

Source: the media

abortion

acrylamide

agent **orange**

alcohol **aldrin** alfatoxin

Nut mould. Nasty.

asphalt fumes **atrazine**

meat **benzene** **benzidine**

betacarotene **betel** **nuts** birth

High doses in smokers linked to lung cancer

bread breasts bus stations **cadmium**

captan **carbon tetrachloride** careers

Fungicide

foods chewing gum Chinesefood Chinese herbal

Vinyl acetate in gum

chlordane **chlorinated** **camphene**

chloroform cholesterol **chromium coaltar**

curry cyclamates dairy products **DDT** deodorants depleted

diesel exhaust diet soda **dimethylsulphate**

epichlorhydrin ethilenedibromide ethnic beliefs

Safe

facebook **fat** fibre fluoridation flying **formaldehyde**

Lack of real contact alters our biology apparently

gingerbread global warming gluteraldehyde **granite** grilled

supplements **heliobacter pylori hepatitis B**

bone mass **HRT** hydrazine hydrogen peroxide **incense**

In poorly ventilated spaces

laxatives **lead** left handedness **Lindane** Listerine low

Higher risk of breast cancer

mammograms manganese **menopause** methylbromide

Minimal risk

mixed spices mobile phones **moisturizers** **mould** MTBE

No link. Now proven.

breast feeding not having a twin **nuclear power**

juice **oxygenated gasoline** oyster sauce ozone

Contains carcinogens

PCBs peanuts **pesticides** pet birds plastic

When mouldy

PVC radio masts **radon** railway sleepers

It's the creosote. Don't lick.

sausage dye selenium semi conductor plants

soy sauce statins **stress** strontium styrene

sunscreen talc testosterone tetrachloroethylene

toothfillings toothpaste toothwhitening

Probably okay

under-armshaving **unvented stoves**

vegetables **vinyl** **bromide**

vitamins vitreous fibres wallpaper

water wifi wine winter

x-rays

acrylonitril

air pollution alar

arsenic **asbestos**

AZT babyfood **barbecued**

benzopyrene **beryllium**

control pills bottled water bracken

calcium channel blockers cannabis

for women car fumes casual sex celery **charred**

supplements chinese medicine chips chloramphenicol

chlorinated water **chlorodiphenyl**

coffee **coke ovens** cooked foods crackers creosote

uranium depression **dichloryacetylene dieldrin**

dinitrotouluene dioxane dioxin dogs

ethyleacrilate ethylene **ethylenedichloride** Ex-Lax

free radicals french fries fruit frying **gasoline** genes

meat **Gulf war hair dye** hamburgers health

virus hexachlorbutadiene hexachlorethane high

infertility jewellery **Kepone kissing** lack of exercise

cholesterol low fibre diet magnetic fields **malonaldehyde**

methylenechloride microwave ovens milk hormones

nickel night lighting **nightshifts nitrates not**

plants Nutrasweet **oestrogen** olestra olive oil orange

ozone depletion papaya **passive smoking**

IV bags polio vaccine power lines proteins Prozac

redmeat Roundup saccharin salmon salt sausage

shaving shellfish sick buildings smoked fish

sulphuricacid sunbeds sunlight

tight bras toast toasters **tobacco**

train stations **trichloroethylene** tritium

uranium **UVradiation**

vinyl chloride vinyl toys

weight gain welding fumes **well**

wood dust work

Pesticide & fruit spray

Only if contaminated

Aggressive form of testicular cancer but also anti-tumour

Antibiotic

May help combat cancer

unproven links to breast cancer

Linked to many cancers

Kissing disease (infectious mononucleosis)

Probable cause of cancer

Most red meat linked to bowel cancer

Air quality

source: UK and US media reports [via numberwatch.co.uk], Wikipedia

Types of Coffee

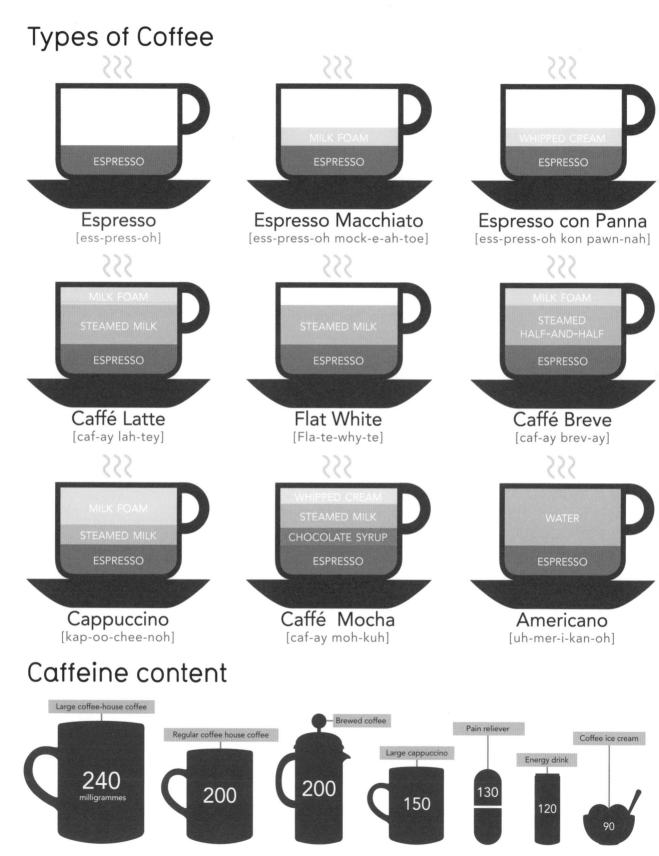

Espresso
[ess-press-oh]

ESPRESSO

Espresso Macchiato
[ess-press-oh mock-e-ah-toe]

MILK FOAM
ESPRESSO

Espresso con Panna
[ess-press-oh kon pawn-nah]

WHIPPED CREAM
ESPRESSO

Caffé Latte
[caf-ay lah-tey]

MILK FOAM
STEAMED MILK
ESPRESSO

Flat White
[Fla-te-why-te]

STEAMED MILK
ESPRESSO

Caffé Breve
[caf-ay brev-ay]

MILK FOAM
STEAMED HALF-AND-HALF
ESPRESSO

Cappuccino
[kap-oo-chee-noh]

MILK FOAM
STEAMED MILK
ESPRESSO

Caffé Mocha
[caf-ay moh-kuh]

WHIPPED CREAM
STEAMED MILK
CHOCOLATE SYRUP
ESPRESSO

Americano
[uh-mer-i-kan-oh]

WATER
ESPRESSO

Caffeine content

Large coffee-house coffee
240 milligrammes

Regular coffee house coffee
200

Brewed coffee
200

Large cappuccino
150

Pain reliever
130

Energy drink
120

Coffee ice cream
90

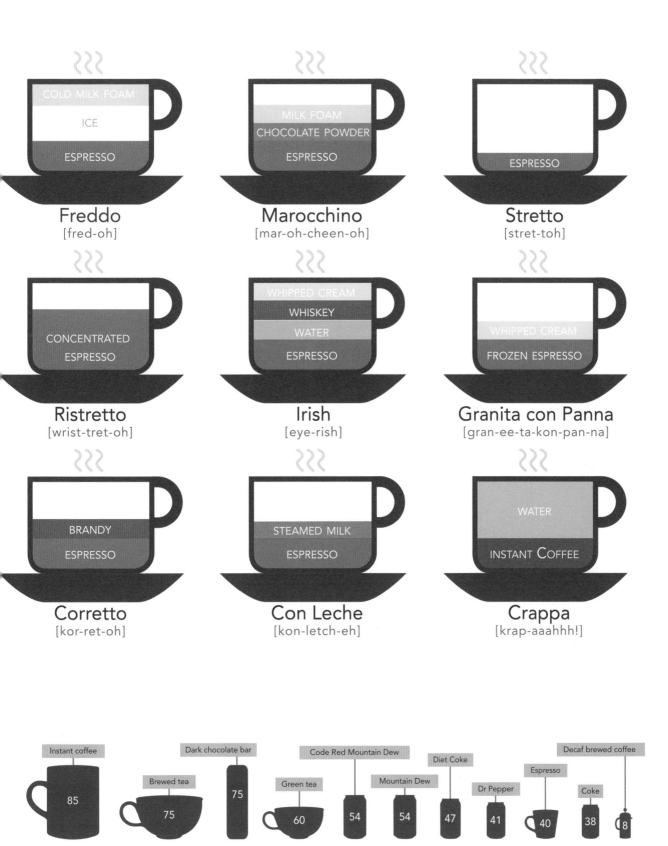

Freddo
[fred-oh]

COLD MILK FOAM
ICE
ESPRESSO

Marocchino
[mar-oh-cheen-oh]

MILK FOAM
CHOCOLATE POWDER
ESPRESSO

Stretto
[stret-toh]

ESPRESSO

Ristretto
[wrist-tret-oh]

CONCENTRATED
ESPRESSO

Irish
[eye-rish]

WHIPPED CREAM
WHISKEY
WATER
ESPRESSO

Granita con Panna
[gran-ee-ta-kon-pan-na]

WHIPPED CREAM
FROZEN ESPRESSO

Corretto
[kor-ret-oh]

BRANDY
ESPRESSO

Con Leche
[kon-letch-eh]

STEAMED MILK
ESPRESSO

Crappa
[krap-aaahhh!]

WATER
INSTANT COFFEE

Instant coffee 85
Brewed tea 75
Dark chocolate bar 75
Green tea 60
Code Red Mountain Dew 54
Mountain Dew 54
Diet Coke 47
Dr Pepper 41
Espresso 40
Coke 38
Decaf brewed coffee 8

idea: Lokesh Dhakar @ lokeshdhakar.com

Tons Of Carbon II

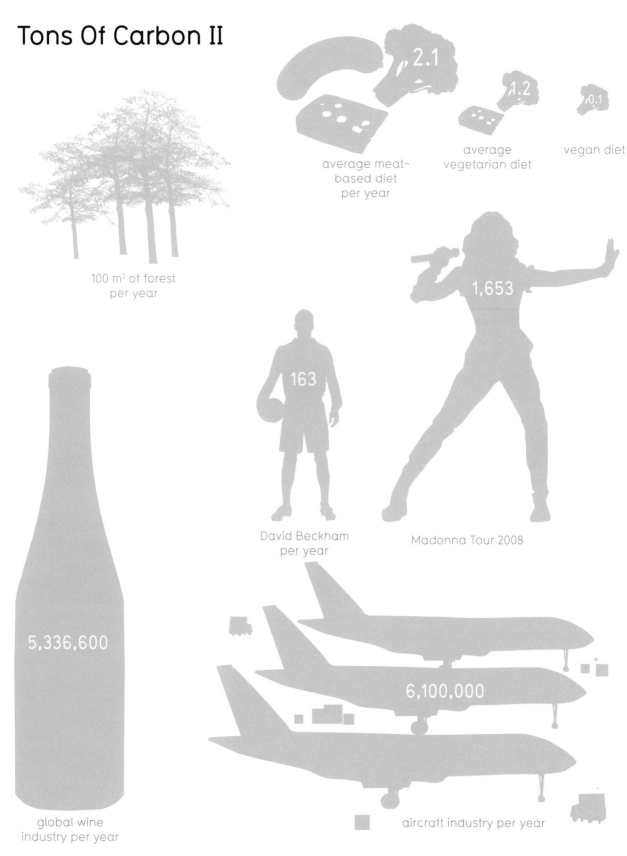

2.1

average meat-
based diet
per year

1.2

average
vegetarian diet

0.1

vegan diet

100 m² of forest
per year

1,653

163

David Beckham
per year

Madonna Tour 2008

5,336,600

global wine
industry per year

6,100,000

aircraft industry per year

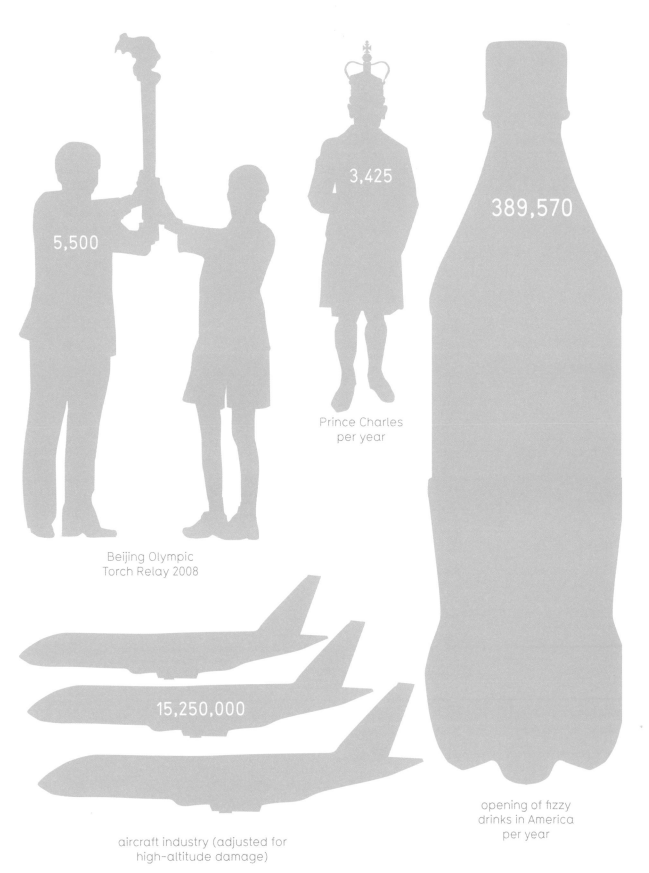

5,500

Beijing Olympic
Torch Relay 2008

3,425

Prince Charles
per year

389,570

opening of fizzy
drinks in America
per year

15,250,000

aircraft industry (adjusted for
high-altitude damage)

source: New York Times, Environmental Protection Agency, IPCC, Energy Information Administration. UNESCO

Articles of War
Most edited Wikipedia pages

Lamest / key argument (Approximate number of edits)

Death Star
120km or 160km in diameter?

J.K. Rowling
Is her name pronounced like "rolling" or does it rhyme with "howling"? (1943)

The Beatles
Should they be listed in the "traditional" order or in alphabetical order? Is it "The Beatles" or "the Beatles" (1073)

Hummus
Should it be in Israeli cuisine? Or is it a purely Arab food that the Zionists have illegally occupied?

Wii
"Wii" or "Nintendo Wii"? "Wii" or "the Wii"? Or maybe "Nintendo Wii"? Does it rhyme with "We" or "Wee"? Is "Wee" slang or a euphemism for urine? Is it a British or International slang word for urine? etc. (12,465)

Avril Lavigne
"I'm With You"or "I'm with You"? (3398)

Cute
Is it NPOV (Neutral Point Of View) to say an animal is "cute"?

Kiev, capital of Ukraine
Kiev (Russian)? Or Kyiv (Ukrainian)? Battle involved both Russian and Ukrainian governments. (1323)

Freddie Mercury
Ancestry. Iranian? Indian? Parsi? Azeri? (1731)

2006 FIFA World Cup
So should the German name use "Fußball" or "Fussball"? Unresolved. (2199)

Arachnophobia
Appropriate to use a huge pic of a tarantula on a page about fear of spiders?

Anus
Should article use an image of a human anus? If so, male or female? Hairless or "Moderately" hairy?

Cow tipping
Appropriate to use a picture of a cow with the caption: "An unsuspecting victim"?

Grey or Gray Squirrel
Slow and remorseless edit war over this spelling.

Sulfur or Sulphur?
(3100)

Christianity
Use of the word "orthodoxy" before "heresy" in the following sentence: "...Church authorities condemned some theologians as heretics, defining orthodoxy in contrast to heresy, the most notable being Christian Gnosticism." (9539)

Jesus
Very long running dispute over whether to use BC or AD. (15,386)

Alumin(i)um
MASSIVE (1609)

Grand Theft Auto IV
Is the main character Serbian, Slovak, Bosnian, or from some other Eastern European country? (1485)

Palin
Is a political candidate more famous than a Monty Python member?

Nicolaus Copernicus
Polish, German or Prussian? Don't ask. (2612)

Brazil or Brasil?

Tiger
Should it be described as the "most powerful living cat"?

United States presidential election 08
Was American comedian Stephen Colbert a serious candidate? If so, is the candidate Stephen Colbert (comedian) or Stephen Colbert (character)?

Jennifer Aniston
American or American-born? Greek-American? English-American (1306)

Fossil fuel for reciprocating piston engines equipped with spark plugs
Should this substance be called "gasoline" or "petrol"? (1599)

Wrestlemania III
Was the attendance of the event in question 78,000 or 93,178 – or is it really 75,500? (3100)

John Kerry
His first Purple Heart award in Vietnam. Was it just a wound or a "minor wound"? Was the injury "bandaged", or simply wrapped with "gauze"? (9718)

Yoghurt or Yogurt?

Clover (creature)
Cloverfield. Clover. The Cloverfield creature. Clover (creature). WHICH?

Gdanzig
What is the exact name of this Polish German Prussian Eastern Central Northern European Baltic Baltijas city? LEGENDARY (500)

Faeces
Should this page include this picture of a large human turd? (3972)

Potato Chip
Flavoured or flavored? Compromise reached: "seasoned".

Money
What exactly is the time signature of this Pink Floyd song? The band, who have no musical training, say 7/8. Most people say 7/4. Experts will go as far as to say 21/8. (4446)

Grace Kelly & Cher
Are they gay icons?

Iron Maiden
Should this direct to the band or the torture device? (2785)

Nikola Tesla
Born of Serbian parents in Austrian Empire, a part of the Hungarian half of Austria-Hungary and is now in Croatia. Category nightmare! (1260)

Cat
What describes the correct relationship? "Owner", "caregiver", or "human companion". LEGENDARY (500+)

Wikipedia
Is Jimmy Wales the founder or a co-founder with Larry Sanger. (21,748)

"Heather" of Silent Hill 3
The protagonist from Konami's survival horror video game. What is her last name? (1598)

Ann Coulter
Was the American political commentator born in 1961 or 1963? (7696)

Mayonnaise
Does traditional Mayonnaise contain lemon juice or not?

U2
Is it relevant that Bono plays the harmonica? (2988)

2000
As there was no year zero, the millennium we are currently in started in 2001 (2835)

Angels & Airwaves
Angels & Airwaves IS a band or ARE a band? (British English requires "are" as the band comprises multiple people, while American English requires "is", as the band is a singular entity.) FIGHT! (2463)

Street Fighter Characters
Drawn-out revert wars over the correct heights and weights of fictional characters like Ken Masters and Balrog. (1048)

Star Wars
Are Anakin Skywalker and Darth Vader considered one character or two separate ones? Do they deserve separate listings in the "credits" section? Should *Star Wars Episode III* should be listed as the "preceding film" in the infobox. (8610)

2006 Atlantic Hurricane Season
Should a tropical cyclone that formed on December 30, 2005 and lasted until January 6, 2006 be placed in the 2006 Atlantic hurricane season article or the 2005? (2477)

source: Wikipedia: Lamest_edit_wars

Water Towers

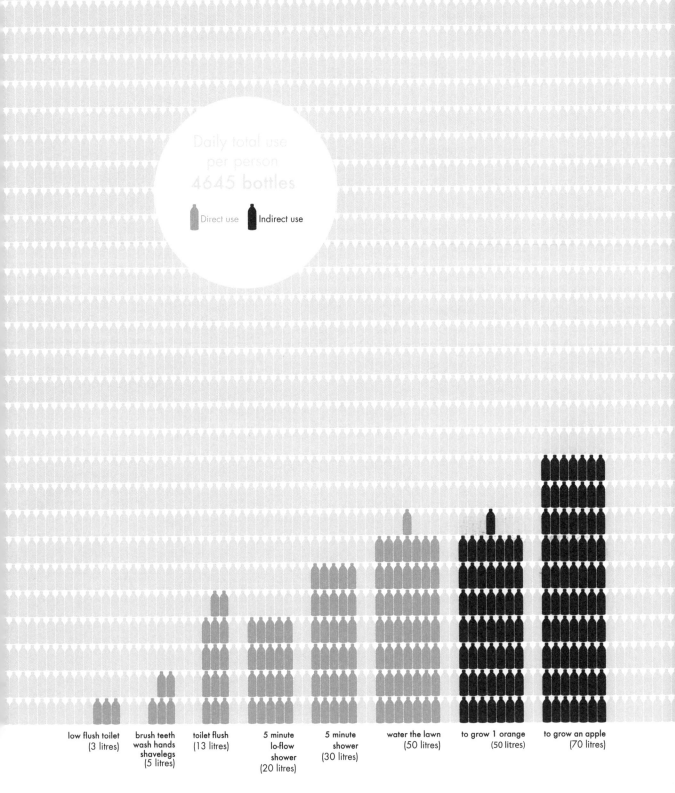

Daily total use
per person
4645 bottles

Direct use Indirect use

low flush toilet (3 litres)

brush teeth wash hands shavelegs (5 litres)

toilet flush (13 litres)

5 minute lo-flow shower (20 litres)

5 minute shower (30 litres)

water the lawn (50 litres)

to grow 1 orange (50 litres)

to grow an apple (70 litres)

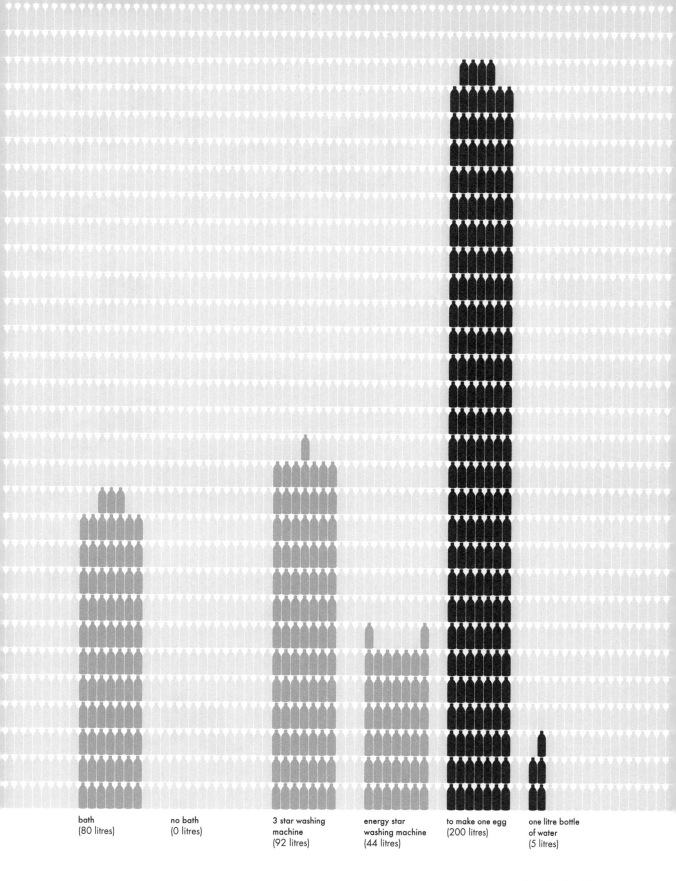

bath
(80 litres)

no bath
(0 litres)

3 star washing
machine
(92 litres)

energy star
washing machine
(44 litres)

to make one egg
(200 litres)

one litre bottle
of water
(5 litres)

source: Wikipedia, Good Magazine

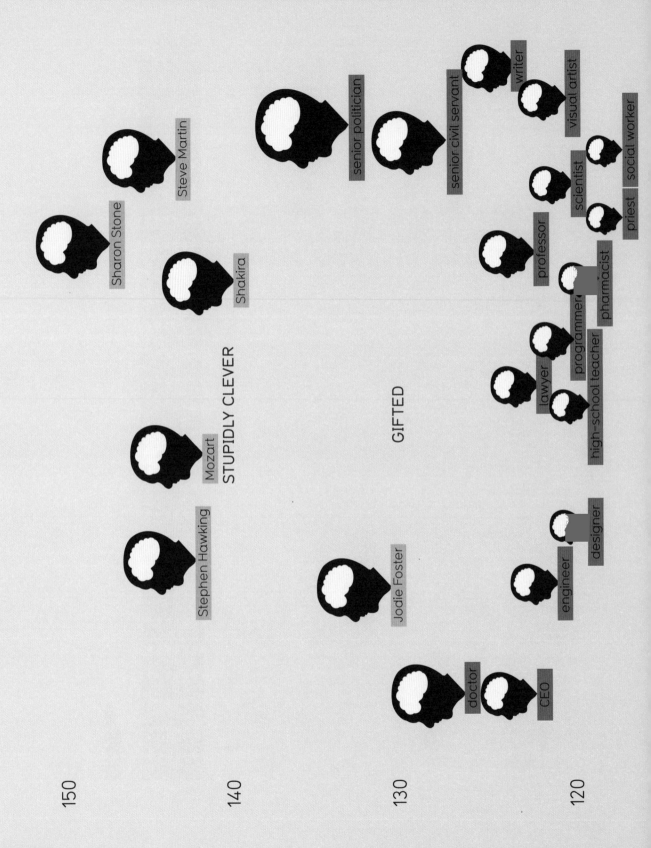

STUPIDLY CLEVER

Sharon Stone

Steve Martin

Shakira

Mozart

Stephen Hawking

senior politician

senior civil servant

writer

visual artist

scientist

social worker

priest

professor

pharmacist

programmer

lawyer

high-school teacher

GIFTED

Jodie Foster

engineer

designer

doctor

CEO

150

140

130

120

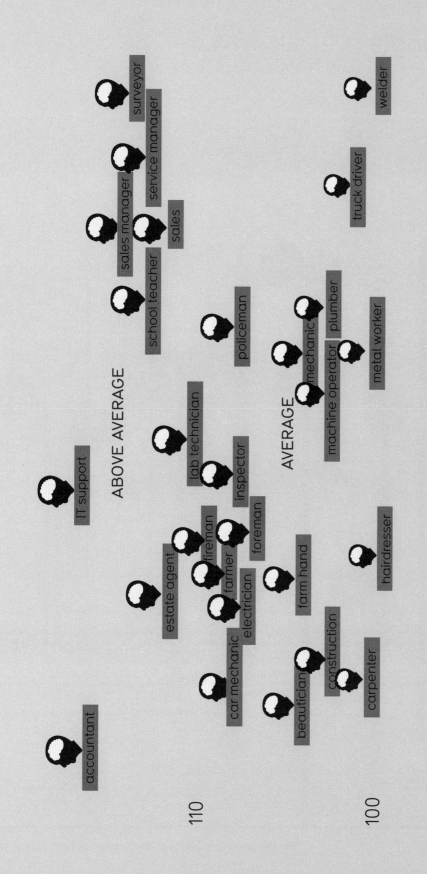

Who Clever Are You?
Average IQs of different callings

source: University Of Wisconsin Henmon-Nelson IQ Distributions 1992-94 (via Hauser, Robert M 2002)

The Media Jungle
Selected international magazines, newspapers and tv channels

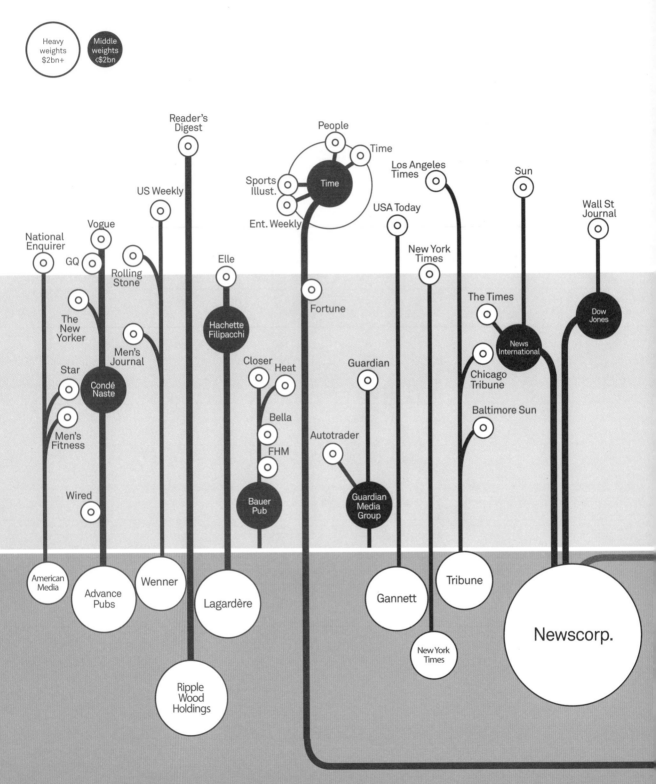

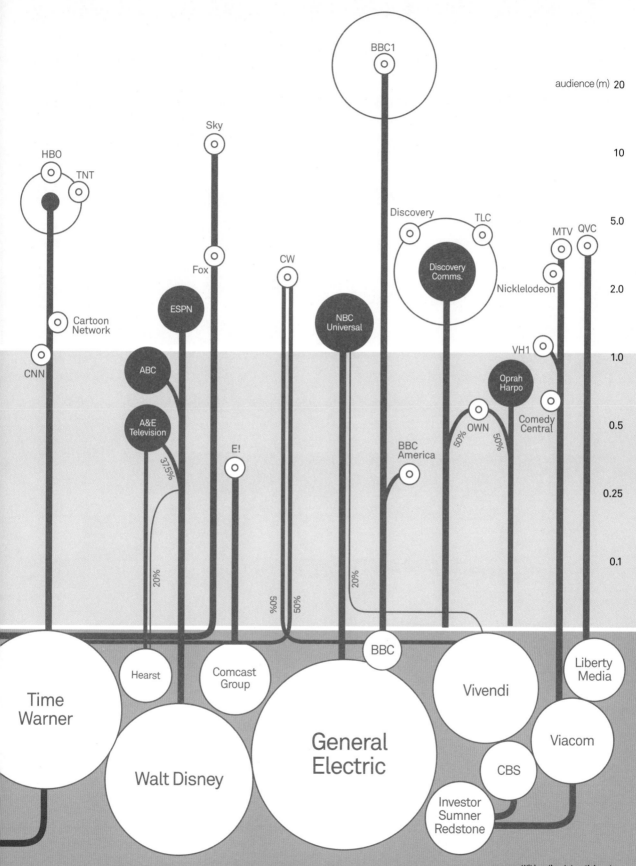

audience (m) 20

10

5.0

BBC1

Sky

HBO
TNT

2.0

Discovery
TLC
MTV QVC

Fox

ESPN

Discovery
Comms.

Nicklelodeon

CW

Cartoon
Network

NBC
Universal

VH1

1.0

CNN

ABC

Oprah
Harpo

0.5

A&E
Television

OWN

50%

50%

Comedy
Central

37.5%

E!

BBC
America

0.25

0.1

20%

50%

50%

20%

BBC

Hearst

Comcast
Group

Liberty
Media

Time
Warner

Vivendi

General
Electric

Viacom

Walt Disney

CBS

Investor
Sumner
Redstone

source: Wikipedia, Advertising Age

Daily Diets
How do they stack up?

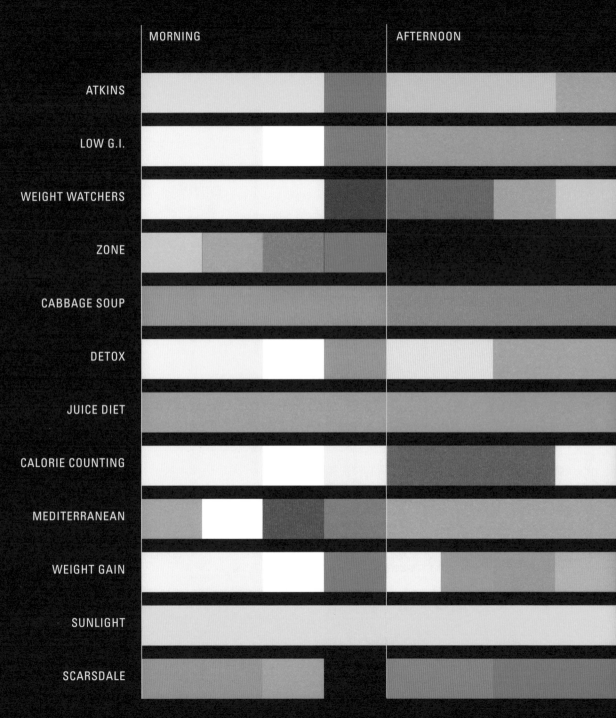

	MORNING	AFTERNOON
ATKINS		
LOW G.I.		
WEIGHT WATCHERS		
ZONE		
CABBAGE SOUP		
DETOX		
JUICE DIET		
CALORIE COUNTING		
MEDITERRANEAN		
WEIGHT GAIN		
SUNLIGHT		
SCARSDALE		

EVENING SNACKAGE WATER

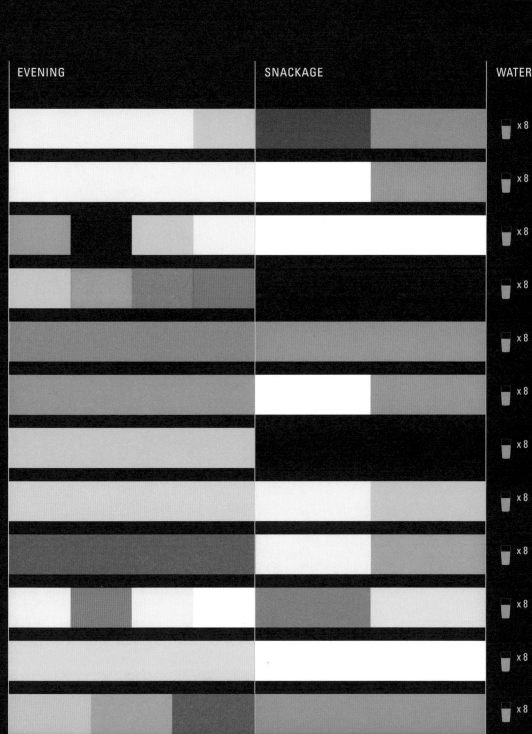

x 8
x 8
x 8
x 8
x 8
x 8
x 8
x 8
x 8
x 8
x 8
x 8

Calories In
Average load

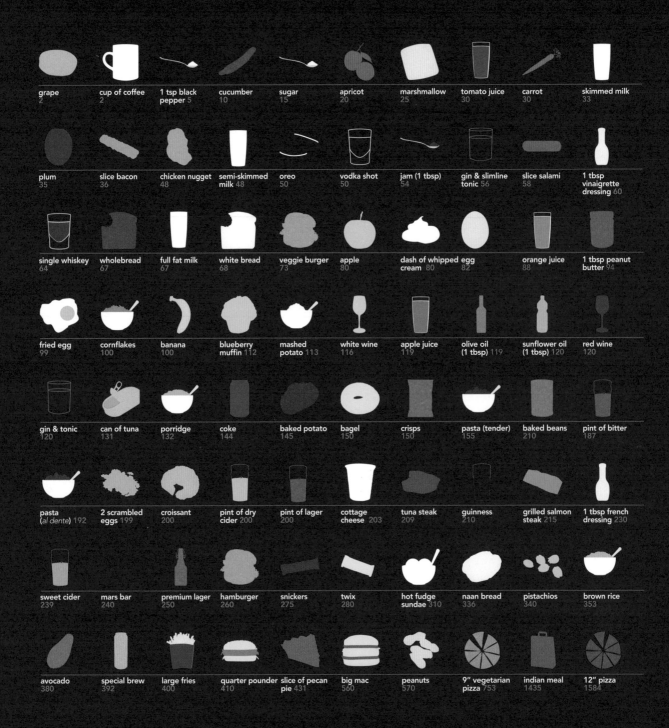

grape
2

cup of coffee
2

1 tsp black
pepper 5

cucumber
10

sugar
15

apricot
20

marshmallow
25

tomato juice
30

carrot
30

skimmed milk
33

plum
35

slice bacon
36

chicken nugget
48

semi-skimmed
milk 48

oreo
50

vodka shot
50

jam (1 tbsp)
54

gin & slimline
tonic 56

slice salami
58

1 tbsp
vinaigrette
dressing 60

single whiskey
64

wholebread
67

full fat milk
67

white bread
68

veggie burger
73

apple
80

dash of whipped
cream 80

egg
82

orange juice
88

1 tbsp peanut
butter 94

fried egg
99

cornflakes
100

banana
100

blueberry
muffin 112

mashed
potato 113

white wine
116

apple juice
119

olive oil
(1 tbsp) 119

sunflower oil
(1 tbsp) 120

red wine
120

gin & tonic
120

can of tuna
131

porridge
132

coke
144

baked potato
145

bagel
150

crisps
150

pasta (tender)
155

baked beans
210

pint of bitter
187

pasta
(al dente) 192

2 scrambled
eggs 199

croissant
200

pint of dry
cider 200

pint of lager
200

cottage
cheese 203

tuna steak
209

guinness
210

grilled salmon
steak 215

1 tbsp french
dressing 230

sweet cider
239

mars bar
240

premium lager
250

hamburger
260

snickers
275

twix
280

hot fudge
sundae 310

naan bread
336

pistachios
340

brown rice
353

avocado
380

special brew
392

large fries
400

quarter pounder
410

slice of pecan
pie 431

big mac
560

peanuts
570

9" vegetarian
pizza 753

indian meal
1435

12" pizza
1584

Calories Out
Average burn for 30 minutes of...

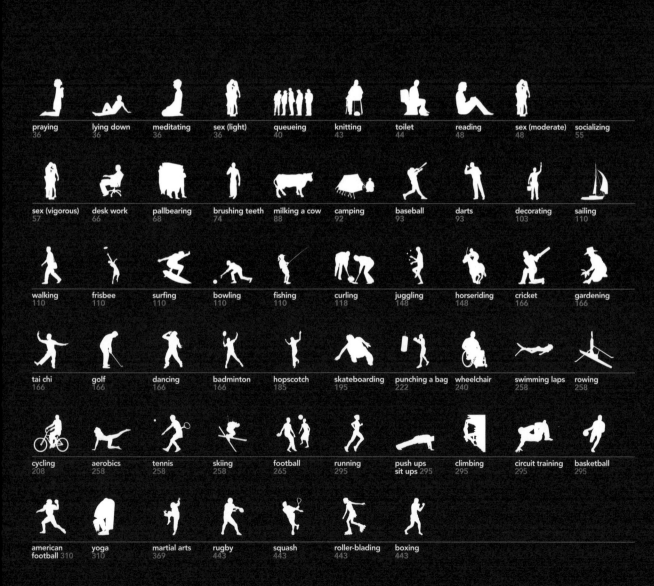

praying 36	lying down 36	meditating 36	sex (light) 36	queueing 40	knitting 43	toilet 44	reading 48	sex (moderate) 48	socializing 55
sex (vigorous) 57	desk work 66	pallbearing 68	brushing teeth 74	milking a cow 88	camping 92	baseball 93	darts 93	decorating 103	sailing 110
walking 110	frisbee 110	surfing 110	bowling 110	fishing 110	curling 118	juggling 148	horseriding 148	cricket 166	gardening 166
tai chi 166	golf 166	dancing 166	badminton 166	hopscotch 185	skateboarding 195	punching a bag 222	wheelchair 240	swimming laps 258	rowing 258
cycling 208	aerobics 258	tennis 258	skiing 258	football 265	running 295	push ups sit ups 295	climbing 295	circuit training 295	basketball 295
american football 310	yoga 310	martial arts 369	rugby 443	squash 443	roller-blading 443	boxing 443			

source: cross-referenced from various dieting websites

Types of Facial Hair
A little hair says a lot about a man

Major
Al Assad, Hafez
Sudan (reigned 1971-2000)
Killed: 25,000

Traditional
Al-Bashir, Omar
Sudan (1989-)
Killed: 400,000

Painter's Brush
Kai-Shek, Chiang
China (1928-31)
Killed: 30,000

Pyramid
Franco, Francisco
Spain (1939-75)
Killed: 30,000

Freestyle
King Abdulla
Saudi Arabia (2005-)
Killed: -

Chevron
Lenin, Vladimir Illyich
Russia (1917-24)
Killed: 30,000

Handlebar
Stalin, Joseph
Soviet Union (1924-53)
Killed: 23,000,000

Natural Full
Castro, Fidel
Cuba (1976-2008)
Killed: 30,000

Horseshoe
Habre, Hissene
Chad (1982-90)
Killed: 40,000

Toothbrush
Hitler, Adolf
Germany (1933-45)
Killed: 58,000,000

Walrus
Hussein, Saddam
Iraq (1979-2003)
Killed: 6,000,000

Zappa
Mengitsu, Haile Maiam
Ethiopa (1987-91)
Killed: 150,000

Fu Manchu
Temujin, Genghis Khan
Mongolia (1205-27)
Killed: millions

Nu Geek
McCandless
UK (1971)
Killed: 0

source: Wikipedia and general web

Vintage Years White Wine

The rating scale uses dots of varying size and shading:

	
· (tiny dot)	avoid (or no data)
• (small solid)	poor
● (medium solid)	average
● (large solid)	very good
⬤ (large dark)	outstanding
○ (open circle)	store

	07	06	05	04	03	02	01	00	99	98	97	96	95	94	93	92	91	90
AMERICA California	○	○	○	●	○	○	○	●	○	●	·	○	●		⬤	○	○	
North West	·	○	●	●	●	○	●	●	●	●		●		●		●		
ARGENTINA	○	○	○	○	○	○	●	·	●		●	●	●	●	●			
AUSTRALIA S.Australia	○	○	○	○	○	○	●	●	○	●	○	●	·	●	●	●	●	○
New South Wales	○	○	○	·	●	○	●	●	○	●	●	·	●	●	●	●	·	
W.Australia	○	·	●	·	○	●	●	●	○	●	⬤	·	●	●	●	●	●	●
CHILE	○	○	○	●	●	·	·	●	●	●	●	●	●	●	·	●		
FRANCE L.Bordeaux	·	○	○	○	○	○	●	●	○	·	●	●	●	●	●	●		●
R.Bordeaux	·	○	○	○	○	●	●	○	○	●	●	●	●	●	●			●
Burgundy		○	○	○	●	○	●	●	●	●	○	○	·	●	●			●
S. of France	○	○	·	●	·	●	●	⬤	●	●	·	●	●	●	·			⬤
N.Rhone	○	○	○	○	●	●	●	●	⬤	●	●	●	·		·			⬤
S. Rhone	○	○	○	○	●	·	○	●	●	●	⬤	●	●		·	·		⬤
The Loire	○	○	○	●	·	●	●	●	●	●	●	●	●	·				⬤
ITALY Piedmonte	○	○	○	○	·	●	○	○	○	●	○	●	·	·	●			⬤
Tuscany	○	○	○	·	●	●	●	○	○	○	○	●	·	·				⬤
Veneto	·	○	○	○	●	·	○	○	●	●	●	●	·	●				⬤
NEW ZEALAND N. Island	○	○	●	●	●	●	●	●	●	●	●	●	●					·
PORTUGAL	·	○	○	○	●	·	●	●	●	●	●	●	○		·	92	91	·
SOUTH AFRICA	○	○	○	○	○	·	·	●	●	●	●	●	●	●		·		
SPAIN Rioja	○	○	○	○	○	●	●	○	●	●	●	⬤	·	●	·			·
Ribera	○	○	○	○	○	●	○	○	○	●	⬤	●	·	●	●			·

Vintage Years Red Wine

| | 07 | 06 | 05 | 04 | 03 | 02 | 01 | 00 | 99 | 98 | 97 | 96 | 95 | 94 | 93 | 92 | 91 | 90 |

AMERICA California

ARGENTINA

AUSTRALIA S.Australia

W.Australia

Hunter Valley

Victoria

AUSTRIA Riesling

FRANCE Alsace

Bordeaux

Burgundy

Chablis

Champagne

Loire Valley Sweet

Loire Valley Blanc

North Rhone

GERMANY Mosel

Rheingau

ITALY North Italy

NEW ZEALAND Marlborough

SOUTH AFRICA

CHILE

SPAIN Rioja

| 07 | 06 | 05 | 04 | 03 | 02 | 01 | 00 | 99 | 98 | 97 | 96 | 95 | 94 | 93 | 92 | 91 | 90 |

store *outstanding* *very good* *average* *poor* *avoid (or no data)*

source: Amelia Pinsent

Amphibian Extinction Rates
Canaries in a coal mine?

Normal rate

1x

1990s

200x

 Chrytid fungus

 Habitat Loss

UV-Radiation

Insecticides

In the 1930s, the African clawed frog, an immune carrier of this deadly fungus, was popular for pregnancy tests. Doctors injected a pregnant frog with a woman's urine. If it gave birth, the woman was pregnant. Escaped frogs gradually spread the fungus among their non-immune peers.

Even a tiny amount of Malathion, the most common insecticide in the US, can lead to a devastating chain reaction that destroys bottom-dwelling algae, the primary food of tadpoles. It, and another pesticide, Atrazine, are considered key factors in the loss of entire populations.

Today
25,400x

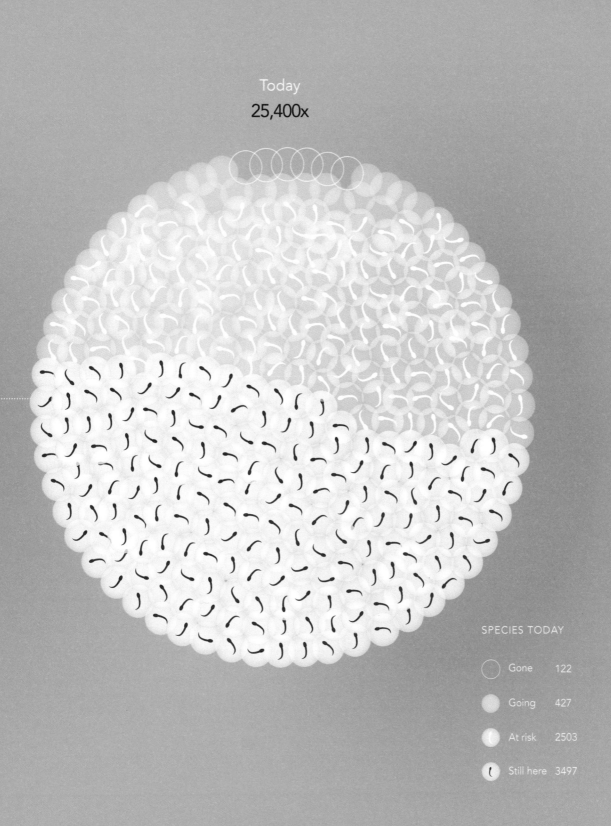

SPECIES TODAY

Gone 122

Going 427

At risk 2503

Still here 3497

source: National Academy Of Sciences, Discovery.com

Motive

Searches for the phrase "we broke up because..."

he couldn't keep his hands to himself • "we're at different stages in our lives" • she was cheating with women • he wanted to experience the whole college thing • he said he needed space • he's a complete idiot • I was guy I **I don't clip my toenails enough** cheating on him so he made-out with the was cheating on him with • of Drugs • of Def Jam • of her partying ways • his parents don't like me • his girlfriend got suspicious • her husband needs oral sex • I didn't love her • i too much control him • of all of the time he spent on his attempts to break into film-making • we had different life goals • of religious reasons – he refused to worship me • of my drinking – I binge drink • he has a small pee-pee and wouldn't buy me any jewellery • I smothered her • we didn't have anything in common and everything was completely physical • of parental disapproval • he pressured me into having sex • I have a high-pitched voice! **she just realized I'm a better friend** I wasn't comfortable telling her who I really am • we fell out of love • he couldn't keep his hands to himself • he is traumatized by his former relationship and can't reach his feelings for anything or anyone. • We, well, my family has money • i moved. i want him back more than i can say • I basically caught him in bed with one of his co-workers • he liked another guy. Yes, a guy • he was short and kind of looked like a giant mole that stood upright • of one of those arguments • she was way too hurt by my lack of effort to call her• I "bug" him • I was overprotective? • he lied too much & went crazy & punched a hole in the wall • he made out with my friend • i realized me being insecure due to the hurtful past experiences, was not going to enable us to **he doesn't have "love" for me** take our relationship to the next level • he said i wasnt treating him right. and i wasnt • of time and dist. • I was a complete arsehole to her • of this election • i asked "are we ok?" caused she seemed a little weird lately and she said next time you ask that again we are thru • we fought a lot and several red flags kept showing up • I felt that he deserved better than me. • I needed help. I have abandonment, insecurity, and anxiety issues • she wants to find herself as an individual • she likes to deal with her problems alone and not to really share them • he thinks his career won't match up to mine • I realized that I had been gradually developing strong feelings for one of her close friends • He belonged to a different religion and wanted me to convert • not because I got somebody pregnant • she hurt me on Valentines night • we love each other? • we had never been with anyone else and we felt it was too serious for our age **of artistic differences** • We Were On A Break And I Started To Treat Him Bad • i lied about my age • I can't make him stay with me • He's in love with his mother • I'm "immature" & like to party too much...... ummm hello I'm twenty-one!!!! I couldn't have a tree • she didn't want to change her FB status • of the stock market • I'm passive • I wouldn't submit to his views on what a wife should be • we couldn't agree on a sex position together • he only saw me as a weekend fling • he has a fatal flaw, as caring, romantic, and intuitive as he is, he has a horrid temper... • I felt that he wasn't present in the relationship. I felt alone while seeing him • he was gay • I feel that I hurt her too much and I feel she deserves better • i told simple lies (small lies that i didnt have to tell) • im too "clingy" • he cheated on me twice **he told people I was crazy** and it was a year ago • I was jealous that he swiped her ass with her credit card, and not mine • she was too flirty • she just realized I'm a better friend. • he always ignored me and got mad over any little thing. He was extremely jealous • he messed around with my worse enemy • the sex was bad • his fear of commitment?!? • he is not financially stable • I am dangerous • no reason

source: searches for "we broke up because..." on Facebook, Twitter & Google. Apologies for heterosexual bias.

Timing
Most common break-up times, according to Facebook status updates

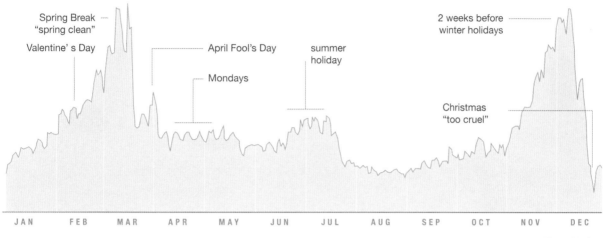

Spring Break "spring clean"

Valentine's Day

April Fool's Day

Mondays

summer holiday

2 weeks before winter holidays

Christmas "too cruel"

| JAN | FEB | MAR | APR | MAY | JUN | JUL | AUG | SEP | OCT | NOV | DEC |

source: Facebook lexicon

Delivery
Most common methods of break-up

Those born before 1975

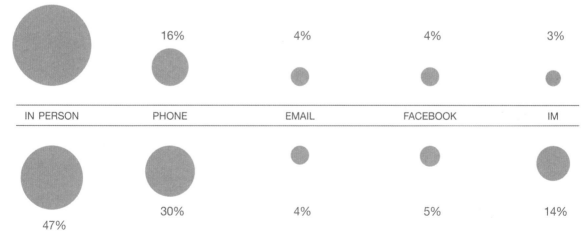

74%

16%

4%

4%

3%

| IN PERSON | PHONE | EMAIL | FACEBOOK | IM |

47%

30%

4%

5%

14%

Those born after 1984

source: survey of 10,000 Twitter users

Good News
It's all we could find. Sorry.

Booming trees & plants

6.2%

Thanks to climate change. source: NASA

National smoking bans

27

source: Wikipedia

Smokers quitting

4%

source: Cancer Council Victoria

Russian health spending

+ 200%

source: WHO

The Good of Bush
Stuff that improved under Dubya

Artifical limb research funds

$7.2m

source: *Christian Science Monitor*

Violent crime

8%

source: US Dept. Justice

Painkiller sales

88%

2001 2005

source: *Pharmatimes*

Roads in Afghanistan

2793 km
1999

Mobile phones & cancer

SAFE

source: 20-year 420,000 person Danish study

CFC usage

96%

1986 2006

source: NASA

Gender pay gap

20%
2001

16%
2007

source: OECD

Shark Attacks

2000

79

62

2007

source: University Of Florida

Leaded fuel

2001

1%

2006

source: UN

Patients getting free anti-viral drugs in Africa

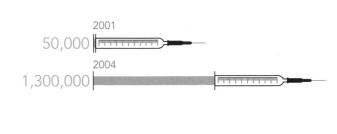

2001
50,000

2004
1,300,000

source: *The Independent*

Education budget

29%

Racial gaps in results

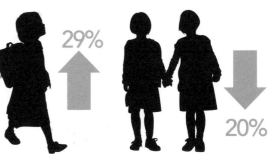

20%

source: US Dept. of Education

12350 km
2008

source: USAID

Feeding Frenzy
The organic food market

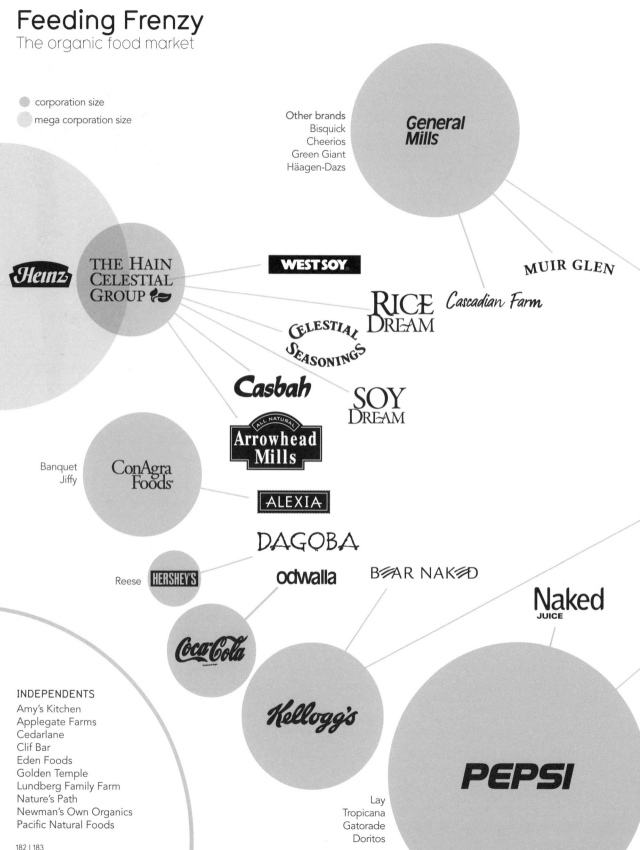

corporation size
mega corporation size

Other brands
Bisquick
Cheerios
Green Giant
Häagen-Dazs

General Mills

THE HAIN CELESTIAL GROUP

Heinz

WEST SOY

MUIR GLEN

Cascadian Farm

RICE DREAM

CELESTIAL SEASONINGS

Casbah

SOY DREAM

ALL NATURAL
Arrowhead Mills

Banquet
Jiffy

ConAgra Foods

ALEXIA

DAGOBA

Reese **HERSHEY'S**

odwalla

B★AR NAK★D

Naked
JUICE

Coca-Cola

Kellogg's

PEPSI

INDEPENDENTS
Amy's Kitchen
Applegate Farms
Cedarlane
Clif Bar
Eden Foods
Golden Temple
Lundberg Family Farm
Nature's Path
Newman's Own Organics
Pacific Natural Foods

Lay
Tropicana
Gatorade
Doritos

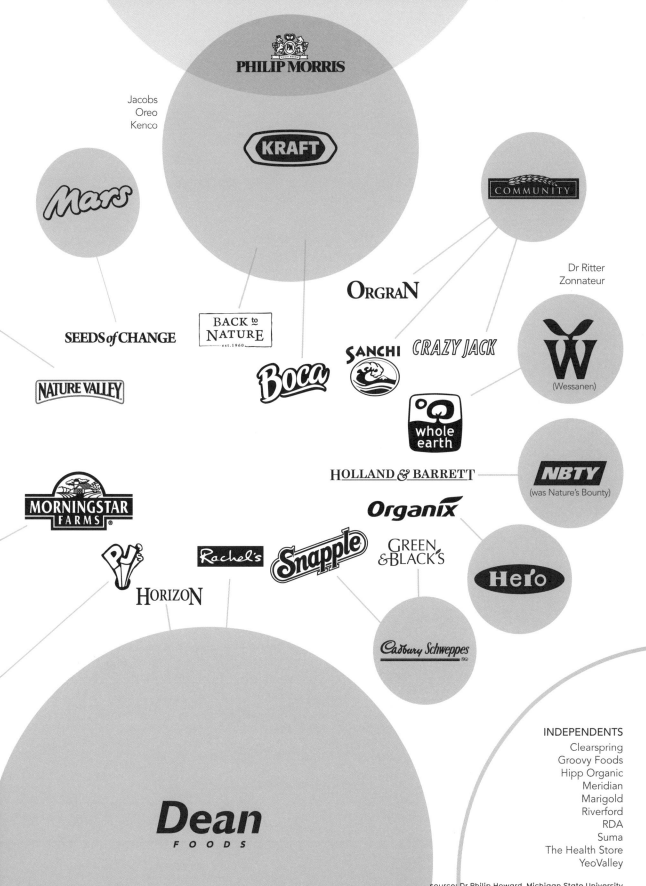

PHILIP MORRIS

Jacobs
Oreo
Kenco

KRAFT

COMMUNITY

Mars

Dr Ritter
Zonnateur

ORGRAN

SEEDS of CHANGE

BACK to NATURE
est.1960

CRAZY JACK

SANCHI

W
(Wessanen)

Boca

NATURE VALLEY

whole earth

HOLLAND & BARRETT

NBTY
(was Nature's Bounty)

MORNINGSTAR FARMS®

Organix

PJ's

Rachel's

Snapple

GREEN &BLACK'S

Hero

HORIZON

Cadbury Schweppes

Dean
FOODS

INDEPENDENTS
Clearspring
Groovy Foods
Hipp Organic
Meridian
Marigold
Riverford
RDA
Suma
The Health Store
YeoValley

source: Dr Philip Howard, Michigan State University

Virtual Kingdoms
Massively multiplayer online worlds

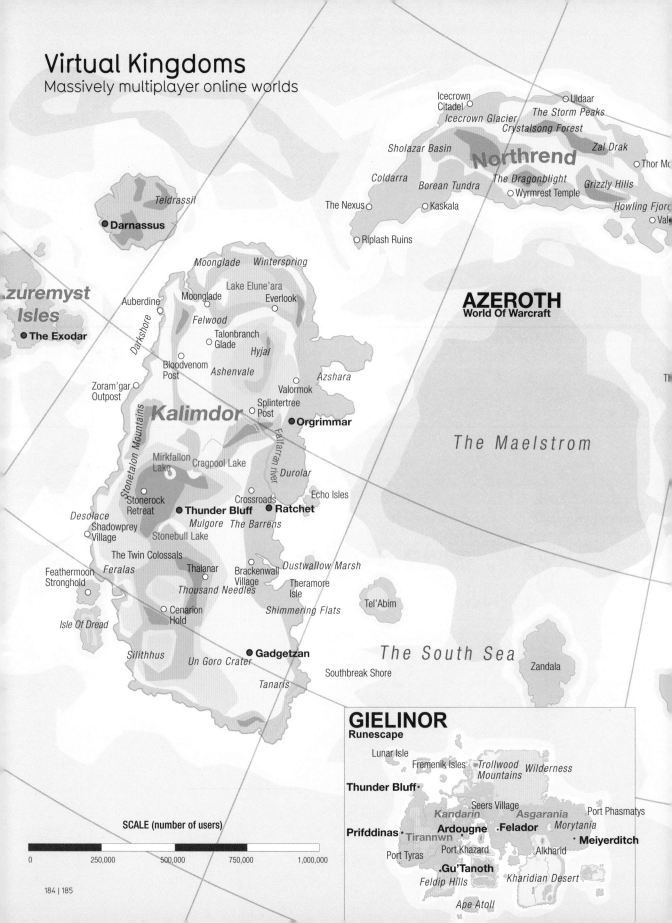

Icecrown
Citadel
○ Uldaar
Icecrown Glacier
The Storm Peaks
Crystalsong Forest
Sholazar Basin
Zal Drak
Northrend
Coldarra
The Dragonblight
○ Thor Mo
Borean Tundra
○ Wyrmrest Temple
Grizzly Hills
The Nexus ○
○ Kaskala
Howling Fjor
○ Val

AZEROTH
World Of Warcraft

○ Riplash Ruins

Teldrassil
● **Darnassus**

**zuremyst
Isles**
● **The Exodar**

Moonglade Winterspring
Lake Elune'ara
Auberdine
Moonglade
Everlook
○
Felwood
Talonbranch
○ Glade
Hyjal
Bloodvenom
Post
Ashenvale
Zoram'gar
Outpost
Valormok
○
Splintertree
□ Post
● **Orgrimmar**
Kalimdor

The Maelstrom

Mirkfallon
Lake
Cragpool Lake
Durolar
Stonerock
Retreat
Crossroads
Echo Isles
Desolace
Shadowprey
○ Village
● **Thunder Bluff** ● **Ratchet**
Mulgore *The Barrens*
Stonebull Lake
The Twin Colossals
Feralas Thalanar
Brackenwall
Village
Dustwallow Marsh
Feathermoon
Stronghold
Thousand Needles
Theramore
Isle
Shimmering Flats
Tel'Abim
Cenarion
Hold
Isle Of Dread
Silithhus
The South Sea
Zandala
Un Goro Crater ● **Gadgetzan**
Southbreak Shore
Tanaris

GIELINOR
Runescape

Lunar Isle
Fremenik Isles *Trollwood Wilderness*
Mountains
Thunder Bluff ·
Seers Village
Kandarin *Asgarania* Port Phasmatys
Prifddinas · **Ardougne** · ● **Feludor** *Morytania*
Tirannwn
● **Meiyerditch**
Port Tyras Port Khazard Alkharid
·**Gu'Tanoth**
Feldip Hills *Kharidian Desert*
Ape Atoll

SCALE (number of users)

| 0 | 250,000 | 500,000 | 750,000 | 1,000,000 |

Nordheim

Vanaheim Asgard Hyperborea Sythia Path

Korvela Cimmeria Brythunia Hyrkania

Venarium Border Kingdom Nemedia Yezud Rhamdam

Aquilonia Belverus Yaralet Vilayet Khorosun

Tanasub Galparan Numalia Shadizar Sea

Tarantia Poloponni Sultanapur Onagrul

Shanor Lanthe Aghrapur Khoraf

Kordava Argos Koth Kuthchemes Akhlat Secunderam

Zingara Eruk Shem Samara Meru

Barachan Messantta Asgalun Luxur Set Punt Shangara Ghulist

Isles Khemi River Styx Petion Iranistan Ayodhya

Isle Of The Sukhmet Stygia Keshan Yanaidor Anshan Kosala Peshkhauri

Black Ones Kush Xuchot Alkmeenon Kassali Khorala

Xuthal Gazal Keshai Yola Pong Vendh

Tomalku Black Kingdoms Denizkenar Isles Of Misty

Kulalo Pearl Isles

Abombi The Forbidden City

Southern **HYBORIA**

Isles Age Of Conan

Eastern Plaguelands

Tirisfal Glades Western Plaguelands

Undercity **Eastern Kingdoms**

Lordamere Lake The Hinterlands

Alterac Mountains

oulcher Silverpine Forest Tarren Mill Hammerfall **Western Mini. Zone**

Southshore Aerie Peak Dwarven Vi

Aralhi Highlands Frozen Val

Plunderous Plair

ADEN Schuttgart Archaic For

Lineage II

Wetlands Valley Of The Lords Pavel Ruins

Menethil Orc Village

Harbour Valley Of Heroes Monastic

Ironforge Fortress

Loch Modan Valley Of

Swamp Saints

Dun Morogh Fortress

Kargath **Rune** Swamp of Screams

Searing Gorge Badlands

Primeval Isle Fortress of **Western**

Blackrock Spire the Dead Blazing S

Burning Steppes Dark Elven Village Ivory Fortress Forest Of Evil

Stormwind Redridge Mountains **Aden**

Elwynn Forest Swamp of Sorrows Swampland Elven Village Enchanted Ba

Sentinel Hill Darkshire Stonard Kamael Village **Oren** Valley Narsell L

Westfall Hills Of Gold Elven Fortress Forsa

Deadwind Nethergarde Keep Neutral Zone Iris

Grom'Gol Pass The Blasted Lands Lake Hunters Fortre

Base Camp Evil Hunting Grounds Death Marsh

Stranglehorn Gludio **Cruma Tower**

Vale Cruma Marshlands Dragon Valley

Booty Bay **Dion** **Giran**

Gludin Plains Of Dion Alligator

Floran Island Isle C

Wasteland Hive Fortress Aaru Fortress Pray

ELEVATION (in magic metres) Langk Lizardmen Devil's

Dwellings Southern Fortress Isle Heine

-2000 +1000 +500 +250 +50 +0 +50 +200 +500 +1000 +2000 Talking

Island

Avatars
Most common online character names

James Dave
Chad
Bailey Jim
Richard
Peter
Charles
Helen David
Chris
Paul
Alexander
Adam Pablo Aaron
Daniel Andrew
Max
Rob Ryan Ace
Ben Ed Sam
Joe
Mike Alex Jay **Echo Jack** John Oscar Jason
Charlie Michael Bob
Charlie Liam Craig Steve
Ivan
Angel Johnny
Dan
Echo Jean Andy
Brian JJ
Robert Mark
Faith
Richard Jimmy
Bishop onyx Bane
Enigma
Beowulf Panic rhapsody Toxic
Shadowflame Merciless
Polgara Sage Raven Darklord Bender
Lancealot Turin
Blooddrunk Twinkz Darken Rapidfire
Vengeful Aeus Crysis Twinkie Bubbles
Starfire Obama Mork
Raistlin Doomkin Blessed Nightroad
Retaliation Sapphire Manwe Necrosis Fallen
Boomkin Sparticus
Sephyroth Xerxes Ravage Roland Femmefatale Illusion Martyr
Stabby Bubbles ImBehindU Dante
Lanfear Illusion Prowl Moonkin Dreadlock Scar
Flamestrike Killshot Vindicator Shadowstab
Raijin Ruin Shadowhawke

source: Obijan.com, World Of Warcraft forums

Immortality

Biographies of the famously long-lived examined for clues to longevity

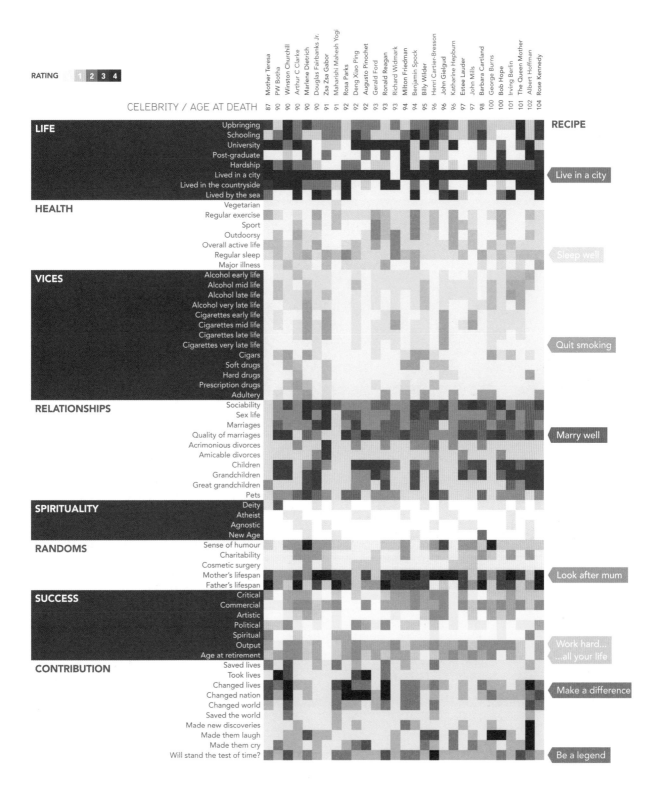

RATING 1 2 3 4

CELEBRITY / AGE AT DEATH

Mother Teresa 87 · PW Botha 90 · Winston Churchill 90 · Arthur C Clarke 90 · Marlene Dietrich 90 · Douglas Fairbanks Jr. 90 · Zsa Zsa Gabor 91 · Maharishi Mahesh Yogi 91 · Rosa Parks 92 · Deng Xiao Ping 92 · Augusto Pinochet 92 · Gerald Ford 93 · Ronald Reagan 93 · Richard Widmark 93 · Milton Friedman 94 · Benjamin Spock 94 · Billy Wilder 95 · Henri Cartier-Bresson 96 · John Gielgud 96 · Katharine Hepburn 96 · Estee Lauder 97 · John Mills 97 · Barbara Cartland 98 · George Burns 100 · Bob Hope 100 · Irving Berlin 101 · The Queen Mother 101 · Albert Hoffman 102 · Rose Kennedy 104

LIFE — Upbringing · Schooling · University · Post-graduate · Hardship · Lived in a city · Lived in the countryside · Lived by the sea

HEALTH — Vegetarian · Regular exercise · Sport · Outdoorsy · Overall active life · Regular sleep · Major illness

VICES — Alcohol early life · Alcohol mid life · Alcohol late life · Alcohol very late life · Cigarettes early life · Cigarettes mid life · Cigarettes late life · Cigarettes very late life · Cigars · Soft drugs · Hard drugs · Prescription drugs · Adultery

RELATIONSHIPS — Sociability · Sex life · Marriages · Quality of marriages · Acrimonious divorces · Amicable divorces · Children · Grandchildren · Great grandchildren · Pets

SPIRITUALITY — Deity · Atheist · Agnostic · New Age

RANDOMS — Sense of humour · Charitability · Cosmetic surgery · Mother's lifespan · Father's lifespan

SUCCESS — Critical · Commercial · Artistic · Political · Spiritual · Output · Age at retirement

CONTRIBUTION — Saved lives · Took lives · Changed lives · Changed nation · Changed world · Saved the world · Made new discoveries · Made them laugh · Made them cry · Will stand the test of time?

RECIPE — Live in a city · Sleep well · Quit smoking · Marry well · Look after mum · Work hard... ...all your life · Make a difference · Be a legend

source: Wikipedia

Red Vs. Blue

Scientists have discovered that when two evenly matched teams compete,
the team wearing red wins most often

American Football		American Football		Football		Football	
San Francisco 49'ers	Denver Broncos	Kansas City Chiefs	Tennessee Titans/ Houston Oilers	Arsenal	Chelsea	Manchester United	Manchester City
Handball		**Baseball**		**Ice Hockey**		**Rugby League**	
Norway	France	LA Anaheim Angels	Toronto Blue Jays	Detroit Red Wings	Columbus Blue Jackets	Wigan Warriors	Leeds Rhinos
Rugby Union		**Ten Pin Bowling**		**Politics**		**Politics**	
Gloucester	Bristol	U.S.A.	Europe	Democrats	Republican	Labour	Conservative

Red
Vs.
Blue

win 8
draw 2
win 2

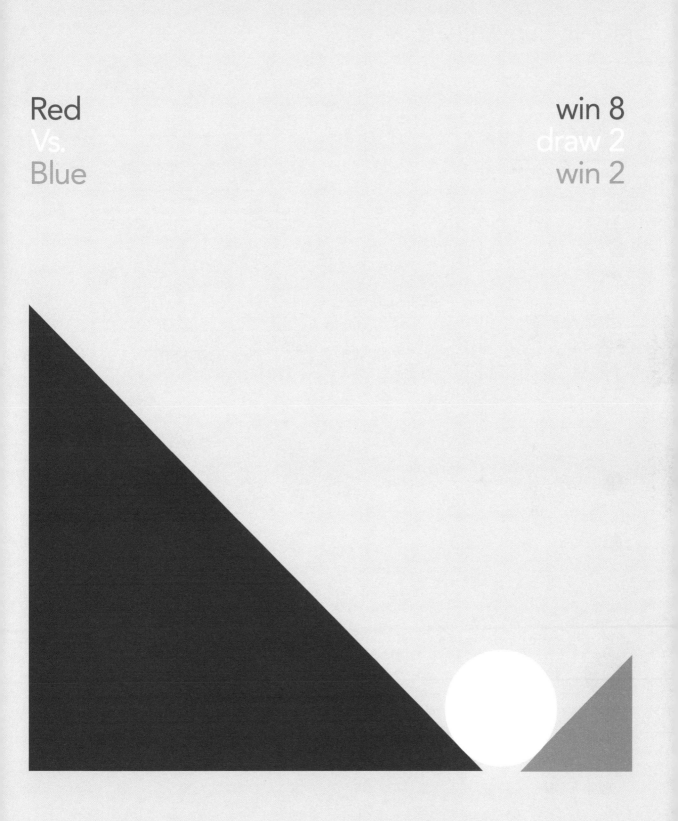

source: Hill & Barton, University Of Durham, Journal Of Sports Sciences [via Nature], Wikipedia

Man's Humanity to Man
Ah, that's better

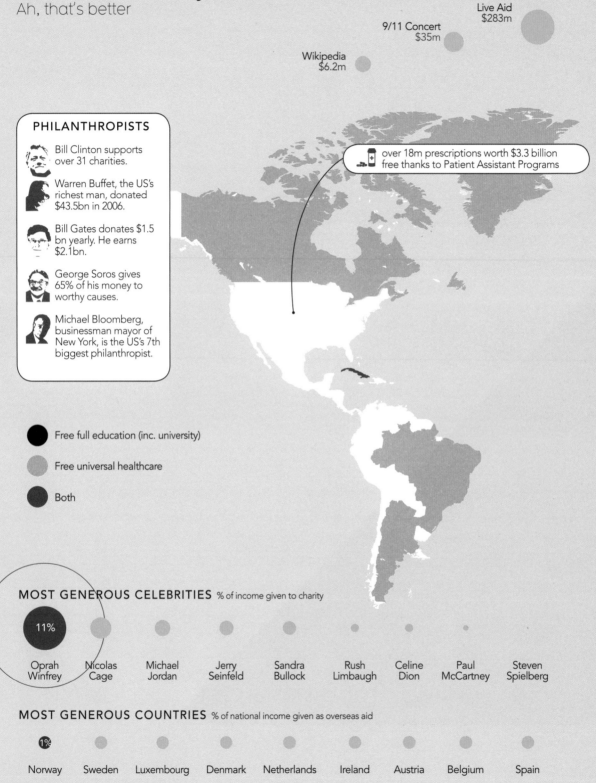

Wikipedia
$6.2m

9/11 Concert
$35m

Live Aid
$283m

PHILANTHROPISTS

Bill Clinton supports over 31 charities.

Warren Buffet, the US's richest man, donated $43.5bn in 2006.

Bill Gates donates $1.5 bn yearly. He earns $2.1bn.

George Soros gives 65% of his money to worthy causes.

Michael Bloomberg, businessman mayor of New York, is the US's 7th biggest philanthropist.

over 18m prescriptions worth $3.3 billion free thanks to Patient Assistant Programs

Free full education (inc. university)

Free universal healthcare

Both

MOST GENEROUS CELEBRITIES
% of income given to charity

Oprah Winfrey	Nicolas Cage	Michael Jordan	Jerry Seinfeld	Sandra Bullock	Rush Limbaugh	Celine Dion	Paul McCartney	Steven Spielberg
11%								

MOST GENEROUS COUNTRIES
% of national income given as overseas aid

Norway	Sweden	Luxembourg	Denmark	Netherlands	Ireland	Austria	Belgium	Spain
1%								

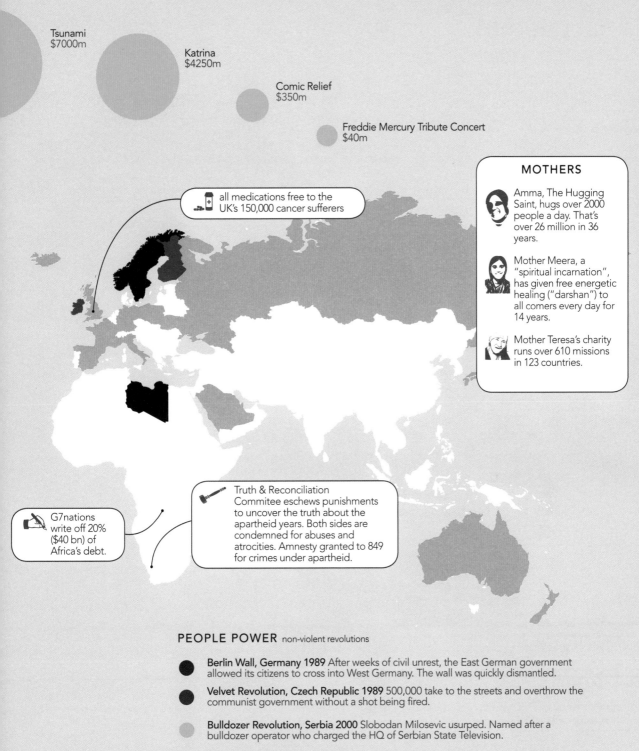

Tsunami
$7000m

Katrina
$4250m

Comic Relief
$350m

Freddie Mercury Tribute Concert
$40m

all medications free to the UK's 150,000 cancer sufferers

MOTHERS

Amma, The Hugging Saint, hugs over 2000 people a day. That's over 26 million in 36 years.

Mother Meera, a "spiritual incarnation", has given free energetic healing ("darshan") to all comers every day for 14 years.

Mother Teresa's charity runs over 610 missions in 123 countries.

G7 nations write off 20% ($40 bn) of Africa's debt.

Truth & Reconciliation Commitee eschews punishments to uncover the truth about the apartheid years. Both sides are condemned for abuses and atrocities. Amnesty granted to 849 for crimes under apartheid.

PEOPLE POWER non-violent revolutions

Berlin Wall, Germany 1989 After weeks of civil unrest, the East German government allowed its citizens to cross into West Germany. The wall was quickly dismantled.

Velvet Revolution, Czech Republic 1989 500,000 take to the streets and overthrow the communist government without a shot being fired.

Bulldozer Revolution, Serbia 2000 Slobodan Milosevic usurped. Named after a bulldozer operator who charged the HQ of Serbian State Television.

Rose Revolution, Georgia 2003 A disputed election led to the peaceful overthrow of president-elect Eduard Shevardnadze.

Orange Revolution, Ukraine 2004 Thousands protest a presidential election marred by fraud and corruption. Election annulled.

Blue Revolution, Kuwait 2005 Kuwaitis protest in support of giving women the vote. The government gives in and women vote in 2007.

source: Wikipedia, Unicef.org, Forbes.com, Un.org

Fast Internet
Most Popular Search Terms 2006

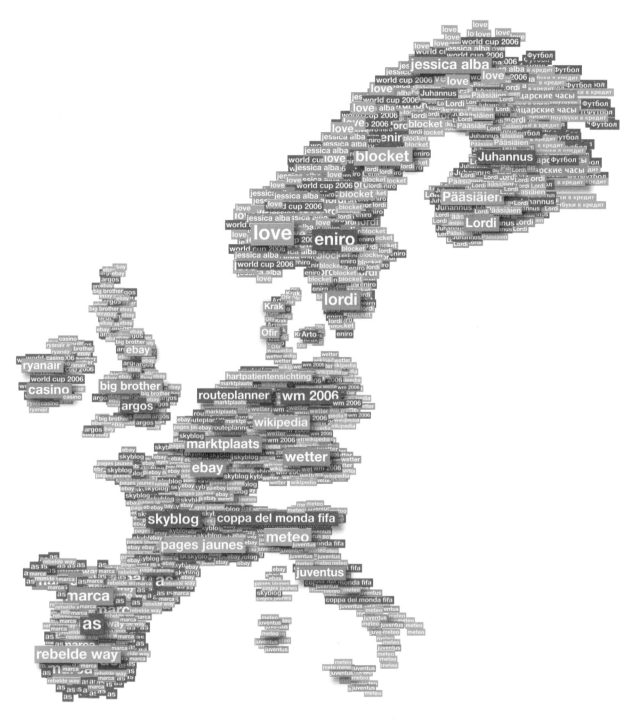

Most Popular Search Terms 2008

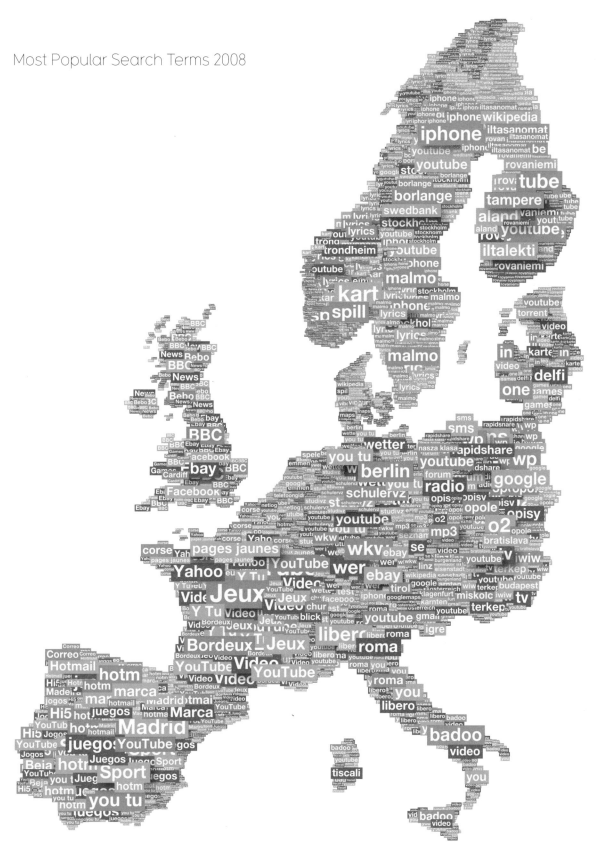

idea: Christian Lange coccu.de source: Google Zeigeist

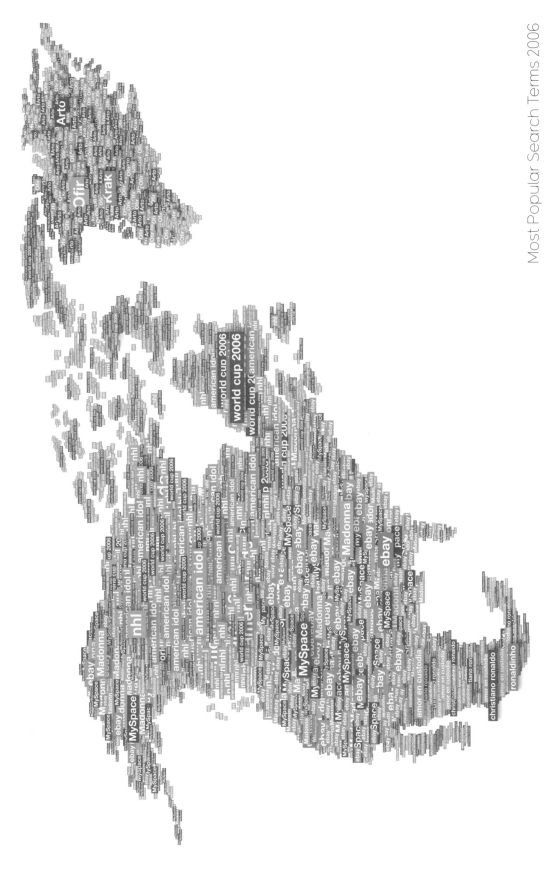

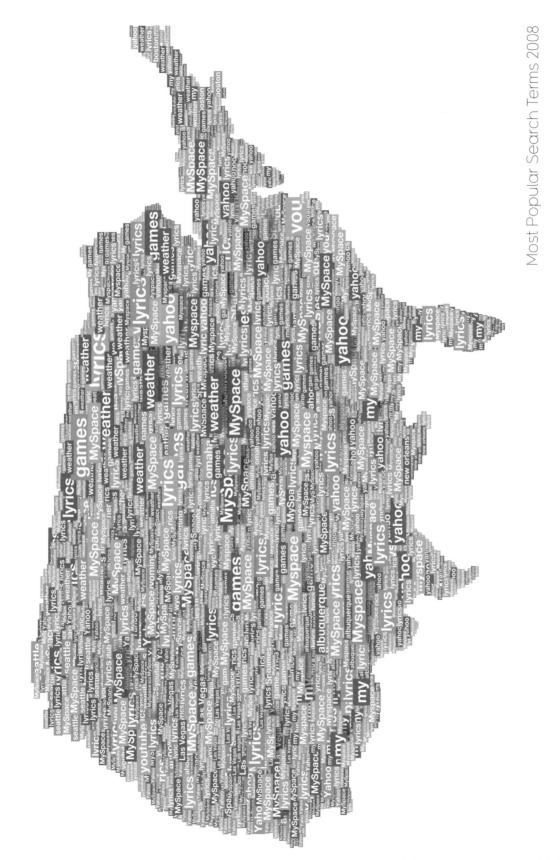

Most Popular Search Terms 2008

idea: Christian Lange coccu.de source: Google Zeigeist

Simple Part II

Time to Get Away
Legally required paid annual leave in days per year

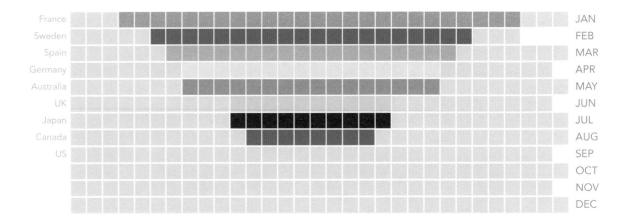

		JAN
France		FEB
Sweden		MAR
Spain		APR
Germany		MAY
Australia		JUN
UK		JUL
Japan		AUG
Canada		SEP
US		OCT
		NOV
		DEC

source: Center for Economic & Policy Research, 2007

Lack of Conviction
Rape in England and Wales

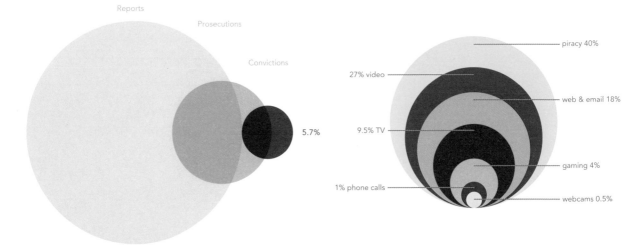

Reports

Prosecutions

Convictions

5.7%

source: UK Home Office. Figures for 2007.

Trafficking
World internet bandwidth usage

piracy 40%

27% video

web & email 18%

9.5% TV

gaming 4%

1% phone calls

webcams 0.5%

source: Cisco visual networking index

Fat Chance
Who has the most influence on your weight?

source: N.Fowler, J.Christakis, *N. England Journal Of Medicine*
[via *New Scientist*]

Shooting Stars
Worldwide yearly arms sales

USA $83b $9b Germany

UK $53b $9b Israel

Russia $33b $17b France

source: Guardian.co.uk

Caused by Global Warming
according to media reports

CLIMATE CHANGE Alaska reshaping, oak deaths, ozone repair slowing, El Nino intensification, Gulf Stream failure, new islands, sinking islands, melting alps, mud slides, volcanic eruptions, subsidence, wildfires, earthquakes, tsunamis RANDOMS witchcraft executions, violin decline, killer cornflakes, tabasco tragedy, truffle shortage, tomato rot, fashion disasters, gingerbread house collapse, mammoth dung melt, UFO sightings, mango harvest failure ANIMALS cannibal polar bears, brain-eating amoebas, aggressive elephants, cougar attacks, stronger salmon, rampant robins, shark attacks, confused birds THE EARTH! light dimming, slowing down, spins faster, wobbling, exploding SOCIAL PROBLEMS floods of migrants, suicides, drop in brothel profits, civil unrest, increased taxes, teenage drinking, early marriages, crumbling roads, deformed railways, traffic jams FOOD soaring prices, sour grapes, shop closures, haggis threat, maple syrup shortage, rice shortage, beer shortage! THE TREES! growth increase, growth decline, more colourful, less colourful HEALTH PROBLEMS dog disease, cholera, bubonic plague, airport malaria, asthma, cataracts, smaller brains, HIV, heart disease, depression LESS moose, geese, ducks, puffins, koalas EVEN LESS krill, fish, glaciers, antarctic ice, ice sheets, avalanches, coral reef MOUNTAINS shrinking, taller, flowering, breaking up INVASIONS cat, crabgrass, wasp, beatle, midge, cockroach, stingrays, walrus, giant pythons, giant oysters, giant squid MORE HEALTH PROBLEMS salmonella, kidney stones, anxiety, childhood insomnia, frostbite, fainting, dermatitis, fever, encephalitis, declining circumcision, diarrhoea, fever, dengue, yellow, west nile, hay DISASTER! boredom, next ice age, cannibalism, societal collapse, release of ancient frozen viruses, rioting and nuclear war, computer models, terrorism, accelerated evolution, conflict with Russia. billions of deaths, the end of the world as we know it

source: UK and US media reports [via numberswatch.co.uk]

Life Times

How will you spend your 77.8 years?

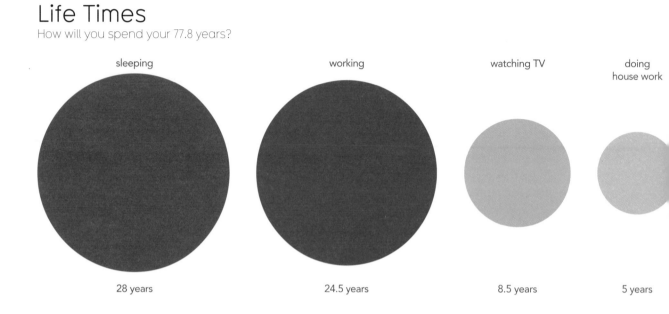

sleeping	working	watching TV	doing house work
28 years	24.5 years	8.5 years	5 years

Visible Spectrum

Current best guess for the composition of the universe Dark energy // Dark matter // Intergalactic gas // Normal matter

Invisible

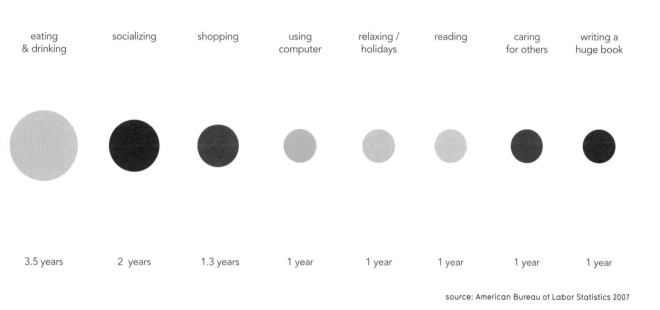

eating & drinking	socializing	shopping	using computer	relaxing / holidays	reading	caring for others	writing a huge book
3.5 years	2 years	1.3 years	1 year	1 year	1 year	1 year	1 year

source: American Bureau of Labor Statistics 2007

ns, planets, us etc)

78% 22% 3.6% 0.4%

Visible

source: Wikipedia

Mainstream-O-Meter
Average listener counts on Last.fm

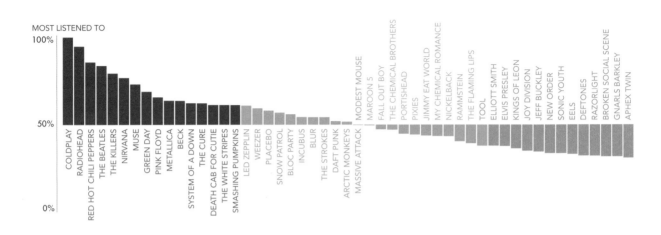

MOST LISTENED TO
100%

50%

0%

COLDPLAY
RADIOHEAD
RED HOT CHILI PEPPERS
THE BEATLES
THE KILLERS
NIRVANA
MUSE
GREEN DAY
PINK FLOYD
METALLICA
BECK
SYSTEM OF A DOWN
THE CURE
DEATH CAB FOR CUTIE
THE WHITE STRIPES
SMASHING PUMPKINS
LED ZEPPLIN
WEEZER
PLACEBO
SNOW PATROL
BLOC PARTY
INCUBUS
BLUR
THE STROKES
DAFT PUNK
ARCTIC MONKEYS
MASSIVE ATTACK
MODEST MOUSE
MAROON 5
FALL OUT BOY
THE CHEMICAL BROTHERS
PORTISHEAD
PIXIES
JIMMY EAT WORLD
MY CHEMICAL ROMANCE
NICKELBACK
RAMMSTEIN
THE FLAMING LIPS
TOOL
ELLIOTT SMITH
ELVIS PRESLEY
KINGS OF LEON
JOY DIVISION
JEFF BUCKLEY
NEW ORDER
SONIC YOUTH
EELS
DEFTONES
RAZORLIGHT
BROKEN SOCIAL SCENE
GNARLS BARKLEY
APHEX TWIN

Who's a Clever Boy?
Brain mass proportional to body mass

.02 0.4 0.5 .8 .9 1.5 1.8 2.7

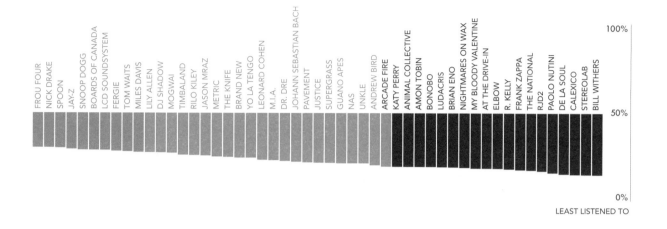

100%

FROU FOUR
NICK DRAKE
SPOON
JAY-Z
SNOOP DOGG
BOARDS OF CANADA
LCD SOUNDSYSTEM
FERGIE
TOM WAITS
MILES DAVIS
LILY ALLEN
DJ SHADOW
MOGWAI
TIMBALAND
RILO KILEY
JASON MRAZ
METRIC
THE KNIFE
BRAND NEW
YO LA TENGO
LEONARD COHEN
M.I.A.
DR. DRE
JOHANN SEBASTIAN BACH
PAVEMENT
JUSTICE
SUPERGRASS
GUANO APES
NAS
UNKLE
ANDREW BIRD
ARCADE FIRE
KATY PERRY
ANIMAL COLLECTIVE
AMON TOBIN
BONOBO
LUDACRIS
BRIAN ENO
NIGHTMARES ON WAX
MY BLOODY VALENTINE
AT THE DRIVE-IN
ELBOW
R. KELLY
FRANK ZAPPA
THE NATIONAL
RJD2
PAOLO NUTINI
DE LA SOUL
CALEXICO
STEREOLAB
BILL WITHERS

50%

0%

LEAST LISTENED TO

source: mainstream.vincentahrend.com

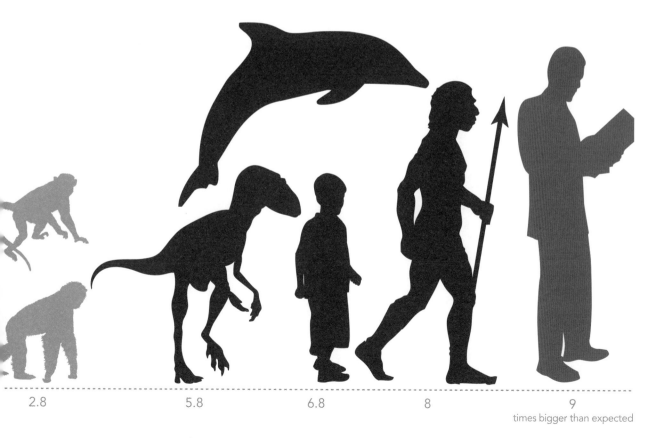

2.8 5.8 6.8 8 9

times bigger than expected

source: figures use Encephalization Quotient from Martin (1984), Stanyon, Consigliere, Moreschalchi (1993) and Jerison (1973)

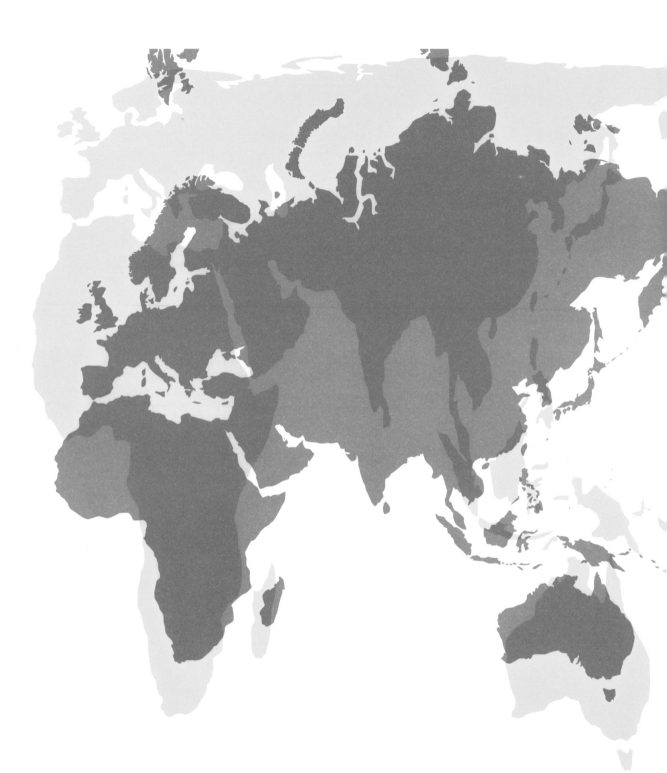

Peter's Projection
The true size of the continents

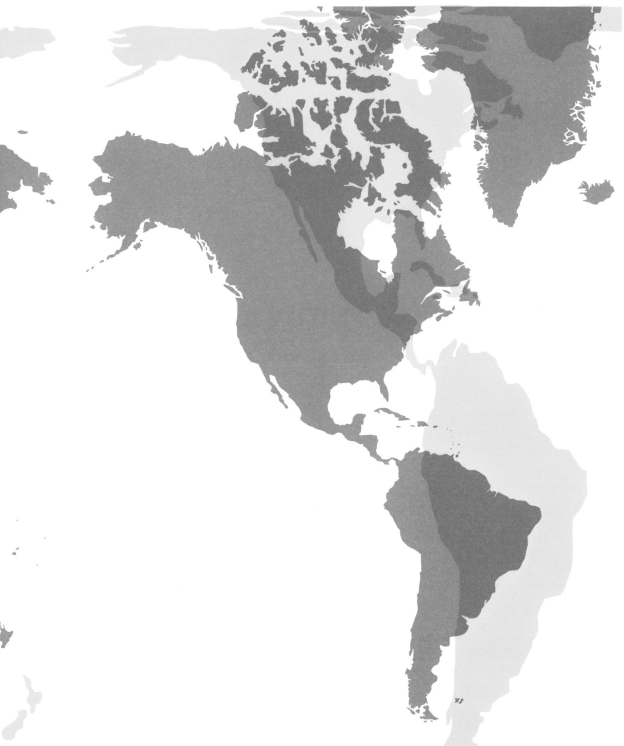

The standard "Mercator" world map inflates the size of nations depending to their distance from the equator. This means that many developing countries end up much smaller than they are in reality (i.e. most of Africa). The Peter's Projection corrects this.

Alternative Medicine

Scientific evidence for complementary therapies

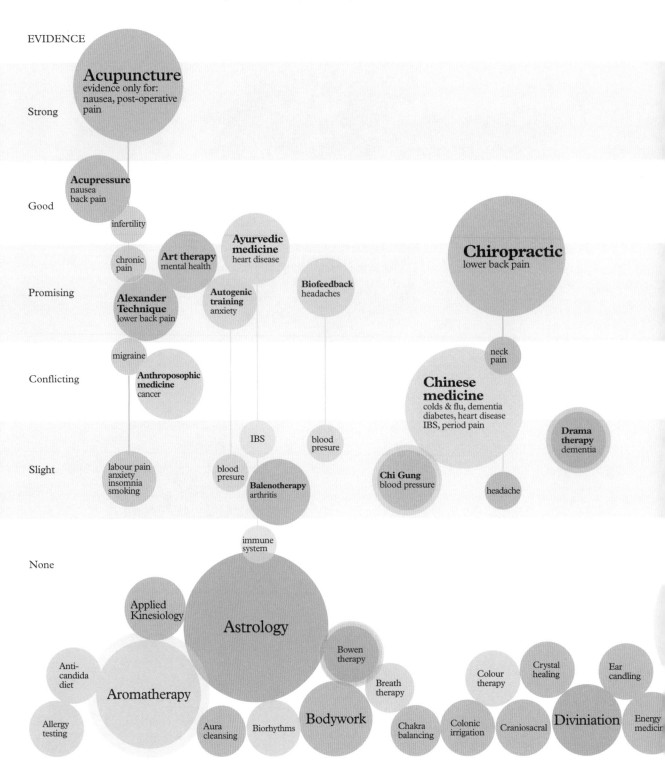

EVIDENCE

Strong

Acupuncture
evidence only for:
nausea, post-operative
pain

Good

Acupressure
nausea
back pain

infertility

chronic
pain

Art therapy
mental health

**Ayurvedic
medicine**
heart disease

Chiropractic
lower back pain

Promising

**Alexander
Technique**
lower back pain

**Autogenic
training**
anxiety

Biofeedback
headaches

migraine

neck
pain

Conflicting

**Anthroposophic
medicine**
cancer

**Chinese
medicine**
colds & flu, dementia
diabetes, heart disease
IBS, period pain

IBS

blood
presure

**Drama
therapy**
dementia

Slight

labour pain
anxiety
insomnia
smoking

blood
presure

Balenotherapy
arthritis

Chi Gung
blood pressure

headache

immune
system

None

Applied
Kinesiology

Astrology

Bowen
therapy

Colour
therapy

Crystal
healing

Ear
candling

Anti-
candida
diet

Breath
therapy

Allergy
testing

Aromatherapy

Aura
cleansing

Biorhythms

Bodywork

Chakra
balancing

Colonic
irrigation

Craniosacral

Diviniation

Energy
medicir

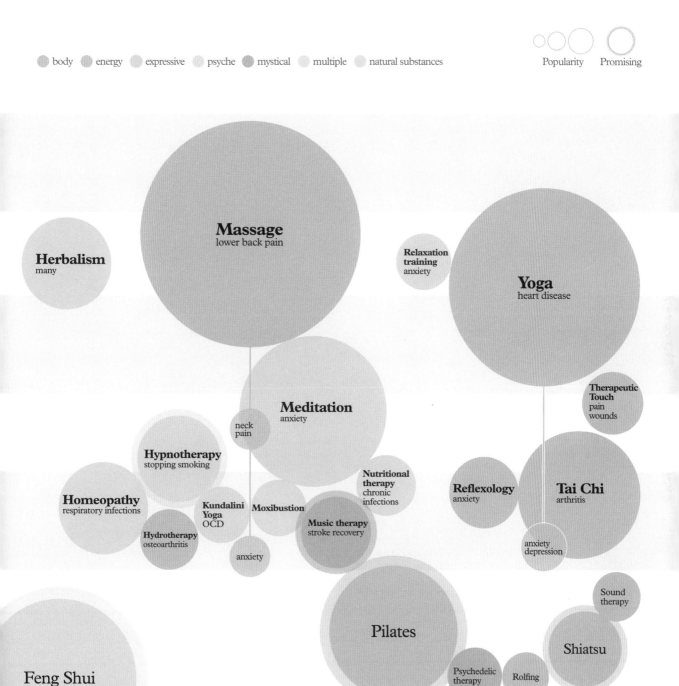

body energy expressive psyche mystical multiple natural substances

Popularity Promising

Herbalism
many

Massage
lower back pain

**Relaxation
training**
anxiety

Yoga
heart disease

**Therapeutic
Touch**
pain
wounds

Meditation
anxiety

neck
pain

Hypnotherapy
stopping smoking

**Nutritional
therapy**
chronic
infections

Homeopathy
respiratory infections

**Kundalini
Yoga**
OCD

Moxibustion

Reflexology
anxiety

Tai Chi
arthritis

Hydrotherapy
osteoarthritis

Music therapy
stroke recovery

anxiety

anxiety
depression

Sound
therapy

Pilates

Shiatsu

Feng Shui

Psychedelic
therapy

Rolfing

Iridology

Mantra

Polarity
therapy

Tantra

NLP

Reiki

Feldenkrais
method

Flower
remedies

Holotropic
Breathwork

Indian Head
massage

Macrobiotics Naturopathy

Past life
regression

Shamanic
healing

source: Cochrane.org and other English language meta-studies (via Pubmed.org)

The Cloud
Who owns the top 100 websites?

Size of corporate owner
Most influential

BBC

Disney
ABCNews

Adobe

Amazon

Alexa

amazon.com

Tripod

A9

Go

IMDb

Orange

ESPN

Nokia

About

NY Times

The New York Times Company

Newsweek

Wikipedia

Friendster

Brides

IStockPhoto

Ning Miniclip

gettyimages

IBM

Wikia

Target

JupiterImages

Livejournal

BoingBoing

Napster

Reuters Expedia

Cnet

Last.fm

Metacritic

Download MySimon
GameFAQs

Ultimate Guitar

BEST BUY

Channel4

TV **CBS**

Skyrock

Wordpress

TechRepublic VersionTracker

ArsTechnia

Game Spot GameRankings

Reddit Style

Walmart

ZDNet Mp3

CondeNet

Bestbuy

Telegraph Perfspot

The Huffington Post

Wired

Neopets

Pandora

Washington Post

Scribd

Delicious

Atom Game Trailers

FT

FoxyTunes **Flickr**

Wowhead

VIACOM

LinkedIn

Playstation Yell

Military

Upcoming.org MyBlogLog

MTV

Tumblr

Argos Sourceforge

Yahoo! Geocities

Metafilter

Tesco

Xfire

Monster

Netflix

Fasteweb

Weather iVillage

monster

NBA

ProNurses

Xanga

NBC UNIVERSAL

TheRoot

HMForces

Rhapsody Real Perezhilton

Hulu Netlogs

Ask
Reference
Bloglines
CitySearch
CollegeHumour
Gamesville Hotbot
Evite
Vimeo
Angelfire
Excite
Thesaurus
Ask
Smileycentral
Ticketmaster
Match
Ebay
Meetup
Craigslist

Truveo
RR
MapQuest
CartoonNetwork
GameTap
Bebo
Engadget
CNN
TimeWarner
PGA
AOL
Userplane
GameDaily
AIM
Sphere
Joystiq
ICQ
Nascar
Cricinfo
TUAW

Tagged
Stumbleupon
Altavista
Gumtree
ebaY
Skype
DailyMail
PayPal
Dealtime
TheFreeDictionary
Apple
Half
Shopping
Facebook

Fark
Consumer Search
MoneySavingExpert
Word Reference
GaiaOnline
Typepad
Answers
Ebaumshead
Ain'tItCool
Mozilla
Live
Xbox
Buzznet
Guardian
Forbes
BUZZNET
Guardian Media Group
Idolator Stereogum
gmg
Microsoft
Deviant Art
Digg
Autotrader
Microsoft
MSN
Information
Symantec
BudgetTravelOnline
Newegg
Xanga
FriendFeed
Runescape
WWE
Pogo
IMeem
Tradedoubler
Twitter
TheBigMoney
Foxnews
Technorati
Ikea
Blogger
Rottentomatoes
Doubleclick
Google
Odeo
IGN
WSJ
YouTube
Feedburner
Softpedia
News Corporation
Play
Foxsports
Newgrounds.com
Sky
Gamespy
Picasa
Orkut
Tube8
Archive.org
Photobucket
Plaxo
Panoramio
Quizrocket
MySpace
Slate
Hi5
Times Online Sun
Metafilter
NewYorker

source: Alexa.com, Web Trends Map @ informationarchitects.jp

Being Defensive
How psychotherapy sees you

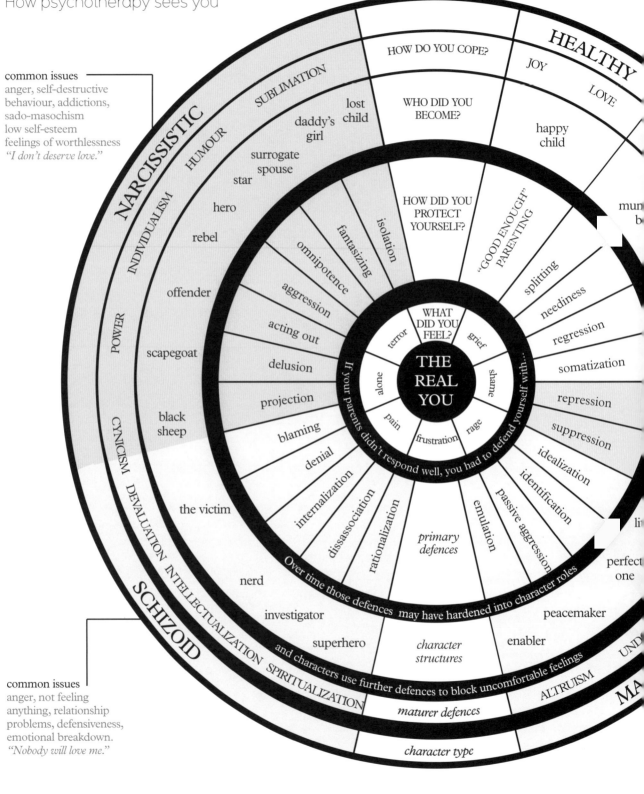

common issues
anger, self-destructive
behaviour, addictions,
sado-masochism
low self-esteem
feelings of worthlessness
"I don't deserve love."

HOW DO YOU COPE?

HEALTHY

JOY

LOVE

WHO DID YOU
BECOME?

happy
child

NARCISSISTIC

SUBLIMATION

HUMOUR

lost
child

daddy's
girl

surrogate
spouse

star

hero

INDIVIDUALISM

rebel

offender

POWER

scapegoat

black
sheep

CYNICISM DEVALUATION INTELLECTUALIZATION

SCHIZOID

SPIRITUALIZATION

the victim

nerd

investigator

superhero

fantasizing

isolation

omnipotence

aggression

acting out

delusion

projection

blaming

denial

internalization

dissassociation

rationalization

HOW DID YOU
PROTECT
YOURSELF?

"GOOD ENOUGH"
PARENTING

splitting

neediness

regression

somatization

repression

suppression

idealization

identification

passive aggression

emulation

primary
defences

character
structures

WHAT
DID YOU
FEEL?

terror grief

THE
REAL
YOU

alone shame

pain rage

frustration

If your parents didn't respond well, you had to defend yourself with...

Over time those defences may have hardened into character roles

and characters use further defences to block uncomfortable feelings

mun
b

perfect
one

peacemaker

enabler

ALTRUISM

UND

MA

li

maturer defences

character type

common issues
anger, not feeling
anything, relationship
problems, defensiveness,
emotional breakdown.
"Nobody will love me."

ORAL

EROTICIZATION

DISPLACEMENT

PLANNING

PERFECTIONISM

REVERSAL

RIGID

MASOCHISTIC

the baby

sickly child

family rescuer

parent

common issues
addictions, manic depression,
lethargy, rage, suicidal
impulses, chaotic lifestyle
"I can't get love for myself."

common issues
sex-love-intimacy problems,
stress, inflexibility, failed
relationships, compulsions
coldness, nervous breakdown
"I don't know what love is."

common issues
obsessive compulsions,
abusive relationships, fear,
anxiety, phobias, self-harm,
obesity, depression, nervous
breakdown.
"I'll be loved if I'm good."

PRIMARY DEFENCES

acting out
turn it into behaviour

aggression
attacking

blaming
someone else's fault

delusion
lie to yourself & believe it

denial
it's not happening

dissassociation
go numb

distortion
changing the story to fit

emulation
copy what you know

fantasizing
go into other worlds

idealization
over regard for others

identification
forge an alliance

internalization
holding it all in

isolation
separate off feelings

neediness
over-dependence on another

omnipotence
all powerful, no weakness

passive aggression
indirect & concealed attacks

projection
put your feelings on someone

regression
revert back to immaturity

repression
unconsciously burying it

rationalization
a false but plausible excuse

somatization
turn it into a physical illness

splitting
good/bad, love/hatred

suppression
consciously burying it

MATURER DEFENCES

altruism
efface it with good deeds

cynicism
everything is false

devaluation
it doesn't matter

displacement
find a teddy bear

eroticization
safety in sex

humour
deflect with jokes

individualism
celebrate it

intellectualization
turn it into safe concepts

perfectionism
never slip up again

power
control everyone

planning
safety in organization

reversal
do the opposite of how you feel

spiritualization
it's all a divine purpose

sublimation
make art out of it

undoing
constant acts of compensation

source: the work of Freud, Heinz Kohut, John Bradshaw and A.H.Almaas

Being Defensive
How psychotherapy works

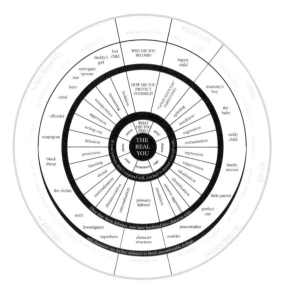

You slowly build a relationship of trust and intimacy with the therapist. That allows you to investigate, explore and ultimately learn to drop your outer defences without feeling threatened.

Exploring your life history, you re-experience situations and relationships from childhood in slow motion with the therapist. This way you can bring adult awareness and understanding to those experiences.

Some types of therapy and their target areas

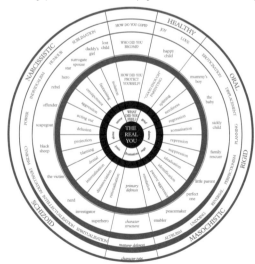

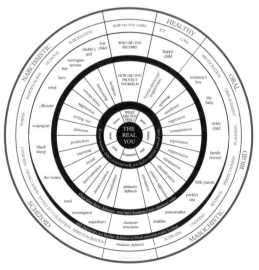

PSYCHOANALYSIS Explores the connection between (possibly "forgotten") events in early life and current disturbances and stress. Talking freely allows fantasies, feelings, dreams and memories to emerge more easily.

COGNITIVE-BEHAVIOURAL THERAPY Uncovering and understanding how inaccurate thoughts, beliefs and assumptions can lead to inaccurate interpretations of events and so to negative emotions and behaviours.

As those experiences are re-felt, digested, understood and perhaps resolved, the difficult and unbearable feelings you weren't able to feel at the time can also be felt. Deeper blocks and resistances may be revealed.

As those feelings are repeatedly felt, you learn to understand, tolerate and deal with them. The "real you", underneath all the defences, can be felt. Nothing really changes. All your defences are still there. You just feel less blocked and become more "transparent".

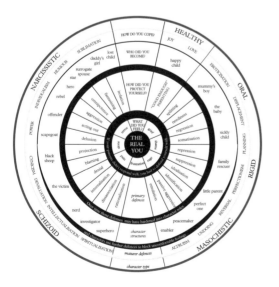

ANTI-DEPRESSANTS Reducing the intensity of symptoms of depression and anxiety and other symptoms of psychological disturbance and distress through regular use of psychiatric medicine.

Most Popular US Girls' Names

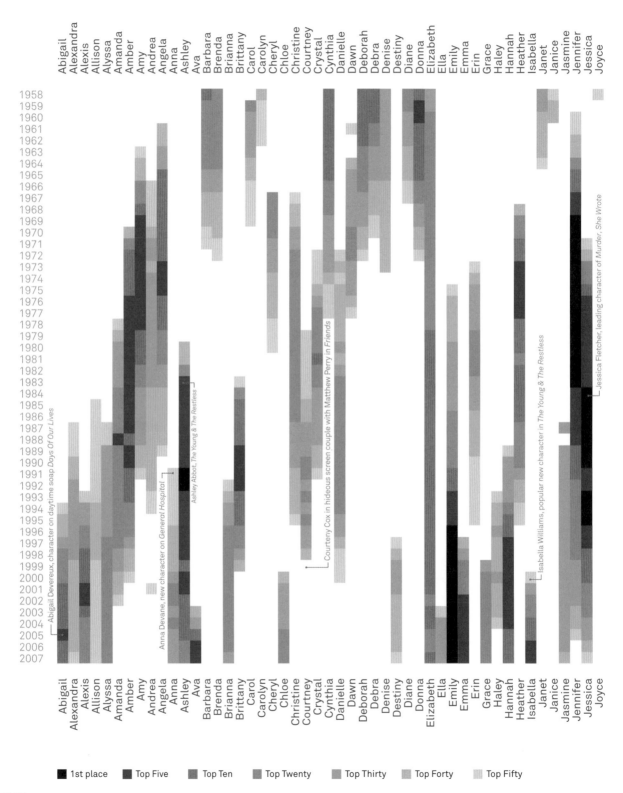

1st place · Top Five · Top Ten · Top Twenty · Top Thirty · Top Forty · Top Fifty

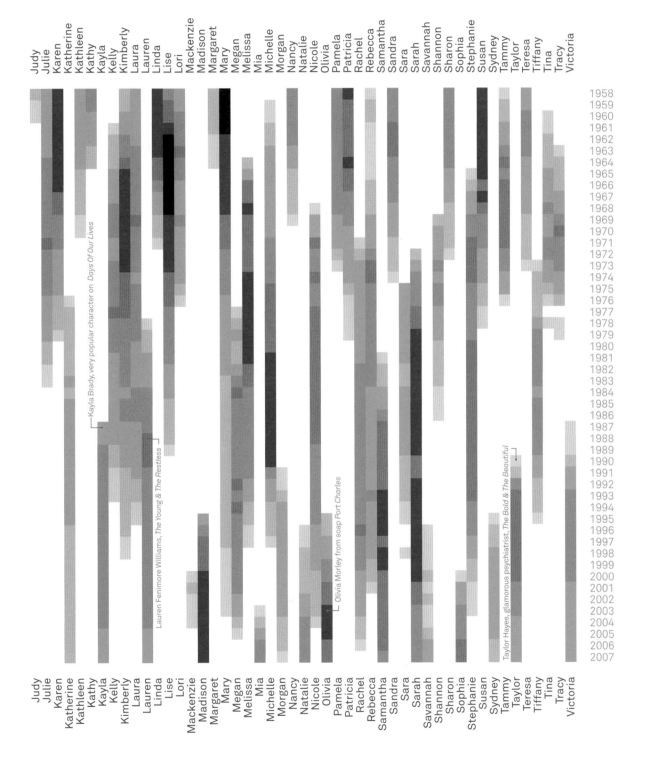

Judy Julie Karen Katherine Kathleen Kathy Kayla Kelly Kimberly Laura Lauren Linda Lise Lori Mackenzie Madison Margaret Mary Megan Melissa Mia Michelle Morgan Nancy Natalie Nicole Olivia Pamela Patricia Rachel Rebecca Samantha Sandra Sara Sarah Savannah Shannon Sharon Sophia Stephanie Susan Sydney Tammy Taylor Teresa Tiffany Tina Tracy Victoria

1958
1959
1960
1961
1962
1963
1964
1965
1966
1967
1968
1969
1970
1971
1972
1973
1974
1975
1976
1977
1978
1979
1980
1981
1982
1983
1984
1985
1986
1987
1988
1989
1990
1991
1992
1993
1994
1995
1996
1997
1998
1999
2000
2001
2002
2003
2004
2005
2006
2007

Kayla Brady, very popular character on *Days Of Our Lives*

Lauren Fenimore Williams, *The Young & The Restless*

Olivia Morley from soap *Port Charles*

Taylor Hayes, glamorous psychiatrist, *The Bold & The Beautiful*

source: US Social Security Administration @ ssa.gov

Most Popular US Boys' Names

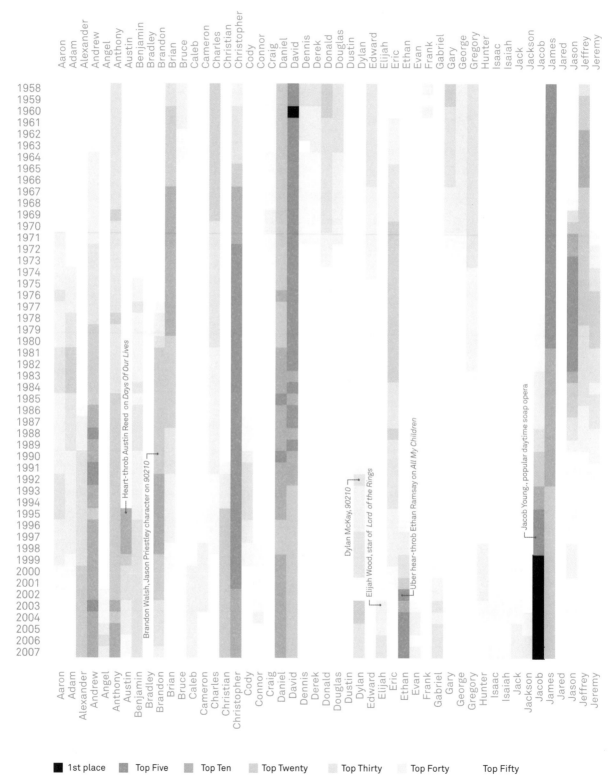

1st place — Top Five — Top Ten — Top Twenty — Top Thirty — Top Forty — Top Fifty

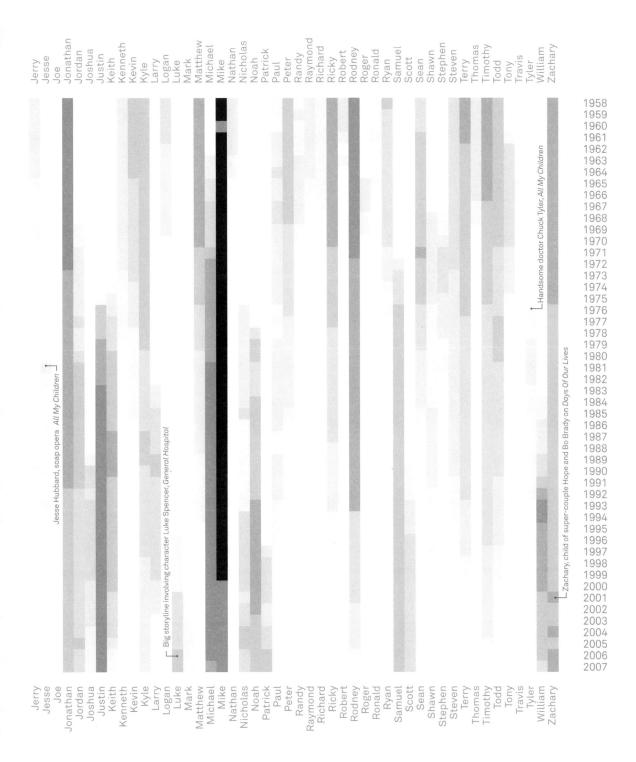

Jerry
Jesse
Joe
Jonathan
Jordan
Joshua
Justin
Keith
Kenneth
Kevin
Kyle
Larry
Logan
Luke
Mark
Matthew
Michael
Mike
Nathan
Nicholas
Noah
Patrick
Paul
Peter
Randy
Raymond
Richard
Ricky
Robert
Rodney
Roger
Ronald
Ryan
Samuel
Scott
Sean
Shawn
Stephen
Steven
Terry
Thomas
Timothy
Todd
Tony
Travis
Tyler
William
Zachary

Jesse Hubbard, soap opera *All My Children*

Big storyline involving character Luke Spencer, *General Hospital*

Handsome doctor Chuck Tyler, *All My Children*

Zachary, child of super-couple Hope and Bo Brady on *Days Of Our Lives*

1958
1959
1960
1961
1962
1963
1964
1965
1966
1967
1968
1969
1970
1971
1972
1973
1974
1975
1976
1977
1978
1979
1980
1981
1982
1983
1984
1985
1986
1987
1988
1989
1990
1991
1992
1993
1994
1995
1996
1997
1998
1999
2000
2001
2002
2003
2004
2005
2006
2007

source: US Social Security Administration @ ssa.gov

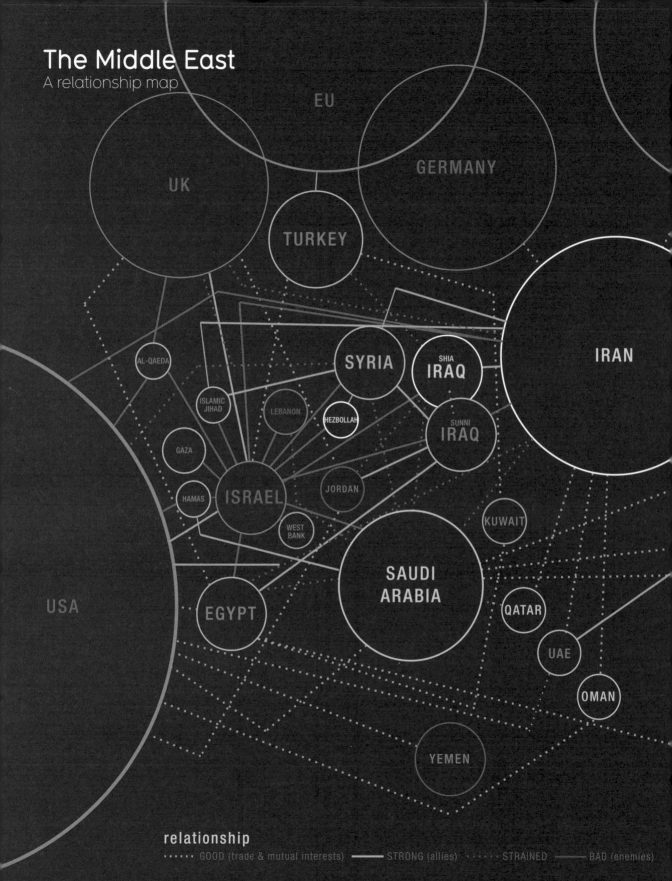

The Middle East
A relationship map

EU

UK

GERMANY

TURKEY

AL-QAEDA

SYRIA

SHIA
IRAQ

IRAN

ISLAMIC
JIHAD

LEBANON

HEZBOLLAH

SUNNI
IRAQ

GAZA

ISRAEL

JORDAN

HAMAS

KUWAIT

WEST
BANK

SAUDI
ARABIA

QATAR

USA

EGYPT

UAE

OMAN

YEMEN

relationship

······· GOOD (trade & mutual interests) ——— STRONG (allies) ······· STRAINED ——— BAD (enemies)

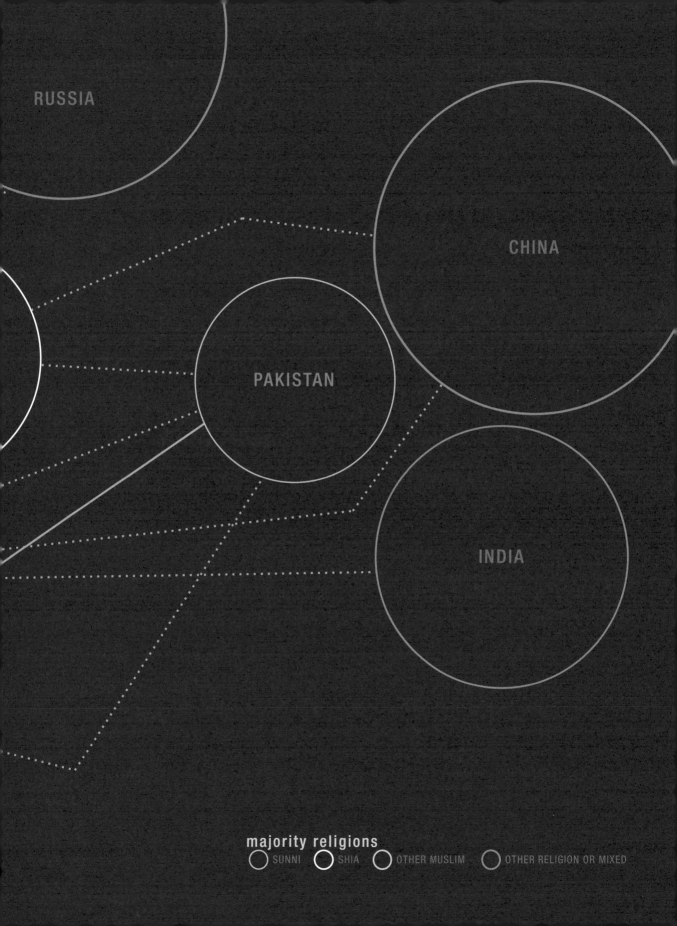

RUSSIA

CHINA

PAKISTAN

INDIA

majority religions
SUNNI SHIA OTHER MUSLIM OTHER RELIGION OR MIXED

The Middle East: Some Context
Palestinian territories

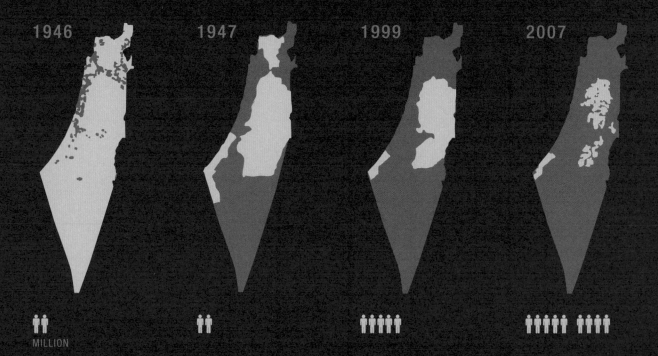

1946 1947 1999 2007

MILLION

Oil States
Who has the world's oil?

2009

Oil States
Who'll have the world's oil?

2020

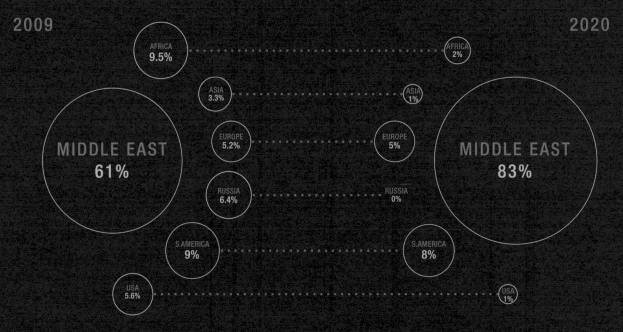

	2009	2020
AFRICA	9.5%	2%
ASIA	3.3%	1%
EUROPE	5.2%	5%
MIDDLE EAST	61%	83%
RUSSIA	6.4%	0%
S.AMERICA	9%	8%
USA	5.6%	1%

The Future Of Energy
Place your bets

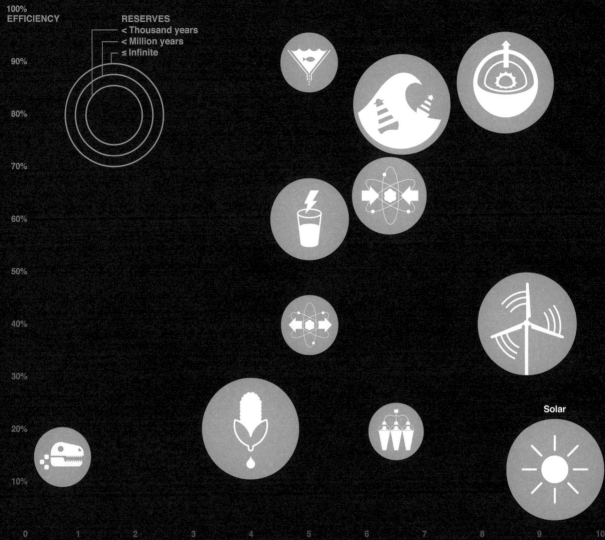

100%
EFFICIENCY

RESERVES
< Thousand years
< Million years
≤ Infinite

90%

80%

70%

60%

50%

40%

30%

Solar

20%

10%

0 1 2 3 4 5 6 7 8 9 10
CLEAN

Biofuel – To replace all of America's petrol consumption with biofuel from plants would take three quarters of all the cultivated land on the face of the Earth.

Fossil Fuel – By products: sulfur dioxide, carbon monoxide, methane, poisonous metals like lead, uranium and of course CO_2.

Geothermal – Drilling for free heat under the earth's surface has lots of advantages and is pollution free. Iceland gets 20% of its energy this way. But watch out for earthquakes!

Human Batteries – The energy in the food needed to feed human power sources is greater than the energy generated. Doh.

Hydroelectric – There's an unavoidable built-in limit to dams. There are only so many places you can put them. And space is running out...

Hydrogen – Currently 96% of hydrogen is made using fossil fuels.

Nuclear Fission – To meet the world's electricity needs from nuclear power would require 2230 more nuclear power stations. There are currently 439 in operation. They can take 5–10 years to build.

Nuclear Fusion – Recreates the temperatures at the heart of the sun. Generates much less nuclear waste than fission. But no one can work out how to do it. "At least 50 years away".

Solar – To replace all current electricity production in the US with solar power would take an area of approximately 3500 square miles (3% of Arizona's land area) covered in solar panels. In most areas of the world, solar panels would cover 85% of household water heating needs.

Tidal – Several question marks remain. Mostly related to its impact on environment and biodiversity.

Wind – Turbines covering about 0.5% of all US land would power the entire country. Around 73,000 to 144,000 5-megawatt wind turbines could power electric cars for every

source: Wikipedia, USGS

Kiss

The Beatles

Black Sabbath

Red Hot Chili Peppers

Nirvana

Aerosmith

The Beach Boys

Pink Floyd

Genesis

The Ramones

AC/DC

U2

Dead members
Sacked members
Members who just gave up
Replaced drummers
Extra lead guitarists
Changes in musical direction
Classical music pretensions
Albums disowned by band
Number of concept albums

Most Successful Rock Bands
True rock success got nothin' to do with selling records

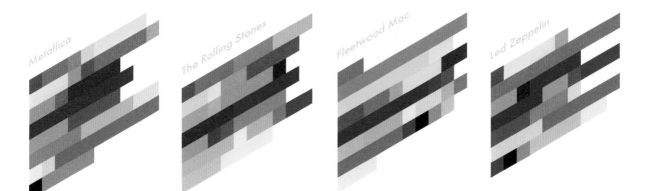

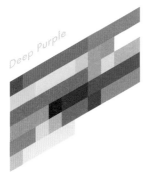

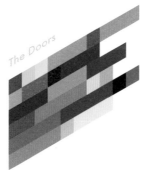

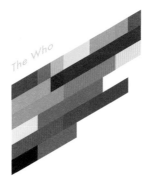

Sex/drugs in album titles	Visits to rehab	Sexual tension in band	Number of estates
Longest time to finish album	Alcoholic members	Supermodel relationships	Glib political statements
Offshoot groups	Heavy drug using members	Record company disputes	Disastrous TV appearances
Solo albums	Hotel room trashings	Court cases	Feature films made
Disbanded and reformed	Own vomit chokings	Hits critically panned	Tribute bands
Severe musical differences	Religious/occult dabblings	Flops critically acclaimed	Riffs heard in guitar shops
Largest single audience	God complex rating	Sheer ardency of fans	'"Greatest Hits" albums
Onstage breakdowns	Groupies	Number of mansions	
Likelihood of cancelling gigs	Divorces	Number of islands	

source: Wikipedia

22 Stories
P=The Protagonist

Fish Out Of Water P tries to cope in a completely different place/time/world.
Mr Bean, Trading Places

Discovery Through a major upheaval, P discovers a truth about themselves and a better understanding of life.
Close Encounters, Ben-Hur

Escape P trapped by antagonistic forces and must escape. Pronto.
Poseiden Adventure, Saw

Journey & Return P goes on a physical journey and returns changed.
Wizard Of Oz, Star Wars

Temptation P has to make a moral choice between right and wrong.
The Godfather, The Sting

Rags To Riches P is poor, then rich.
Trading Places, La Vie En Rose

The Riddle P has to solve a puzzle or a crime.
The Da Vinci Code, Chinatown

Metamorphosis P literally changes into something else (i.e. a werewolf, hulk, giant cockroach)
Spiderman, Pinocchio

Rescue P must save someone who is trapped physically or emotionally.
The Golden Compass, Die Hard

Tragedy P is brought down by a fatal flaw in their character or by forces out of their control.
One Flew Over the Cuckoo's Nest, Atonement

Love A couple meet and overcome obstacles to discover true love. Or – tragically – don't.
Titanic, Grease

Monster Force A monster / alien / something scary and supernatural must be fought and overcome.
Jaws, The Exorcist

Revenge P retaliates against another for a real or imagined injury.
Batman, Kill Bill

Transformation P lives through a series of events that change them as a person.
Pretty Woman, Muriel's Wedding

Maturation P has an experience that matures them or starts a new stage of life, often adulthood.
The Graduate, Juno

Pursuit P has to chase somebody or something, usually in a hide-and-seek fashion.
Goldfinger, Bourne Ultimatum

Rivalry P must triumph over a adversary to attain an object or goal.
Rocky, The Outsiders

Underdog Total loser faces overwhelming odds but wins in the end.
Slumdog Millionaire, Forrest Gump

Comedy A series of complications leads P into ridiculous situations.
Ghostbusters, Airplane

Quest P searches for a person, place or thing, overcoming a number of challenges.
Raiders Of The Lost Ark, Lord of the Rings

Sacrifice P must make a difficult choice between pleasing themselves or a higher purpose (e.g. love, honour).
300, 3:10 to Yuma

Wretched Excess P pushes the limits of acceptable behaviour, destroying themselves in the process.
There Will Be Blood, Citizen Kane

source: Tennesse Screenwriting Association, Robert McKee's *Story*

Most Profitable Hollywood Stories 2007
By percentage of budget recovered

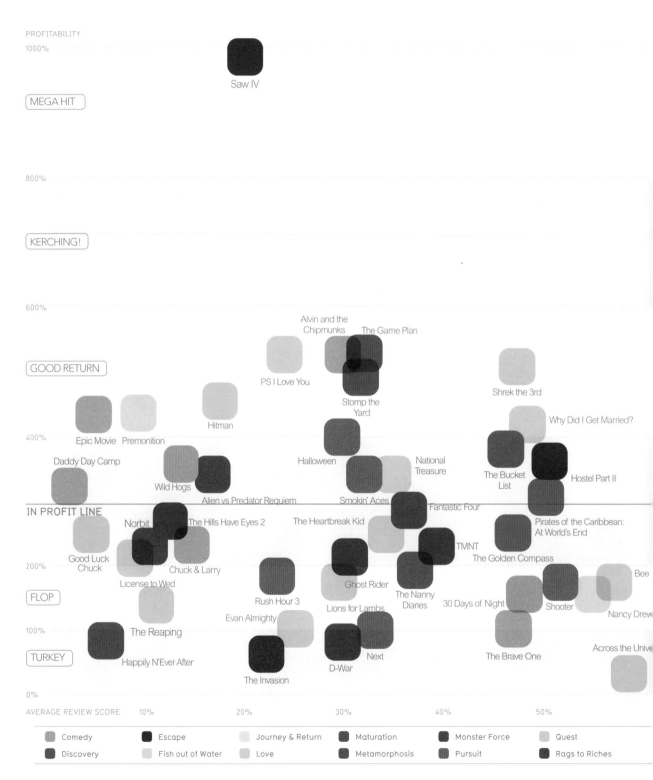

PROFITABILITY

1000%

MEGA HIT

Saw IV

800%

KERCHING!

600%

GOOD RETURN

Alvin and the
Chipmunks The Game Plan

PS I Love You

Shrek the 3rd

Stomp the
Yard

Why Did I Get Married?

Epic Movie Premonition Hitman

400%

Daddy Day Camp

Halloween National
Treasure

The Bucket
List Hostel Part II

Wild Hogs

Alien vs Predator Requiem Smokin' Aces

IN PROFIT LINE

Fantastic Four

Norbit The Hills Have Eyes 2 The Heartbreak Kid

Pirates of the Caribbean:
At World's End

TMNT

The Golden Compass

Good Luck
Chuck

200% Bee

License to Wed Chuck & Larry Ghost Rider

FLOP Rush Hour 3 Lions for Lambs The Nanny 30 Days of Night Shooter
 Diaries Nancy Drew

Evan Almighty

100% Across the Unive

The Reaping Next

TURKEY D-War The Brave One

Happily N'Ever After

The Invasion

0%

AVERAGE REVIEW SCORE 10% 20% 30% 40% 50%

| Comedy | Escape | Journey & Return | Maturation | Monster Force | Quest |
| Discovery | Fish out of Water | Love | Metamorphosis | Pursuit | Rags to Riches |

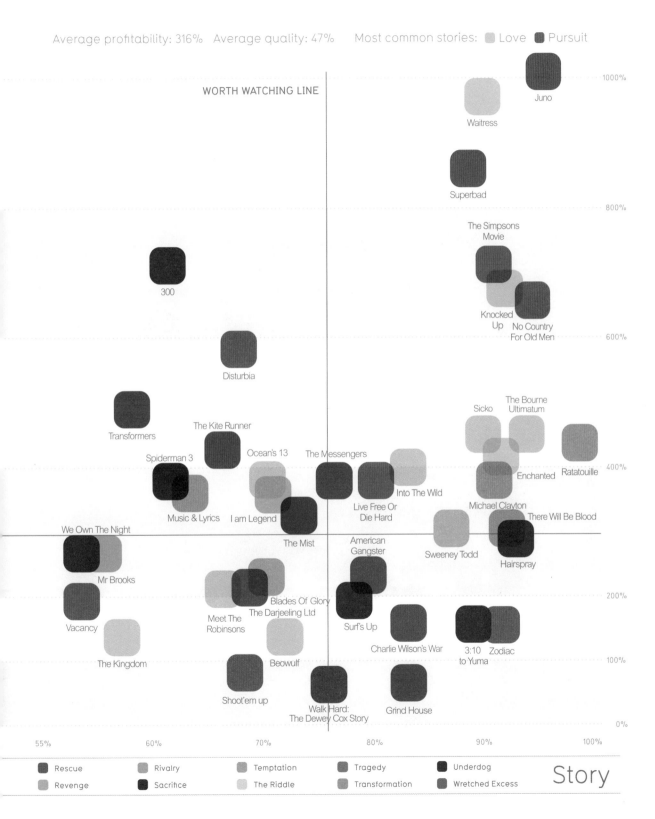

Average profitability: 316% Average quality: 47% Most common stories: ■ Love ■ Pursuit

WORTH WATCHING LINE

1000%

Juno

Waitress

Superbad

800%

The Simpsons
Movie

300

Knocked
Up No Country
For Old Men

600%

Disturbia

Sicko The Bourne
Ultimatum

Transformers

The Kite Runner

Ocean's 13 The Messengers

Spiderman 3 Enchanted Ratatouille

400%

Music & Lyrics I am Legend Into The Wild

Live Free Or Michael Clayton
Die Hard

We Own The Night There Will Be Blood

The Mist American
Gangster Sweeney Todd Hairspray

Mr Brooks

Blades Of Glory 200%

Meet The The Darjeeling Ltd
Robinsons Surf's Up

Vacancy Charlie Wilson's War 3:10 Zodiac
to Yuma

The Kingdom Beowulf 100%

Shoot'em up Walk Hard: Grind House
The Dewey Cox Story

0%

55% 60% 70% 80% 90% 100%

■ Rescue ■ Rivalry ■ Temptation ■ Tragedy ■ Underdog
■ Revenge ■ Sacrifice ■ The Riddle ■ Transformation ■ Wretched Excess

Story

source: BoxOfficeMojo.com, The-Numbers.com, Wikipedia, IMDB.com & RottenTomatoes.com. Note: reported film budgets are notoriously unreliable
(especially for flops)

Most Profitable Bollywood Stories 2007

Average profitability: 292% Average quality: 59% Most common stories: ▨ Love ▩ Pursuit

PROFITABILITY

1000%

MEGA HIT

Taare Zameen Par

800%

KERCHING!

Heyy Babyy

Honeymoon
Travels Pvt Ltd

Bhool Bhulaiyaa

Jab We Met

Guru

Chak De India

600%

Om Shanti Om

GOOD RETURN

Welcome

Laaga Chunari
Mein Daag

Life in a
Metro

Fool and Final Ta Ra
Rum Pum

400%

Namastey
London

Jhoom
Barabar
Jhoom Dhol

Shootout at
Lokhandwala

Cheeni Kum

Aap Kaa
Surroor

IN PROFIT LINE

Partner

Aaja Nachle

Salaam-E-Ishq

Cash

Naqaab Apne

200%

Shaka Laka
Boom Boom

Dhan Dhan
Dhan Goal

FLOP

Ram Gopal
Verma Ki Aag

Nishabd

Awarapan

100%

Traffic Signal

Dus Kahaniyaan

TURKEY

0%

AVERAGE REVIEW SCORE 20% 40% 60% 80% 100%

| ▨ Comedy | ■ Escape | ▨ Journey & Return | ▨ Maturation | ▨ Monster Force | ▨ Quest |
| ▩ Discovery | ▨ Fish out of Water | ▨ Love | ▨ Metamorphosis | ▨ Pursuit | ▨ Rags to Riches |

Most Profitable UK Stories 2007

Average profitability: 277% Average quality: 71% Most common stories: ■ Comedy ■ Monster–Force

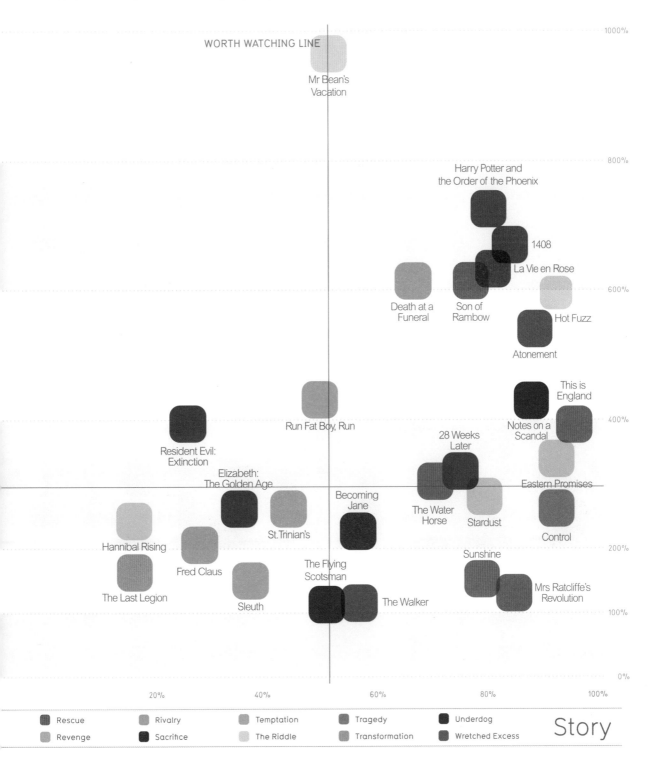

WORTH WATCHING LINE

1000%

Mr Bean's Vacation

800%

Harry Potter and the Order of the Phoenix

1408

La Vie en Rose

600%

Death at a Funeral

Son of Rambow

Hot Fuzz

Atonement

This is England

400%

Run Fat Boy, Run

28 Weeks Later

Notes on a Scandal

Resident Evil: Extinction

Elizabeth: The Golden Age

Becoming Jane

Eastern Promises

The Water Horse

Stardust

Control

200%

Hannibal Rising

St. Trinian's

Sunshine

Fred Claus

The Flying Scotsman

Mrs Ratcliffe's Revolution

The Last Legion

Sleuth

The Walker

100%

0%

20% 40% 60% 80% 100%

■ Rescue ■ Rivalry ■ Temptation ■ Tragedy ■ Underdog

■ Revenge ■ Sacrifice ■ The Riddle ■ Transformation ■ Wretched Excess

Story

source: Naachgaana.com, BoxOfficeIndia.com, The-Numbers.com, BoxOfficeMojo.com & The British Film Institute.

Most Profitable Hollywood Stories 2008

By percentage of budget recovered

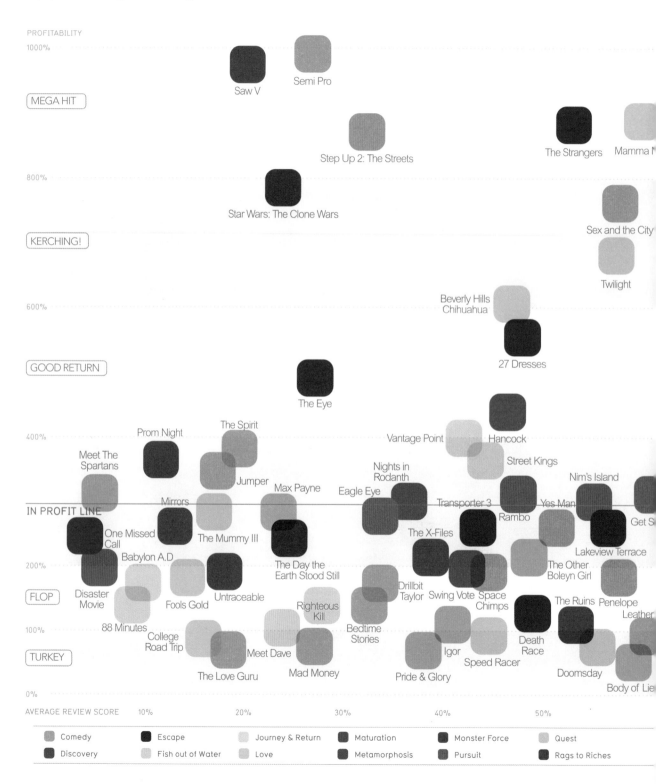

PROFITABILITY

1000%

MEGA HIT

Saw V

Semi Pro

The Strangers

Mamma M

Step Up 2: The Streets

800%

Star Wars: The Clone Wars

KERCHING!

Sex and the City

Twilight

Beverly Hills
Chihuahua

600%

27 Dresses

GOOD RETURN

The Eye

The Spirit

400%

Prom Night

Vantage Point

Hancock

Meet The
Spartans

Nights in
Rodanth

Street Kings

Nim's Island

Jumper

Max Payne

Eagle Eye

Transporter 3

Yes Man

Mirrors

IN PROFIT LINE

Rambo

Get S

One Missed
Call

The Mummy III

The X-Files

Lakeview Terrace

Babylon A.D

200%

The Day the
Earth Stood Still

Drillbit
Taylor

Swing Vote

Space
Chimps

The Other
Boleyn Girl

FLOP

Disaster
Movie

Fools Gold

Untraceable

Righteous
Kill

The Ruins

Penelope

Leather

88 Minutes

Bedtime
Stories

100%

College
Road Trip

Death
Race

TURKEY

Meet Dave

Igor

Doomsday

The Love Guru

Mad Money

Pride & Glory

Speed Racer

Body of Lie

0%

AVERAGE REVIEW SCORE 10% 20% 30% 40% 50%

Comedy Escape Journey & Return Maturation Monster Force Quest

Discovery Fish out of Water Love Metamorphosis Pursuit Rags to Riches

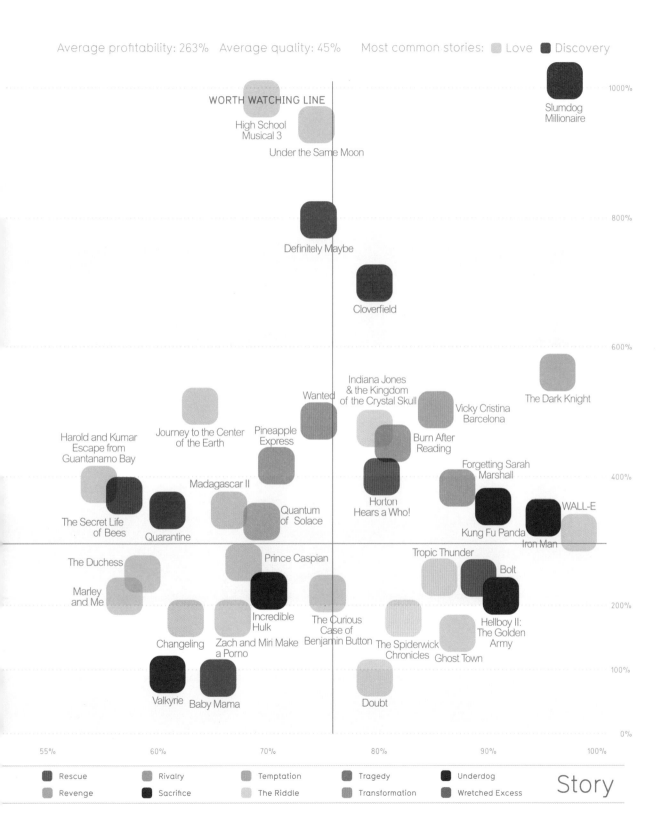

Average profitability: 263% Average quality: 45% Most common stories: ◼ Love ◼ Discovery

Slumdog Millionaire

WORTH WATCHING LINE

High School Musical 3

Under the Same Moon

Definitely Maybe

Cloverfield

The Dark Knight

Indiana Jones & the Kingdom of the Crystal Skull

Wanted

Vicky Cristina Barcelona

Journey to the Center of the Earth

Pineapple Express

Burn After Reading

Harold and Kumar Escape from Guantanamo Bay

Forgetting Sarah Marshall

Madagascar II

Horton Hears a Who!

WALL-E

The Secret Life of Bees

Quantum of Solace

Kung Fu Panda

Iron Man

Quarantine

Prince Caspian

Tropic Thunder

Bolt

The Duchess

Marley and Me

Incredible Hulk

The Curious Case of Benjamin Button

The Spiderwick Chronicles

Hellboy II: The Golden Army

Changeling

Zach and Miri Make a Porno

Ghost Town

Valkyrie

Baby Mama

Doubt

1000%
800%
600%
400%
200%
100%
0%

55% 60% 70% 80% 90% 100%

◼ Rescue ◼ Rivalry ◼ Temptation ◼ Tragedy ◼ Underdog

◼ Revenge ◼ Sacrifice ◼ The Riddle ◼ Transformation ◼ Wretched Excess

Story

source: BoxOfficeMojo.com, The-Numbers.com, Wikipedia, IMDB.com & RottenTomatoes.com. Note: reported film budgets are notoriously unreliable (especially for flops)

Most Profitable Bollywood Stories 2008

Average profitability: 155% Average quality: 62% Most common stories: ■ Love ■ Temptation

PROFITABILITY

1000%

MEGA HIT

Jaane Tu Ya Jaane Ne

800%

KERCHING!

600%

Ghajini

GOOD RETURN

400%

Rab Ne Bana
Di Jodi

Black & White

Janat

Bachna Ae
Haseeno

IN PROFIT LINE

Golmaai Returns

Race

Sarkar Raj

200%

Krazzy 4

One Two
Three

Heroes

Jodhaa Akbar

FLOP

My Name is
Anthony Gonsalves

Fashion

100%

Halla Bol

Khuda Kay Liye

Mere Baap
Pehle Aap

Kismat
Konnection

Mithiya

TURKEY

Love Story 2050

God Tussi Great Ho

0%

20% 40% 60% 80% 100%

■ Comedy ■ Escape ■ Journey & Return ■ Maturation ■ Monster Force ■ Quest
■ Discovery ■ Fish out of Water ■ Love ■ Metamorphosis ■ Pursuit ■ Rags to Riches

Most Profitable UK Stories 2008

Average profitability: 148% Average quality: 57% Most common stories: ◼ Love ◼ Discovery

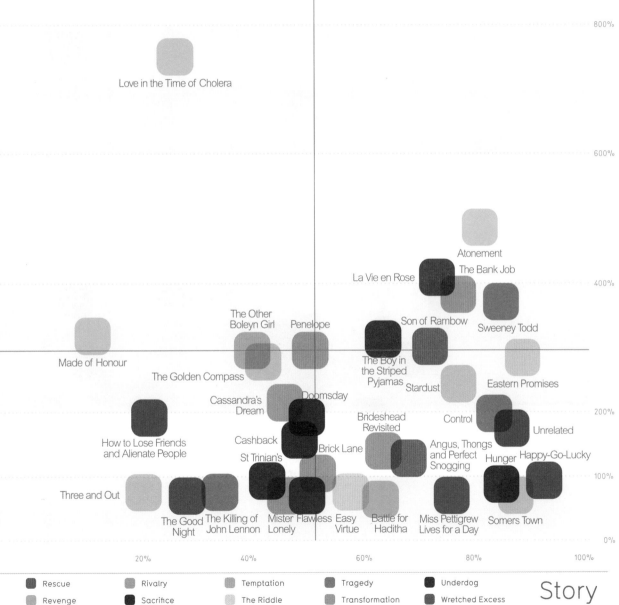

WORTH WATCHING LINE

Mamma Mia!

1000%

Love in the Time of Cholera

800%

600%

Atonement

The Bank Job

La Vie en Rose

400%

The Other Boleyn Girl Penelope Son of Rambow Sweeney Todd

Made of Honour The Boy in the Striped Pyjamas Stardust Eastern Promises

The Golden Compass

Cassandra's Dream Doomsday Control 200%

How to Lose Friends and Alienate People Brideshead Revisited Unrelated

Cashback Brick Lane Angus, Thongs and Perfect Snogging Hunger Happy-Go-Lucky

St Trinian's 100%

Three and Out

The Good Night The Killing of John Lennon Mister Flawless Lonely Easy Virtue Battle for Haditha Miss Pettigrew Lives for a Day Somers Town

0%

20% 40% 60% 80% 100%

◼ Rescue ◼ Rivalry ◼ Temptation ◼ Tragedy ◼ Underdog

◼ Revenge ◼ Sacrifice ◼ The Riddle ◼ Transformation ◼ Wretched Excess

Story

source: Naachgaana.com, BoxOfficeIndia.com, The-Numbers.com, BoxOfficeMojo.com & The British Film Institute.

Most Profitable Stories Of All Time
By percentage of budget recovered

PROFITABILITY

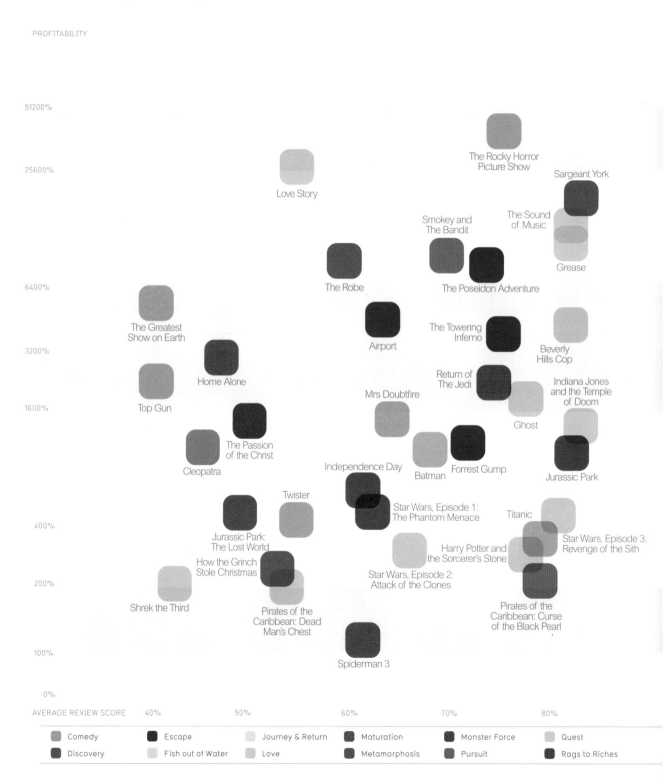

51200%

25600%

6400%

3200%

1600%

400%

200%

100%

0%

AVERAGE REVIEW SCORE 40% 50% 60% 70% 80%

The Rocky Horror Picture Show

Sargeant York

Love Story

Smokey and The Bandit

The Sound of Music

Grease

The Robe

The Poseidon Adventure

The Greatest Show on Earth

Airport

The Towering Inferno

Beverly Hills Cop

Home Alone

Return of The Jedi

Indiana Jones and the Temple of Doom

Top Gun

Mrs Doubtfire

Ghost

The Passion of the Christ

Independence Day

Batman

Forrest Gump

Jurassic Park

Cleopatra

Twister

Star Wars, Episode 1: The Phantom Menace

Titanic

Jurassic Park: The Lost World

Harry Potter and the Sorcerer's Stone

Star Wars, Episode 3: Revenge of the Sith

How the Grinch Stole Christmas

Star Wars, Episode 2: Attack of the Clones

Shrek the Third

Pirates of the Caribbean: Dead Man's Chest

Pirates of the Caribbean: Curse of the Black Pearl

Spiderman 3

Legend

- Comedy
- Escape
- Journey & Return
- Maturation
- Monster Force
- Quest
- Discovery
- Fish out of Water
- Love
- Metamorphosis
- Pursuit
- Rags to Riches

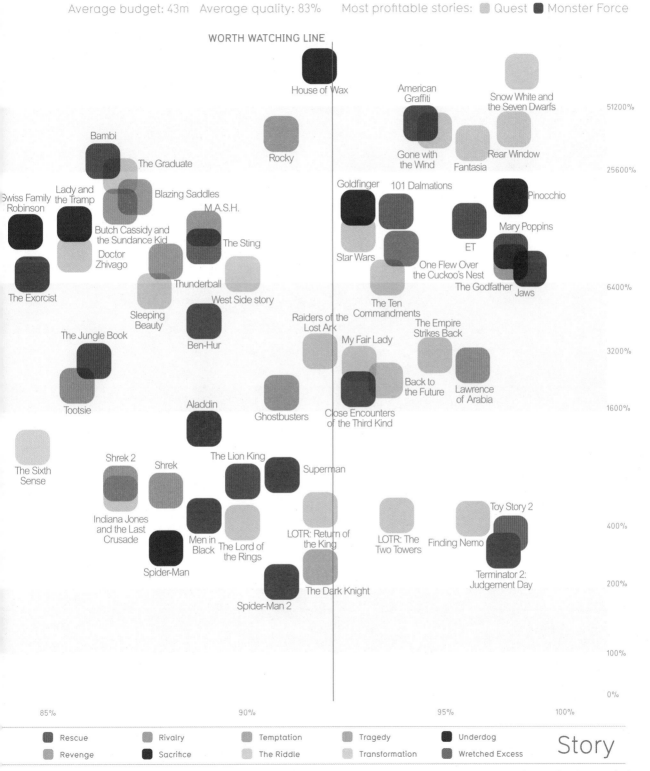

Average budget: 43m Average quality: 83% Most profitable stories: ■ Quest ■ Monster Force

WORTH WATCHING LINE

House of Wax

American Graffiti

Snow White and the Seven Dwarfs

51200%

Rocky

Gone with the Wind Fantasia Rear Window

25600%

Bambi

The Graduate

Goldfinger 101 Dalmations Pinocchio

Swiss Family Robinson

Lady and the Tramp Blazing Saddles

M.A.S.H.

Mary Poppins

Butch Cassidy and the Sundance Kid The Sting

Doctor Zhivago

ET One Flew Over the Cuckoo's Nest

The Godfather Jaws

6400%

The Exorcist

Star Wars

Thunderball

West Side story

The Ten Commandments

Sleeping Beauty Ben-Hur

Raiders of the Lost Ark The Empire Strikes Back

The Jungle Book My Fair Lady

3200%

Tootsie

Back to the Future Lawrence of Arabia

Aladdin Ghostbusters Close Encounters of the Third Kind

1600%

Shrek 2 Shrek The Lion King Superman

The Sixth Sense

Indiana Jones and the Last Crusade

LOTR: Return of the King LOTR: The Two Towers Finding Nemo Toy Story 2

400%

Men in Black The Lord of the Rings

Spider-Man Terminator 2: Judgement Day

200%

Spider-Man 2 The Dark Knight

100%

0%

85% 90% 95% 100%

| ■ Rescue | ■ Rivalry | ■ Temptation | ■ Tragedy | ■ Underdog |
| ■ Revenge | ■ Sacrifice | ■ The Riddle | ■ Transformation | ■ Wretched Excess |

Story

SOURCES: BoxOfficeMojo.com, The-Numbers.com, Wikipedia, IMDB.com, and RottenTomatoes.com for average review scores. Reported budgets are notoriously unreliable (flops especially).

source: BoxOfficeMojo.com, Wikipedia

Enneagram

A personality-type system based around an ancient symbol of perpetual motion. Each type is formed from a key defense against the world. Which one are you?

		I am...	I want to...	Virtue
1	**Reformer**	Reasonable and objective	Be good & to have integrity	Serenity
2	**Helper**	Caring and loving	Feel love	Humility
3	**Achiever**	Outstanding and effective	Feel valuable	Honesty
4	**Individualist**	Intuitive and sensitive	Be myself	Balance
5	**Investigator**	Intelligent, perceptive	Be capable & competent	Detachment
6	**Loyalist**	Committed, dependable	Have support and guidance	Courage
7	**Enthusiast**	Reasonable and objective	Be satisfied and content	Sobriety
8	**Challenger**	Strong, assertive	Protect myself	Innocence
9	**Peacemaker**	Peaceful, easygoing	Have peace of mind	Action

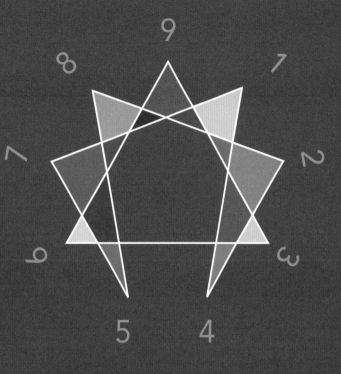

Hidden complaint	I fear being...	Flaw	Saving grace
I am usually right. Others should listen to me.	Bad, wrong	Resentment	Sensible
I'm always loving. Others take me for granted.	Unloved	Flattery	Empathic
I am a superior person. Others are jealous	Worthless	Vanity	Eagerness
I don't really fit in. I am different from others.	Insignificant	Melancholy	Self-aware
I'm so smart. Others can't understand me.	Helpless or incompetent	Stinginess	No bullshit
I do what I'm told . Others don't	Without support	Worrying	Friendly
I'm happy. But others don't give me enough.	In pain	Over-Planning	Enthusiasm
I'm fighting to survive. Others take advantage.	Harmed or controlled	Vengeance	Strength
I am content. Others pressure me to change.	Lost and separated	Laziness	Fluidity

source: Wikipedia, EnneagramInstitute.com

Bee Limit Warning
Why are they disappearing?

EFFECT on bees

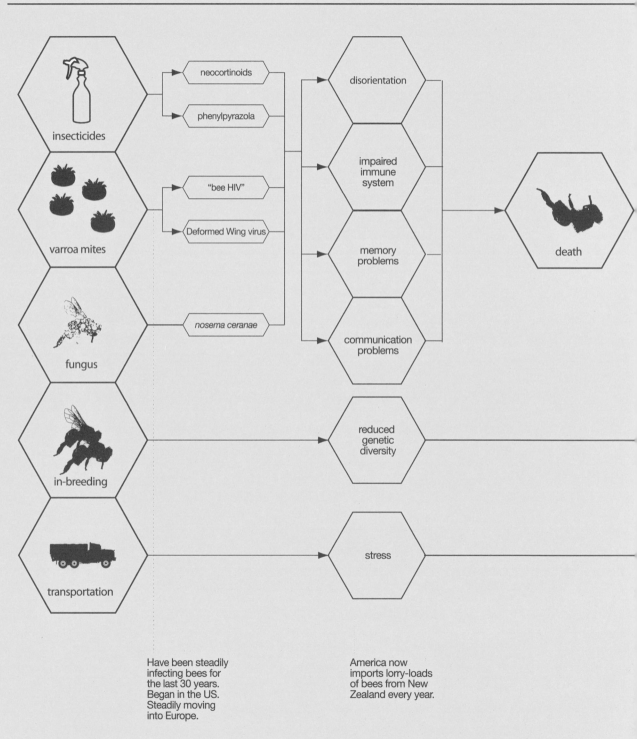

insecticides

neocortinoids

phenylpyrazola

varroa mites

"bee HIV"

Deformed Wing virus

fungus

nosema ceranae

in-breeding

transportation

disorientation

impaired immune system

memory problems

communication problems

reduced genetic diversity

stress

death

Have been steadily infecting bees for the last 30 years. Began in the US. Steadily moving into Europe.

America now imports lorry-loads of bees from New Zealand every year.

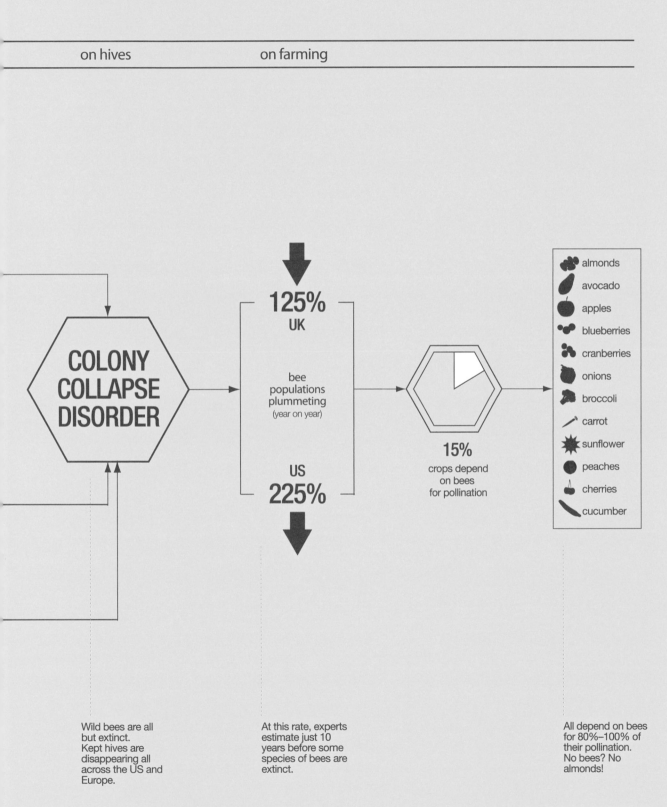

COLONY COLLAPSE DISORDER

125%
UK

bee
populations
plummeting
(year on year)

US
225%

15%
crops depend
on bees
for pollination

almonds
avocado
apples
blueberries
cranberries
onions
broccoli
carrot
sunflower
peaches
cherries
cucumber

Wild bees are all
but extinct.
Kept hives are
disappearing all
across the US and
Europe.

At this rate, experts
estimate just 10
years before some
species of bees are
extinct.

All depend on bees
for 80%–100% of
their pollination.
No bees? No
almonds!

source: Wikipedia, Discovery.com, New York Times

Selling Your Soul

Workers on Amazon.com's Mechanical Turk asked to draw their souls

female

Amazon's Mechanical Turk is a "cloud workforce" of people happy to do microjobs for micropayments ($0.25 and up).
200 people were asked to draw a picture of their soul for the author's ongoing collection. Muhahahahahahahaha...

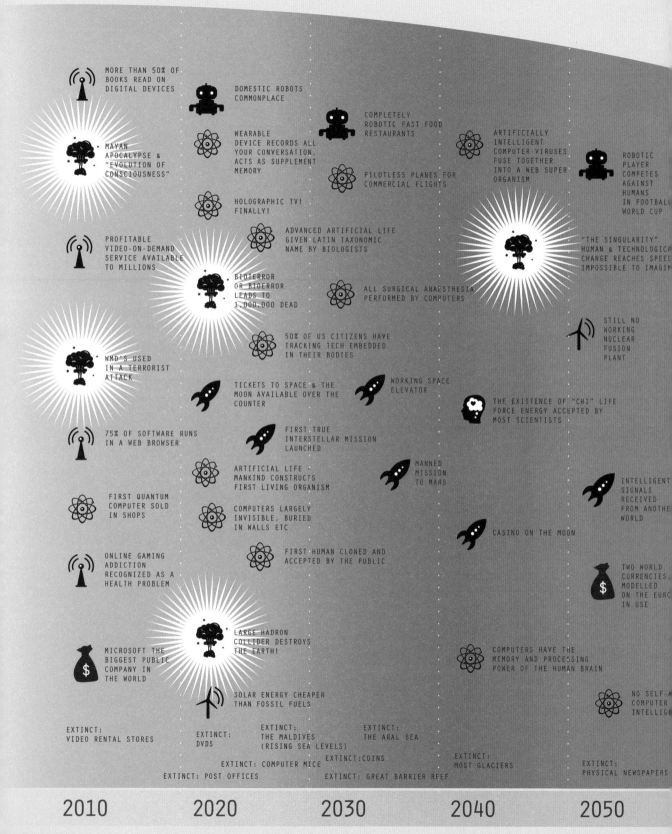

MORE THAN 50% OF BOOKS READ ON DIGITAL DEVICES

DOMESTIC ROBOTS COMMONPLACE

COMPLETELY ROBOTIC FAST FOOD RESTAURANTS

ARTIFICIALLY INTELLIGENT COMPUTER VIRUSES FUSE TOGETHER INTO A WEB SUPER ORGANISM

ROBOTIC PLAYER COMPETES AGAINST HUMANS IN FOOTBALL WORLD CUP

MAYAN APOCALYPSE & "EVOLUTION OF CONSCIOUSNESS"

WEARABLE DEVICE RECORDS ALL YOUR CONVERSATION, ACTS AS SUPPLEMENT MEMORY

PILOTLESS PLANES FOR COMMERCIAL FLIGHTS

HOLOGRAPHIC TV! FINALLY!

PROFITABLE VIDEO-ON-DEMAND SERVICE AVAILABLE TO MILLIONS

ADVANCED ARTIFICIAL LIFE GIVEN LATIN TAXONOMIC NAME BY BIOLOGISTS

"THE SINGULARITY" HUMAN & TECHNOLOGICAL CHANGE REACHES SPEED IMPOSSIBLE TO IMAGINE

BIOTERROR OR BIOERROR LEADS TO 1,000,000 DEAD

ALL SURGICAL ANAESTHESIA PERFORMED BY COMPUTERS

WMD'S USED IN A TERRORIST ATTACK

50% OF US CITIZENS HAVE TRACKING TECH EMBEDDED IN THEIR BODIES

STILL NO WORKING NUCLEAR FUSION PLANT

TICKETS TO SPACE & THE MOON AVAILABLE OVER THE COUNTER

WORKING SPACE ELEVATOR

75% OF SOFTWARE RUNS IN A WEB BROWSER

FIRST TRUE INTERSTELLAR MISSION LAUNCHED

THE EXISTENCE OF "CHI" LIFE FORCE ENERGY ACCEPTED BY MOST SCIENTISTS

ARTIFICIAL LIFE - MANKIND CONSTRUCTS FIRST LIVING ORGANISM

MANNED MISSION TO MARS

FIRST QUANTUM COMPUTER SOLD IN SHOPS

COMPUTERS LARGELY INVISIBLE, BURIED IN WALLS ETC

INTELLIGENT SIGNALS RECEIVED FROM ANOTHER WORLD

CASINO ON THE MOON

ONLINE GAMING ADDICTION RECOGNIZED AS A HEALTH PROBLEM

FIRST HUMAN CLONED AND ACCEPTED BY THE PUBLIC

TWO WORLD CURRENCIES, MODELLED ON THE EURO IN USE

LARGE HADRON COLLIDER DESTROYS THE EARTH!

COMPUTERS HAVE THE MEMORY AND PROCESSING POWER OF THE HUMAN BRAIN

MICROSOFT THE BIGGEST PUBLIC COMPANY IN THE WORLD

SOLAR ENERGY CHEAPER THAN FOSSIL FUELS

NO SELF-AWARE COMPUTER INTELLIGENCE

EXTINCT: VIDEO RENTAL STORES

EXTINCT: DVDS

EXTINCT: THE MALDIVES (RISING SEA LEVELS)

EXTINCT: THE ARAL SEA

EXTINCT: COMPUTER MICE

EXTINCT: COINS

EXTINCT: MOST GLACIERS

EXTINCT: PHYSICAL NEWSPAPERS

EXTINCT: POST OFFICES

EXTINCT: GREAT BARRIER REEF

2010 2020 2030 2040 2050

The Future of the Future

At longbets.org leading thinkers gather to place bets on future predictions

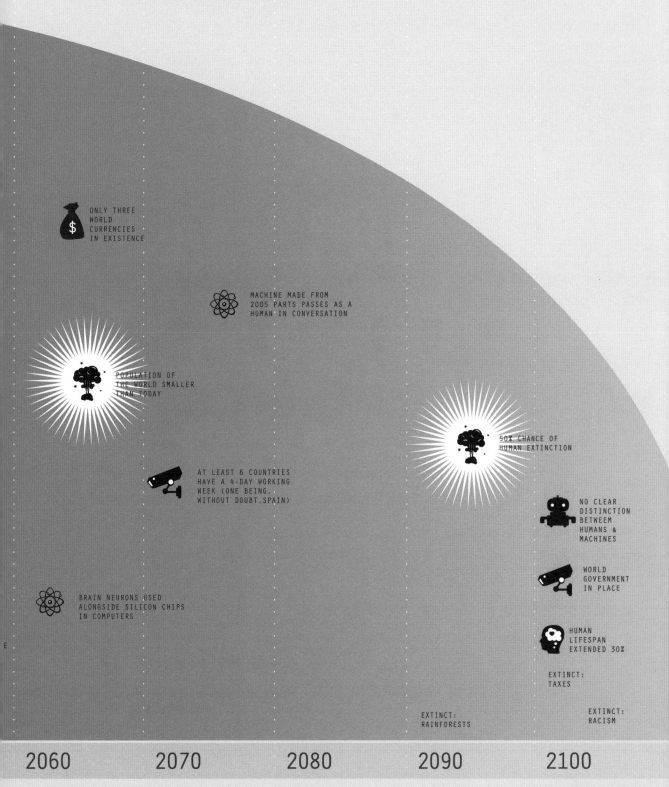

ONLY THREE WORLD CURRENCIES IN EXISTENCE

MACHINE MADE FROM 2005 PARTS PASSES AS A HUMAN IN CONVERSATION

POPULATION OF THE WORLD SMALLER THAN TODAY

50% CHANCE OF HUMAN EXTINCTION

AT LEAST 6 COUNTRIES HAVE A 4-DAY WORKING WEEK (ONE BEING, WITHOUT DOUBT, SPAIN)

NO CLEAR DISTINCTION BETWEEM HUMANS & MACHINES

WORLD GOVERNMENT IN PLACE

BRAIN NEURONS USED ALONGSIDE SILICON CHIPS IN COMPUTERS

HUMAN LIFESPAN EXTENDED 30%

EXTINCT: TAXES

EXTINCT: RAINFORESTS

EXTINCT: RACISM

2060 2070 2080 2090 2100

source: longbets.org

Making a Book

The first six months

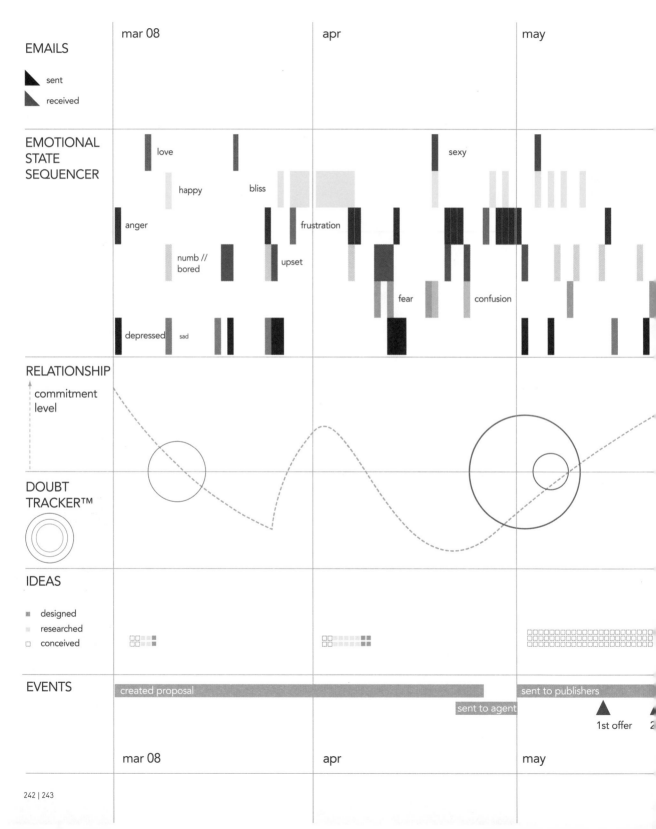

EMAILS

mar 08 apr may

▲ sent
◤ received

EMOTIONAL STATE SEQUENCER

love happy bliss sexy anger frustration numb // bored upset fear confusion depressed sad

RELATIONSHIP

↑ commitment level

DOUBT TRACKER™

IDEAS

■ designed
■ researched
□ conceived

EVENTS

created proposal

sent to agent

sent to publishers

▲ 1st offer ▲ 2

mar 08 apr may

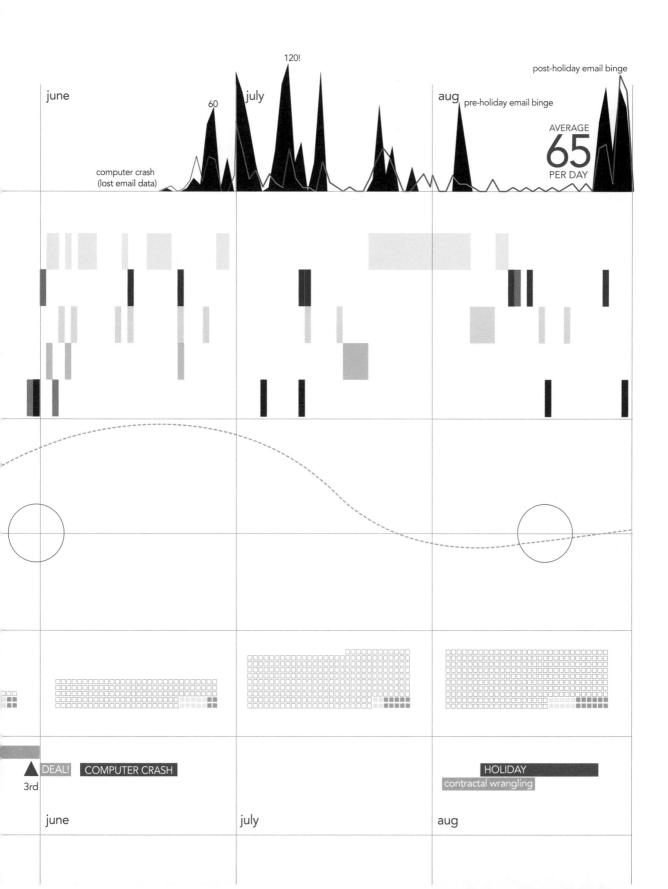

june

july

120!

60

computer crash
(lost email data)

aug

pre-holiday email binge

post-holiday email binge

AVERAGE
65
PER DAY

3rd

DEAL! COMPUTER CRASH

HOLIDAY
contractal wrangling

june

july

aug

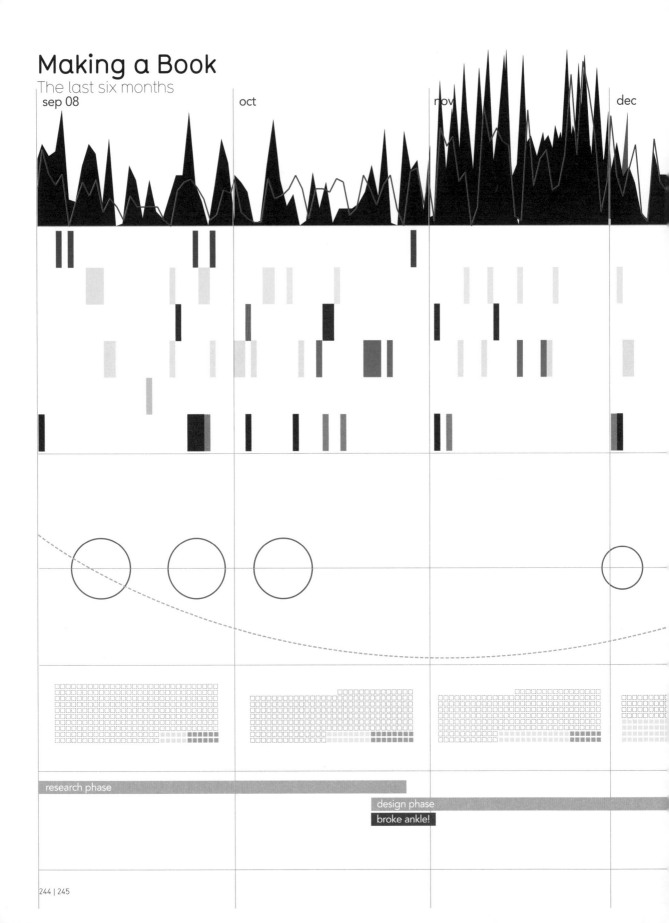

Making a Book
The last six months

sep 08 oct nov dec

research phase

design phase

broke ankle!

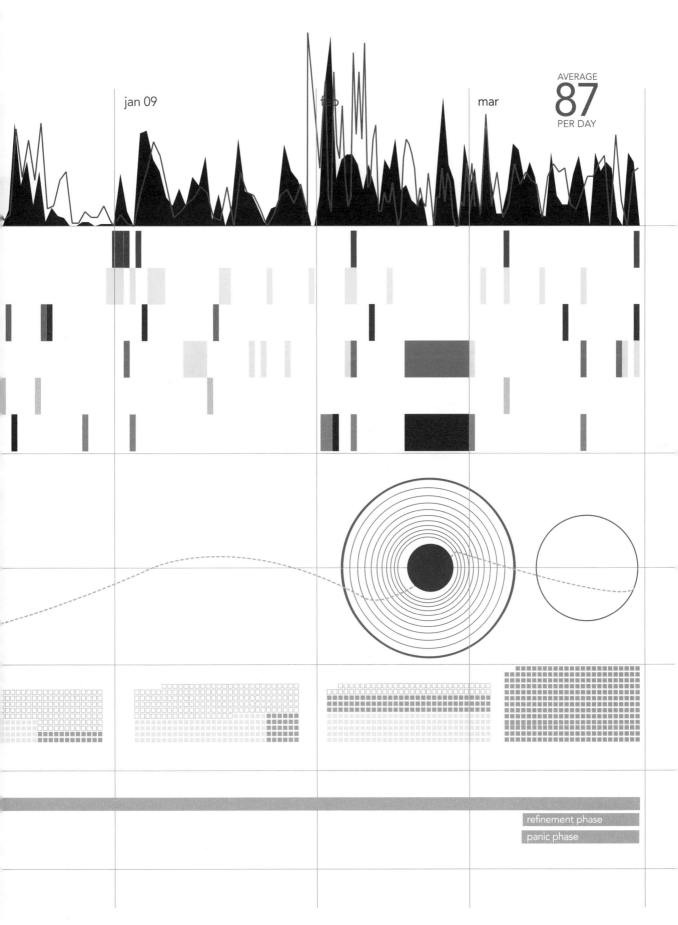

jan 09

feb

mar

AVERAGE
87
PER DAY

refinement phase
panic phase

Acknowledge Map
Thanks to all who helped and supported

MANY THANKS TO: Vincent Ahrend, Dr David Archer, Steve Beckett, Delfina Bottesini, Laura Brudenell, Candy Chang, Susanne Cook Greuter, Dave Cooper, Kesta Desmond, Robert Downes, Danielle Engelman, Edward Farmer, Richard Henry, Dr Phil Howard, Claudia Hofmeister, Aegir Hallmundur, Becky Jones, Dongwoo Kim, Jenny McIvor, Priscila Moura, Mark O'Connor, Kate O'Driscoll, Dr. Lori Plutchik, Laura Price, Richard Rogers, Twitter Army, Mechanical Turkers.

Denise Bates Claire Kingston Lucie Jordan Anna Martin Stephanie Meyers

Airella Feiner

Simon Trewin

David Christianne Michelle Holly

iMac 24" Macbook Pro 17" PB G4 12"

Google

Wikipedia

Amazon

Wordle

Illustrator CS3

Indesign CS3

Photoshop CS3 MacJournal 5

Google Docs

Twitter iStockPhoto Google Insights Britannica Ffffound Google Reader Decodeme

Design

Freelance design

Art direction

Research

Freelance Research

Interns

Programmer

HarperCollins

UnitedAgents

Family

Hardware

Software

Webware

Bibliograph

Inspiration and source material

Schott, Ben, *Schott's Almanac* 2007 (London: Bloomsbury Publishing Plc., 2007)

Tufte, Edward R., *Envisioning Information* (Cheshire, Connecticut: Graphics Press LLC, 2005)

Fry, Ben, *Visualizing Data* (Sebastopol, CA: O'Reilly Media, Inc., 2008)

Abrams, Janet and Peter Hall, *Else/Where: Mapping* (Minneapolis: University of Minneapolis Design Institute, 2006)

Bakhtiar, Laleh, *Sufi* (New York: Thames and Hudson Inc., 2004)

Tufte, Edward R., *The Visual Display of Quantitative Information* (Cheshire, Connecticut: Graphics Press LLC, 2006)

Levitt, Steven D. and Stephen J. Dubner, *Freakonomics* (London: Penguin Books, 2006)

Harmon, Katharine, *You Are Here* (New York: Princeton Architectural Press, 2004)

Solomon, Lawrence, *The Deniers* (Richard Vigilante Books, 2008)

Ayers, Ian, *Super Crunchers* (London: Random House, Inc., 2008)

Image Credits

InformationIsBeautiful.net

Visit the website for the book

discover more
our blog covers visual journalism, unusual infographics,
far-out data visualisations

be involved
crowdsource and help us investigate, research and
unearth facts and information for new designs

get animated
play with interactive visuals and animations

have a play
access all the data and research used in this book
and find editable versions of all the images

find extra stuff
tons of new diagrams, idea maps, bubble charts,
factoramas, knowledgescapes and infomaps...

twitter: @infobeautiful // facebook.com/david.mccandless

Can Drugs Make You Happy?

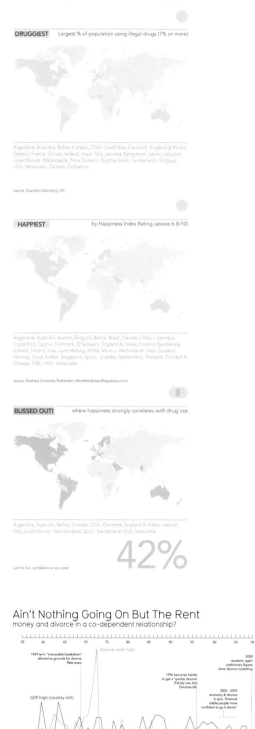

DRUGGIEST
Largest % of population using illegal drugs (7% or more)

Argentina, Australia, Belize, Canada, Chile, Czech Rep, Denmark, England & Wales, Estonia, France, Ghana, Ireland, Israel, Italy, Jamaica, Kyrgyzstan, Latvia, Lebanon, Luxembourg, Madagascar, New Zealand, Nigeria, Spain, Switzerland, Uruguay, USA, Venezuela, Zambia, Zimbabwe

source: Guardian Data blog, UN

HAPPIEST
by Happiness Index Rating (above 6.8/10)

Argentina, Australia, Austria, Belgium, Belize, Brazil, Canada, Chile, Colombia, Costa Rica, Cyprus, Denmark, El Salvador, England & Wales, Finland, Guatemala, Iceland, Ireland, Italy, Luxembourg, Malta, Mexico, Netherlands, New Zealand, Norway, Saudi Arabia, Singapore, Spain, Sweden, Switzerland, Thailand, Trinidad & Tobago, UAE, USA, Venezuela

source: Erasmus University Rotterdam, Worlddatabaseofhappiness.eur.nl

BLISSED OUT!
where happiness strongly correlates with drug use

Argentina, Australia, Belize, Canada, Chile, Denmark, England & Wales, Ireland, Italy, Luxembourg, New Zealand, Spain, Switzerland, USA, Venezuela

42%

just for fun, correlation is not cause

Ain't Nothing Going On But The Rent
money and divorce in a co-dependent relationship?

1969 term "irrevocable breakdown" allowed as grounds for divorce. Rate soars.

divorce rates high

2008 recession again preliminary figures show divorce rocketing

1996 becomes harder to get a 'quickie divorce' (Family Law Act) Divorces fall.

GDP high (country rich)

2002 - 2005 economy & divorce in sync. Financial stable people more confident to go it alone?

0% change

divorce rates low

1973 Matrimonial Causes Act The courts now decide how the money will be split. Divorce rate plummets.

GDP low (recession)

2006 Lowest number of divorces 29 years. McCartney & Mills high profile divorce in the news

1973, 1980 & 1990 England in recession Divorce rates rise. Connection?

1955 2009

Pre-Flight Check
Reduce your odds of dying in a plane crash

Final Destination
Density of fatal accidents 1942-2009

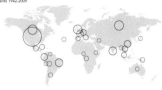

source: www.aviation-safety.net/database/country

Squadron Leaders
Fatal accidents by aircraft type

Boeing 737 family 60
DC-9 family 56
Boeing 747 15
Airbus A320 15
Airbus A300 8
Boeing 757 5
Boeing 767 3
Bombardier CRJ 2
Airbus A330 1
Boeing 777 0
Embraer 0

2nd Squadron Leaders
Ratio of fatal accidents to number of planes in services (the higher the better)

DC-9 family 19:1
Airbus A300 37:1
Boeing 747 52:1
Boeing 737 family 77:1
Boeing 757 183:1
Boeing 767 269:1
Airbus A320 463:1
Bombardier CRJ 700:1
Airbus A330 943:1
Boeing 777 0
Embraer 0

source: www.airsafe.com via the Guardian datablog

Seating Plan
Survival rate relative to seat position

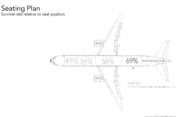

49% 56% 56% 69%

source: Popular Mechanics (Flying2Die.com), University of Greenwich study

Bad Month
Months with the most fatal airline accidents 1942-2009

Jan	Feb	Mar	Apr	May	June
39				2	

July	Aug	Sep	Oct	Nov	Dec
	48				

source: Wikipedia/List_of_air_disasters

The Odds
Chances of actually dying in a plane crash

Falling down	Heart attack	Lightning	Nuclear Accident	Plane Crash	Bee Sting	Mountain Lion Attack	Flogging
20,666:1	498,000:1	2,320,000:1	10,000,000:1	11,000,000:1	15,000,000:1	32,857,000:1	37,435,000:1

source: Google

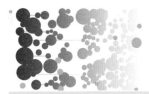
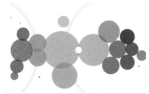
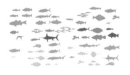

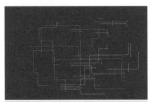

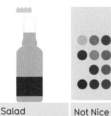

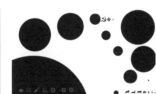

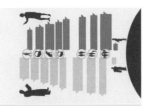